S0-BYM-411

INDOOR
PHOTOGRAPHY

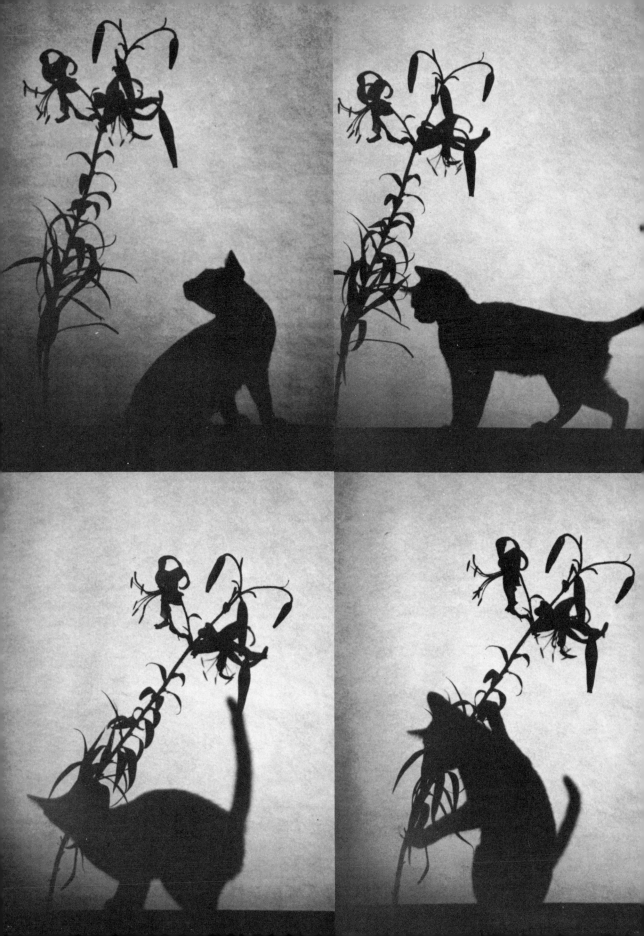

INDOOR PHOTOGRAPHY

BRUCE PINKARD

B. T. Batsford Ltd, London

This book is dedicated to Charles Potts who became something of a marriage broker during my love affair with light

Other books by the same author also published by Batsford
The Photographer's Dictionary
Creative Techniques in Studio Photography
Creative Techniques in Nude Photography

ACKNOWLEDGEMENTS

The author wishes to acknowledge the following organizations without whom this book could not have been completed: A V Distributors Ltd; Keith Johnson Photographic Ltd; Polaroid (UK) Ltd; Agfa-Gevaert AG; Ilford Ltd; 3M Co Ltd; Berkey Technical Ltd.

Many people have continually helped me with this project and I particularly wish to thank Nigel Hodgson, Bill Waller, Alison McKay and Keith Johnson for their very helpful encouragement.

My deepest thanks also to Carolyn MacKenzie of Batsford Ltd for her constant help throughout and to Danny Scanlon who produced the fine, technical illustrations for this book. Finally, a special acknowledgement to Didi for her help and patience while this book was being written.

All photographs are by the author except where otherwise credited.

Frontispiece Photography of this kind, although ultra-simple in technique and lighting, can be a great deal of fun. A paper screen, a flower firmly fixed and a single light behind the cat and screen are all that are required. Any camera will suit the purpose. The results, reminiscent of the Indonesian puppet theatre, are effective and amusing.

© London Associates 1985
First published 1985
All rights reserved. No part of this publication may be reproduced, in any form or by any means, without permission from the Publisher
ISBN 0 7134 4160 7

Typeset and printed in Great Britain by
Butler & Tanner Ltd,
Frome and London

for the publishers
B.T. Batsford Ltd
4 Fitzhardinge Street
London W1H 0AH

Contents

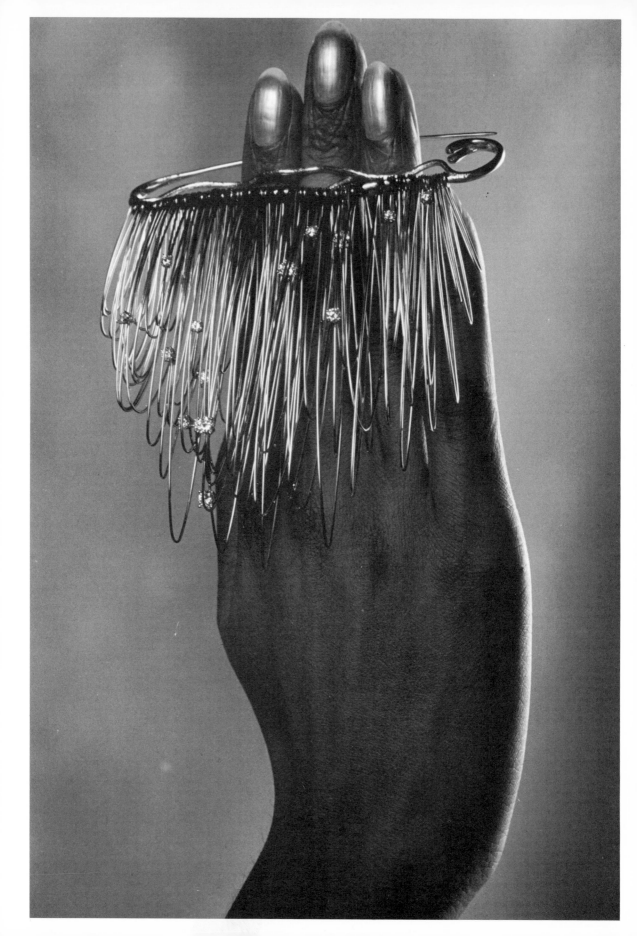

Introduction

Artificial light was the cave-dweller's dream, and when the miracle of fire was harnessed some 400,000 years ago, it was not long before rudimentary oil lamps were being used to lighten the dark dwellings, extend the working day and to dismiss the secret dragons of the icy, pre-historic night.

Artificial light has always been associated with these rites of magic, with reassurance and religion, and Palaeolithic man must have been totally bewitched, 20,000 years ago, to behold, in the sultry gleam of primitive lamplight, the hauntingly beautiful images made by those Magdalenian artists deep in their caves near Altamira and Lascaux. Cave paintings were possibly the first ever pictorial communications, teaching the community about religion, hunting, history or legend. To make and view them was impossible without artificial light.

Prometheus, it is said, brought Mankind the gift of fire and light, and angered the gods but, ironically perhaps, we appease them now as our strident, synthetic beams light up a new twentieth-century Pandora's box, with its own brittle demons of half-truths, hyperbole and mechanical dreams.

Within the brief, 20,000-year flash of maturity that has followed Mankind's multi-million years of evolution, it is only in the last 100 of them that it has been possible to flick a switch and light up our indoor space, with both quantity and quality of light fully under our command and control.

With an ability to command light, mould it to a definite purpose so that it reveals either reality or reverie, the photographer has become a vital and unique force in modern communications. Artificial light endows photography with its special attribute: to dissect, resolve or analyse most of the shapes and concepts of our modern world, making manifest our ideas in commerce, science, art or leisure directly, without any transposition into cultural or literary vernacular.

Photography was 50 years old and had already captured the imagination of the Victorians, when Nadar, in 1859, using Bunsen's generator, made photographs in the catacombs of Paris. Five years later, Mr A. Brothers used the dangerous volatility of magnesium flash to light up the dark recesses of a Derbyshire coalmine and in 1865, Professor P. Smith became the first photographer to use artificial light to photograph formal interiors, when he obtained pictures inside the Great Pyramid. The invention of the carbon filament lamp in 1879 by Swan (UK) and Edison (USA), offered the first opportunity to photographers to use a controllable, safe, light indoors. Open magnesium flash continued to be used with all of its associated hazards well into the twentieth century but after 1880, with the invention of the half-tone engraving process for reproducing photographs in magazines or print, editorial sources put great pressure on photographers to supply pictures of events which occurred in gloomy public interiors or after the sun went down. With the mass-production in the last decade of the nineteenth century of fast-dry Maddox-type emulsions, together with the advent of the filament lamp and improved camera optics, there was swift growth in this kind of photography which took as its special interest the indoor environment. Towards the end of the Victorian age, floodlighting was used with confidence and, with ultra-fast optics being made available, it was now possible to

1 Opposite *A low-angle, expressive photograph, using the hand as a major prop.*

achieve snapshot exposures in almost any interior, however dark.

In the bold years after the First World War, inventions and artistic discoveries proliferated. Television was demonstrated by Baird, Penicillin was identified by Fleming, MGM produced *Broadway Melody*, the first film musical, and photographers Moholy-Nagy and Man Ray conducted heady experiments in abstract photo-art, using projected light.

The Surrealists were a growing force in art and literature and the financial collapse of Wall Street was bringing economic nightmares to an unprepared world, when the expendable flashlamp was first marketed in Germany and the USA. This totally enclosed lamp was smokeless, intensely bright and could be synchronized with Deckel's new Compur leaf shutters. The portability and control of such a light source, which had been specifically designed for photography, opened the entire communications field to the go-anywhere, see-everything photographers of the 1930s and 1940s. Editorial communication began then to depend heavily on artificial light and, without the benefit of Ostermeier's flashlight and the 1935 invention in the USA of electronic flash, much of the world's activities between dusk and dawn would never have been recorded.

The film industry demonstrated just how much skill could be applied to the use and control of light and that for communication in the fields of leisure, commerce or education, no better means existed than to link photography with synthetic light.

In the energetic 'fifties which followed the war years, advertising entered its great ripening period and the still photograph, mostly taken indoors, was at the heart of this commercial and communication revolution.

Today we are equipped with fast lenses; automatic exposure metering; low-contrast, high-speed film in colour or in black and white; miniscule electronic flash, or tiny tungsten halogen lamps which are almost sun-bright. Taking pictures indoors holds few technical terrors for skilled photographers and even very little for the enthusiastic hobbyist.

In this book I have tried to convey some of the fascination and possibilities available when photographing indoors with controlled light; I trust that all those who read it will understand something of the magic and prodigious power which was placed in our hands when the phenomenon of synthetic light was applied to modern photographic technology and the twentieth century was given probably its most revolutionary and effective means of touching the minds and hearts of all Mankind.

1 Equipment and Techniques

For several decades after the invention of photography by Louis Jacques Mande Daguerre in 1839, it proved impossible to take lively or convincing pictures of interiors in which people were included. Portraits of the day were made in special studios with very large expanses of windows to give maximum strength to the exposing daylight, and even with very fast lenses, such as those newly invented by Petzval for the Voigtlander Company, snapshot exposures were rarely successful. Slow emulsions and, consequently, very little depth of field, made it impossible properly to render both the indoor environment and its inhabitants.

Most interior photography at that time required the use of the formidable and bulky bellows cameras which were locked securely to a wooden tripod with the photographer peering into the back of the mysterious machine while covered by swirling shrouds of black velvet cloth. To some extent, modern but largely unchanged versions of such cameras often provide the ideal solution to many of the problems encountered during the photography of interiors.

As the photographic process was improved and the inconveniences of wet collodion were replaced by the Maddox-type dry emulsions which were pre-coated by factory processes and considerably faster, many photographers began to find it within their ability to include environmental background to support reasonably candid, indoor portraiture. When George Eastman, in 1889 and 1890, introduced his revolutionary Kodak roll film cameras, which offered the photographer fast films and small size at an economic price, it became even more feasible to attempt this kind of picture and to include complex interiors of all kinds.

Although magnesium light had been used since its introduction in England in 1864, and in later Victorian times was a fairly commonplace illuminant for indoor photography, it was a hazardous and somewhat chancy affair, and its use was mostly restricted to a few daring professionals who found such a portable source of interior light quite indispensable to their business.

The expendable flashlight, which is filled with aluminium or magnesium wire and ignited by a spark from a dry cell battery, was introduced by Ostermeier of Germany in 1929. It was to revolutionize press photography and the lighting techniques used for all indoor pictures, and slowly found its way into the huge amateur market, where it underwent a series of miniaturizations in order to make it compatible with the small cameras which were becoming available and very popular. In the form of flash cubes and flash bars, the expendable flashlamp is still with us, but has tended to be replaced by the electronic re-usable flashgun.

ELECTRONIC FLASH

Electronic flash was invented in the late 1930s but its miniaturization and versatility are really very recent. Many cameras are now being equipped with flash built into the camera body; others have very sophisticated, 'dedicated' flash systems, whereby a separate meter detects a suitable quantity of light for the chosen film speed; all are physically small and very powerful.

Improving the quality of light

For those sensitive to the flowing revelations of form, texture and mood produced by good indoor lighting, flash will not be the first choice, particularly if it is aimed along the

BASIC PHOTOGRAPHY

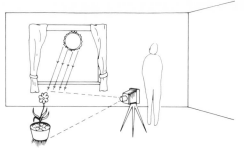

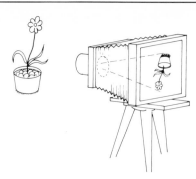

2a *We see by the reflected light from the sun. Colours are seen when the image absorbs a proportion of the sun's rays, but reflects most other rays in the colour perceived. The camera 'sees' in similar fashion.*

2b *Both the eye and the camera see an inverted image. The brain turns it the right way up.*

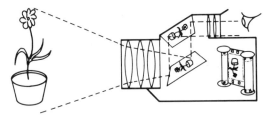

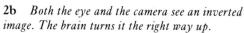

2c *The modern reflex camera, by the use of mirrors, also turns the image the right way up for viewing. When taking the picture, the mirror flips up and the image is recorded on the film still upside-down.*

2d *The front of the camera (lens) collects and concentrates rays of light. The back of the camera (film) records and retains these rays.*

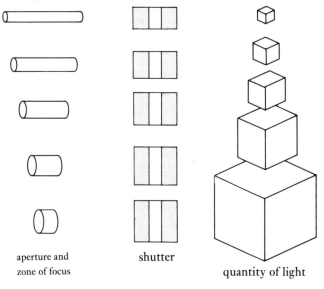

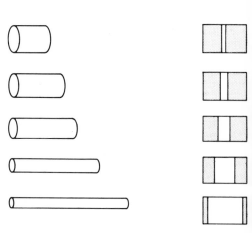

aperture and
zone of focus

shutter

quantity of light

2g *Altering the 'f' stop but keeping the same shutter speed not only changes the extent of the zone of sharp focus but also alters the quantity of light reaching the film. When the light is weak the aperture is opened up by selecting a smaller number 'f' stop; when the light is bright a larger 'f' stop number is used, which indicates a* smaller *aperture.*

2h *Shutter and 'f' stop work in mathematical proportion to each other. When small apertures are used, longer shutter speeds are needed to compensate. In the above diagram each combination allows the same amount of light to reach the film.*

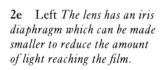

2e Left *The lens has an iris diaphragm which can be made smaller to reduce the amount of light reaching the film.*

2f Right *The amount of light reaching the film is also controlled by a moving shutter which works in proportional steps to cut off or admit light as needed. These steps or speeds are mathematically compatible with the lens openings or apertures, which are called 'f' stops.*

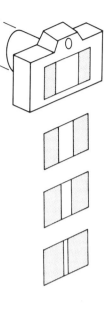

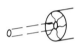

2i Below *Altering the two controls of 'f' stop and shutter speed independently of each other also changes image structure: large apertures create shallow zones of sharpness around the focus point; smaller apertures create broad zones of sharpness around the focus point, making background and foreground objects clearer.*

2j *Brief shutter speeds allow action to be seen clearly.*

2k *Slow shutter speeds allow action to blur.*

2l Left *In the camera, light changes the film chemistry wherever it strikes, creating an invisible image from the ray pattern which the lens throws.*

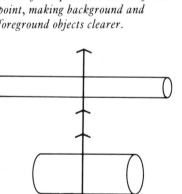

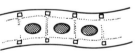

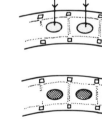

2m Right *In the darkroom, a developer permanently darkens the film wherever light has affected it, creating a negative and making the image visible for the first time.*

2n Right *In the darkroom the negative is photographically reversed and a positive print is made. What was dark in the negative is now light on the print and vice versa.*

lens axis from a camera-mounted flash unit. This flash-on-camera lighting will flatten contours, reduce texture and usually produce the harshest view of the human face or the interior that can ever be made. The startled subject looms out, brilliantly but flatly lit, against a black background which the tiny flash cannot penetrate, with the result that the final photograph will have little visual or aesthetic merit.

The first step in getting a better result with this type of equipment, if forced to use it, is to move the light away from the lens axis, that is to say, off the camera. This is easily done, in one of two ways. The first employs an extension cable of at least 1m (40in) in length which allows the unit to be disconnected from the hot shoe camera mounting and held at arm's length away from the camera. The lamp is then aimed and angled in at the subject, creating a modest lighting angle which does at least produce some modelling in the subject's contours. The light, however, will remain specular and harsh.

The second easy alternative to on-camera flash is simply to bounce the flash on to the

3 *On-camera flash aims the light almost along the lens axis and is often most suitable for good rendering of contoured metal objects. On most other subjects, particularly people, an on-camera flash is not really a suitable lighting position.*

4 *With simple flash systems fixed to the camera hot-shoe, only three possibilities are likely to exercise lighting control: (a) flash on camera – not best suited for people; (b) flash held at arm's length away from camera – very good for portraits and groups as it avoids the problem of 'red eye'; (c) flash bounced on the ceiling or a top reflector gives even, diffused top light, well suited to groups and interiors or shiny objects.*

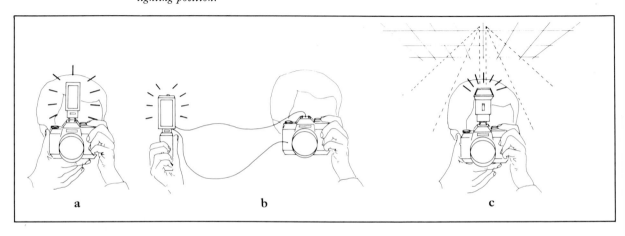

a b c

ceiling or on to a separate reflector so that, again, light reaches the subject at an angle to the lens axis, but this time is also diffused.

Bounce lighting creates a more natural appearance, with the result that the quality of light has something of the values found in photographs taken outdoors in overcast but very bright conditions. Where light is bounced on a ceiling, the light reflected on to the subject will be a top light, with good contour modelling.

If the subject is a person, there is some risk that the shadows under the eyes and chin may be too dense and, as a further complication, such bounce lighting reduces the amount of light by almost two 'f' stops, needing, therefore, the compensation of wider apertures and, consequently, a reduction in the zone of the sharp focus. Objects some distance from the main focus point may be rendered with very soft edges, unless a faster film is loaded in the camera.

The professional who lights an interior in which human subjects are included has, of course, much more equipment, both to aid calculation of exposure and the final lighting of the subject. Very powerful lights (sometimes, over short distances, several times more brilliant than the sun) are used and, if these are electronic flash units, they normally contain a modelling light in the same reflector as the flash head, so arranged that the form of light is similar in both cases. The direction and quality of the flashlight is therefore easily previewed. Professionals also use sophisticated hand-held meters to calculate exposures precisely and, finally, most will check the picture design and exposure estimation by the use of a Polaroid print taken just before the real exposure.

For the millions of amateurs who work to make good indoor pictures, the cost of such professional equipment cannot be justified unless the photographer is in a fee-paying or business situation, but, if first-class results are wanted, it is well to aspire to something like the care and finesse with which the professional completes his task. Going back to the earlier example of flashlighting and the improvement which may be made if the light is moved some distance from the lens axis, a further refinement may easily be made even with this basic 'off-axis' lighting plan. This is done by diffusing the light gently with face tissue, tracing paper or Roscofrost

(available from professional photo-suppliers) and also by being precise about aiming the reflector so that full use of the flash unit's power is made.

The bounce light technique, which is the other refinement suggested for those who possess only a single flash unit or single floodlight, can also be improved dramatically by the addition of simple, inexpensive equipment. By using the bounce light as the main key light (opening the camera lens two further 'f' stops from the aperture calculated from the guide number, or taking a careful reading with an exposure meter if floodlights are being used) and then adding a large white card, at least 75×100cm (30×40in.), as a reflector which catches the main key light and sends it back softly into the shadows, very much better results in either colour or black and white will be seen. Some modern flash units – Agfa, Metz, Osram, Braun, Phillips and Vivitar – incorporate a feature in the flash head which, while the main lamp is turned upwards to bounce light from above, beams a secondary source of light along the lens axis to act as an active fill in for the shadows. Where the photographer is forced to use flash-on-camera, this is a very desirable innovation.

Multiple flash units

For many indoor photography needs, where the convenience of small, portable flash units is considered necessary, it probably will be found that a number of units, linked by a cable or by electronic means to the camera, will be essential.

This use of multiple flash units may seem difficult but, in practice, it will be found that, provided the flash heads are aimed precisely and their lighting angle is known, and that distances of lamp to subject are measured accurately by *tape-measure*, no real problem will be encountered. The guide number (GN) is usually calibrated by the manufacturer of the flash unit, but the photographer should correct these figures to suit his own equipment and the processing techniques for the film usually chosen. This is done by exposing a bracket of flash exposures over a measured distance, selecting the best photographic result and then multiplying the selected 'f' stop by the measured distance. For example: measure 4m (13.3ft), place the camera at one end so that the flash head co-

incides accurately with the beginning of the measured distance. Place a test card and, if possible, a human subject as well, at the other end of the distance measured, and make a 'bracket' of exposures, using the X flash setting on the camera and successive 'f' stops of 5.6, 8, 11, 16, and 22. Keep a precise note of the 'f' stop by writing each clearly on white card and placing them within the picture before each change of lens setting. Process the results and choose the most pleasing in terms of colour, highlight detail, shadow detail and tonal range. Now multiply

the chosen 'f' stop by the measured distance; for example, if f11 is chosen, $4 \times 11 = 44$, and this is the GN where metres are the unit of measurement. If working in feet, $13.3 \times 11 = 146.3$ and 146 is the GN where feet are the unit of measurement.

To work with multiple flash, place the flash where it is estimated that the spread of light and the angle of light in relation to the lens axis will solve the lighting problem, measure (with a tape-measure) the distance of the lamp from the selected focus point on the subject, and divide this measurement into the GN. The answer obtained is the 'f' stop required under the new conditions.

Where flash heads of the same power are put together to form a key light and their light is overlapping, reduce the lens aperture by one full stop. If the light does not overlap, the GN from one unit is used to calculate the 'f' stop. Fill lights, to open up the shadows, are added, as in figure 5, and if these are kept the same distance from the subject as the key light and diffused by a frosted paper screen, the total exposure, as calculated from the main key light, should be reduced by half a stop.

Connecting several flash units can be easily accomplished by using a multi-connector (figure 6) and long cables, or by the use of a radio or infra-red pulse. When working indoors in low light levels, the most useful technique of multi-synchronization is by the use of 'slave' cells. These small, light-sensitive accessories (figure 15) are attached to a short synchronizing cable and aimed toward the main key flash unit, which is the only one that should be connected to the camera. When this key light is fired by the shutter, all other flash units which have 'slave' cells will automatically fire in correct synchronization. Obviously, if working where other photographers are also using flash, this is not a viable solution. Many professional flash units have 'slave' cells built into the flash head or the flash generator.

One of the most useful of internationally available multiple flash units, very suited to the serious amateur's needs or even those of the young professional, is the Profilite system devised by Multiblitz of Germany or, alternatively, their Vario light. Both of these combine a powerful tungsten halogen lamp of 3200K and a flash tube linked to a variable switch, which, as it changes the strength of

5 *Obtaining a flash guide number: A is main key light, B is fill light, C is accent light.* Method: *take five exposures at f5.6, f8, f11, f16 and f22 with key light (A) only. Process and assess result; disregard light in C and B for calculation. Choose the negative which shows the best printing density in highlight and shadow.*

Measure the distance from key light (A) to subject and multiply the chosen aperture by this number: e.g. if flash-to-subject distance measures 2m and the best exposure on the test is found to be f22, the GN is therefore 44.

Whenever this flash unit is used with the same film speed, correct exposure may be calculated by dividing the GN by the desired aperture and the key light is then placed that distance from the subject; e.g., if an 'f' stop of 11 is required, divide this into the GN of 44 and the key light must be placed 4m from the subject for correct exposure. Alternatively, if the key light must be placed at 6m from the subject, the GN of 44 is divided by giving an answer of 7.33 – f8 would be the 'f' stop needed to produce good negatives.

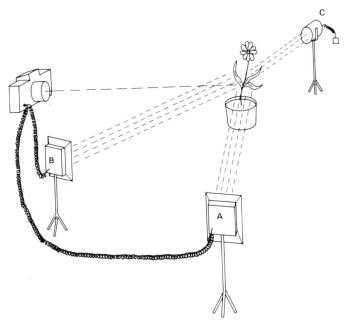

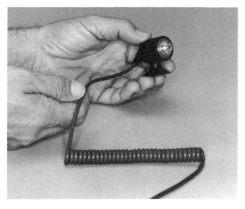

6 *To trigger multiple flash units by firing the flash on camera and without using complex wiring, a photocell slave unit may be attached to a flash cord.*

the tungsten light, also alters the power output of the flash in a precisely proportional relationship. This kind of lamp will be suitable for use with tungsten or daylight colour film and a preview of the exact pattern of flashlight and strength may be seen.

EXPENDABLE FLASHLAMPS

The limited amount of light from electronic flash systems, unless produced by the large and expensive studio units of professionals, often will not give enough light to penetrate the depths of large interiors. Bowens Limited of London still make single and multiple reflectors to contain expendable flashlamps and their 'Blaster' (figure 7) is particularly useful in dealing with large areas indoors. Whenever power/weight factors are to be considered, or a powerful flash is needed from a hidden position within the camera range, this equipment is invaluable, despite the fact that every time the flash fires, new lamps must be fitted.

TUNGSTEN HALOGEN LAMPS

Where slow exposures are possible or wherever particular finesse in lighting or great depth of field is required, the photographer should resort to tungsten halogen lamps in suitable reflectors and on high-rise stands. Berkey Colortran is a very suitable supplier of small, portable, professional tungsten lighting kits, with excellent lightweight stands and good lighting control accessories, such as barn doors, scrims, and so on. For extreme portability and power, Low-

7 *For very large, open interiors considerable flash power must be used. This is a Bowens 'Blaster' unit which uses four large flashbulbs synchronized to the camera.*

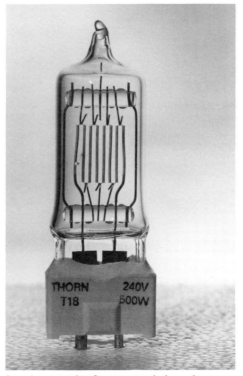

8 *An example of a tungsten halogen lamp, as used in most photographic floodlights. It is essential that the lamp does not come into direct contact with the fingers as this considerably shortens the lamp life.*

15

ell Inc. make a speciality of location fixtures, some of which may be simply taped to a wall or a door. Lowell's large 1600-watt soft light is extremely compact and lightweight, needing only a lightweight stand or clamp, yet it delivers a very strong and controllable source of light. Some battery-powered floodlamps, such as those used for video and film cameras, may be of use, but their application to most indoor lighting problems is rather limited.

Where it becomes standard technique for the photographer to use tungsten lights for indoor work, a dimming system on each lamp (if it is not already built in by the maker) is most useful. This allows all setting-up to be done with dimmed lights and only during exposures must full power be used. By the use of dimmers it is also possible to reduce or increase light on the

subject in a very precise way without actually moving the lamp-head.

Tungsten halogen lamps, throughout their life, burn at a consistent 3200K, the required colour temperature for exposing Type B colour film for perfect balance, and it is always desirable to use these for indoor colour photography. For black and white processes, colour temperature is not so critical and ordinary screw-based display lamps may be used. One of the most useful is the 150-watt clear garden spotlight, having its own built-in reflector and with the distinct advantage of being weatherproof. Several of these, fitted into simple, clip on lamp-holders provide an inexpensive but effective means for many special areas of photography, and in the hands of any photographer who has seriously studied lighting techniques such as those discussed in Chapter 2, this type of equipment may solve almost all indoor needs for a very long time.

One disadvantage of working with tungsten lights is that all lamps generate excessive heat, particularly photo-floods or tungsten halogen lamps. This means that special care must be taken in placing the lamps so that no surroundings are damaged or fire risks caused, and that the lamp-house or reflector is suitably constructed and vented to aid cooling. All lamps, as far as possible, should be fitted in porcelain lamp-holders. Where any hot lamp is placed near cold draughts of air, there is a potential danger that the glass envelope of the lamp could crack or explode. Whenever working close to people in these circumstances, a wire safety grid must be fitted to the reflector. If this is a fairly open mesh it will also soften the specular nature of the open flood and produce a rounder, more tactile feeling in the light. It should also be noted that whenever handling hot lamps the lighted filament is particularly sensitive to damage. Sudden bumps or vibrations could fracture the filament. Whenever handling any lamp-house with hot lamps, use oven gloves to avoid burns and make any movements gently. All tungsten halogen lamps must be handled without the fingers contacting the glass outer envelope. Oil from the skin on these lamps greatly shortens their life expectancy. Repeatedly switching such lamps on and off has the same effect, so it is better to keep them burning when setting up a shot.

9 *Metal barn doors, used on tungsten lights to control the spill of light from the centre beam of the lamp. They are usually intensely hot when the lamp is on and oven gloves should be worn to protect the hands.*

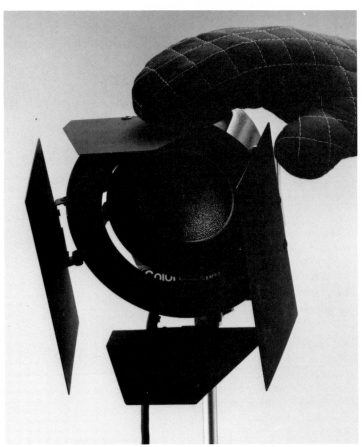

THE USE OF TRIPODS

Photographers working indoors, particularly where any tonal value from the total environment near the subject is required, will almost certainly need at least one tripod, possibly two. Tripods should be bought to suit the needs of the camera and there is little point in using highly portable, lightweight tripods to support medium or large format cameras. Any vibration will be transmitted to the camera and cause unsharp images on long exposures. Generally, a desirable tripod will allow low-level work at least 30cm (12in.) or less from the floor and have a rise to at least 180cm (72in.). It will have an adjustable centre post, preferably geared for easy final adjustment of camera height. For photography of architectural interiors, large groups indoors, or industrial work, a very high-rise tripod is invaluable, having a low-level facility of about 100cm (40in.) and an upper limit of at least 270cm (108in.), again with a movable centre post. All tripods must be equipped with a tilting mechanism such as a ball joint or pan and tilt head and this should, when locked, carry the heaviest camera in a vertical (look down) position without creeping. Tripods made by Leitz, Linhof, Gitzo, Quickset, Manfrotto or Multiblitz all perform well. Where universal heads are not provided by the maker, separate units must be obtained, often costing almost as much as the tripod itself. A photographer who seriously contemplates much indoor photography must anticipate that a good tripod is an essential but costly item of equipment. Always buy the best affordable and do not be surprised if the cost is almost as much as an average 35mm SLR camera.

CAMERAS AND LENSES

Photography indoors could naturally require the use of every type of camera but the most useful for almost all subjects except architecture, would be a single lens reflex (SLR), either in 35 or 120mm formats. Automated

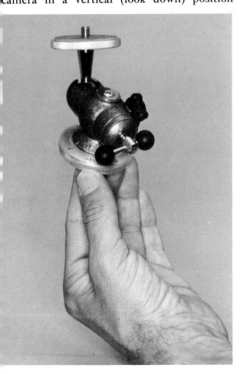

10 *All tripods require a tilt head which is a multi-directional joint to which the camera is attached.*

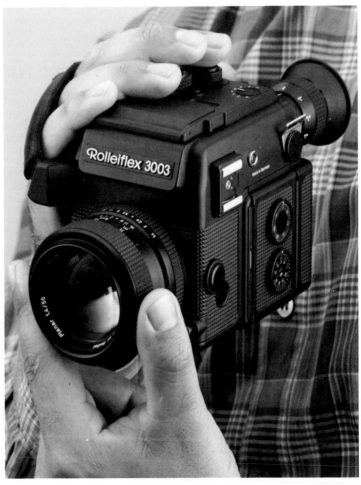

11 *A modern, automatic SLR camera, accepting 35mm film and with mid-roll change facilities by the use of a detachable film magazine. (Photo by Rollei Fototechnic)*

cameras are not generally a benefit, through-the-lens (TTL) metering being much less useful in interior work, and probably the only essential requirement is the facility which allows interchangeable lenses. The larger format cameras, such as Rolleiflex SLX, Hasselblad, Pentax 6 × 7 or Bronica should perhaps have a pentaprism fitted to reverse the viewfinder image for normal viewing, but even this is not really essential in the beginning.

Lenses need not necessarily be ultra-fast, particularly since the advent of 1000ASA colour film and the ease with which 400ASA film may be pushed to give a 1200ASA speed or more. If most work is to be done on a tripod then it will be found that inexpensive lenses may be used even though the widest aperture is sometimes not more than f2.8 or 3.5. Focal lengths for 35mm SLR cameras will tend to be in the wider angles and the 35mm, 50-60mm, 85mm and 135mm lenses would cover most situations to be found in indoor photography. In the 6 × 6cm ($2\frac{1}{4}$in.) format, lenses of 55mm, 80mm and 150mm would serve most needs, while 6 × 7cm ($2\frac{1}{4}$ × $2\frac{3}{4}$in.) would need 75mm, 90mm and 180mm lenses.

Photography of indoor subjects is often about detail and textures and the best camera type for this kind of subject is undoubtedly the view camera (figure 12), which is little changed from those first designed for the Victorian photographers. Modern view cameras are usually built on the monorail system with almost all items of specification interchangeable with a wide range of acces-

sories which extends the function of the camera to an almost unlimited degree. The basic advantage of view cameras for indoor photography is the degree of control possible in increasing or decreasing the zone of sharp focus (depth of field) and in correcting the perspective geometry of architectural subjects, whatever the camera attitude may be. Such cameras are available in 120, 9 × 12cm (4 × 5in.), 13 × 18cm (5 × 7in.), 18 × 24cm (8 × 10in.) formats, and manufacturers such as Arca Swiss, Calumet, Linhof, Plaubel, Sinar and Toyo, make reliable equipment.

Lens-makers for SLR cameras have addressed themselves to these problems of control also, in an attempt to bring the same advantage to fixed-body cameras as are obtained from highly flexible view cameras. The result is the perspective control lens, or PC lens, which has movable lens elements which shift according to the photographer's needs during the alignment of the camera, so that angling or tilting which produces perspective distortion may be minimized or avoided.

Currently the finest example of PC lenses is undoubtedly that made by Schneider of Germany. This is of 55mm focal length with lateral and vertical shift modes but, as well,

12 *A typical large-format view camera.*

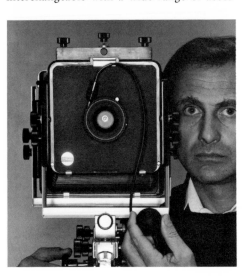

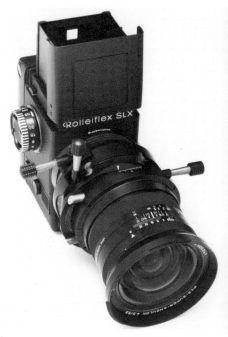

13 *A medium-format, fixed-body camera with a special perspective control lens.*

his lens has a tilting function within the lens to take advantage of the Scheimpflug effect (figure 72, p. 74) in order greatly to increase the zone of sharp focus. When fitted to a 6 × cm (2¼ in. sq.) camera such as the Rollei SLX (figure 13), it makes a formidable but expensive addition to the photographer's equipment. Professionals engaged on architectural work, particularly if it includes active situations for live models will find this combination of electronic camera and flexible lens, most useful indeed.

THE EXPOSURE METER

One other extremely important item of equipment that will be needed to produce high-quality results from indoor situations is an exposure meter. My personal preference is for a 1° spot meter, such as made by Minolta, Soligor or Pentax, but the Minolta Autoflash meter is effective also. This provides multiple functions, such as an incident flash or a tungsten meter, can be used with an attachment which gives a fairly wide angle spot meter or can even be used on film, plane or ground glass, to detect very small differences in lighting values.

Although most modern fixed-body cameras have auto-exposure specifications these are usually based on average outdoor situations and do not perform with accuracy in the far more difficult lighting conditions to be found indoors. A separate hand-held meter is certainly an essential to serious photographers in interior environments. The metering refinements being incorporated in new models of such cameras as the Rollei SLX and 66, both high-performance 6 × 6cm (2¼ in. sq.) cameras, do begin to take care of most of the problems of assessing indoor exposure, but those who wish to specialize in the subject probably will still need a hand-held 1° spot meter to assist them.

CHOOSING FILMS

In making decisions about film emulsions for this kind of work, it is as well to remember that high-speed film in either black and white or colour emulsions will bring two immediate benefits to the indoor photographer: shorter exposures and lower contrast. It also brings a distinct increase in visible grain but, in many situations, this may be considered an attractive part of the whole design, as it adds a lively feeling of *vérité* to the picture. For those who want high-speed benefits in black and white without grain becoming too noticeable, it would be as well to experiment with the new generation of Agfa and Ilford chromagenic films which may either be processed in standard negative colour chemistry or in their own special formulas. If these films, for example, are rated at a speed of 400ASA it is doubtful if this can effectively be much increased whereas conventional black and white 400ASA film – such as Agfa 400, Ilford HP5 and Kodak Tri-X – can, by the use of highly active developers, have their speed doubled or tripled. The chromagenic films, however, do produce superb quality with very low grain factors and a very long scale.

Colour emulsions

High speed in colour emulsions is reaching new sophistication with Kodak and 3M perhaps leading the field, with emulsions of rated speeds of as much as 1000ASA. Used at these speeds such emulsions do have lower contrasts and, if grain is noticeably more pronounced, it is usually quite acceptable for small enlargements. The 3M emulsion seems to offer acceptable grain characteristics and faithful colour even when greatly enlarged. If lighting within the picture area includes many types of light source, such as daylight, fluorescents, electronic flash and normal household room light, it is best to use daylight negative colour film, particularly the

4 *The 1° spot meter gives extreme precision in measuring light, and is particularly useful when exterior scenes are to be phased in with interior exposures.*

Agfa and Kodak 400ASA emulsions, as these cope quite effectively with the problem of varying colour temperatures and have great latitude in terms of contrast and exposure.

If truly high speed is called for in colour, then transparency (reversal) material is needed. Starting with a basic speed of 400ASA, 640ASA or 1000ASA in films made by Agfa, Fuji, Kodak or 3M, and using the E6 processing chemistry, these speeds may be increased by one, two or perhaps three 'f' stops by lengthening the time the film remains in the first developer. One-stop increases are commonplace and do not vary the grain colour balance or contrast to any great degree but do greatly improve shadow detail. Two-stop increases are more hazardous and tend to increase grain and produce desaturation of colours, particularly darker colours and blacks; three-stop increases are usually not recommended as they often produce smoky, desaturated images, poor blacks and degraded shadows with very obvious grain, but such three-stop increases are used sometimes by photographers seeking as special effects, the faults which this treatment embodies. Each film type and brand name reacts differently to speed increases (push-processing) and tests should be made. Negative colour emulsions do not generally respond at all to push-processing and the only certain way to improve results in low light conditions is to augment the light artificially with flash or floodlight.

When it comes to photography that re-

quires the greatest fidelity in terms of colour saturation, colour balance, sharpness or, in the case of black and white photography, absence of grain and the maximizing of tone and texture, then it is better to choose much slower emulsions.

Slow emulsions are rated at 100ASA and less and if push-processed will show immediately an increased contrast and some colour shift. The slowest of the reversal (transparency) colour films, Kodachrome from Kodak Ltd., is one of the finest for indoor work when it includes a lot of daylight in the image, but it will often need augmentation from blue floods or electronic flash. It is only available in 35mm and cannot be push-processed.

Other colour emulsions in either negative or positive (reversal) will generally have speeds in the vicinity of 100ASA and it is as well to consider this as their real speed without resorting to any method of speed increase; contrast will be controllable, colour better balanced and grain minimized. Manufacturers who produce excellent films of this type include Agfa, Fuji, Ilford, Kodak or 3M and, as each has its own special value, it is as well to test different types before finally choosing one major brand. It will be found that some appear colder, others warmer, others have better whites and greys in under-exposed areas, and all may have different characteristics in flesh tones.

To judge such films, pose a suitable model in a normal indoor situation, using daylight or artificial light, whichever the manufacturers have recommended for the film; have the model hold a colour target close to the face and then expose three frames of film – one at normal exposure, one at a full stop under-exposed and one a full stop over-exposed. The subject photographed should be evenly lit and, as well as the colours in the target, black, white and grey should be present. When this test has been made under similar conditions for all the chosen film types, process and assess the results in a light of the quality of sunlight or on a standard transparency viewing box with a colour temperature of between 5000 and 5500K. Particularly, study the under-exposed images and watch for colour shifts into green or blue in areas where white is in shadow, as this is the least desirable attribute for colour emulsions being used for indoor subjects. Also closely

15

FILM SPEED EQUIVALENTS

ASA	DIN	ASA	DIN
1	1/10	40	17/10
1.2	2/10	50	18/10
1.5	3/10	64	19/10
2	4/10	80	20/10
2.5	5/10	100	21/10
3	6/10	125	22/10
4	7/10	160	23/10
5	8/10	200	24/10
6	9/10	250	25/10
8	10/10	320	26/10
10	11/10	400	27/10
12	12/10	500	28/10
16	13/10	640	29/10
20	14/10	800	30/10
24	15/10	1000	31/10
32	16/10		

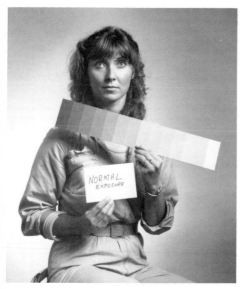

16 *When checking film and developer performance or colour testing of new colour emulsions, include a colour and black and white target next to the skin of an average subject.*

consider the skin tones of the model as these are the most difficult for emulsion-makers to achieve. Choose the skin tone which is the most pleasing, subjectively, to you as the photographer. Although those testing on 35mm will need perhaps to waste a whole roll, these test exercises must be undertaken in the beginning if serious and high-quality work is contemplated.

Black and white emulsions
For black and white photography, the same test procedure is advisable for each emulsion speed and each brand of film but within the same speed category various brand names do not show dramatic differences if processed in those developers recommended by the film manufacturer's data sheets. When, however, a chosen film brand of a certain speed is processed in different developers, considerable changes take place in the areas of sharpness, acutance, granularity, shadow detail, highlight values, contrast and tonal gradation. So the photographer should choose a 100–125ASA film and a 400–1000ASA film from the preferred manufacturer and, using the same test subject of model, target, normal lighting and bracketed exposures, the photographer should test developers rather than film types.

The greatest concern of indoor photo-

graphers will be to overcome the inherent contrast to be found in most interior lighting situations, although, as will be learnt from Chapter 2, this can be achieved in some degree by lighting. When working with black and white, much can be achieved by proper exposure and processing combinations using different developers.

The standard developer by which most others are judged is D76 from Kodak or ID11 from Ilford. Such developers provide excellent tonal qualities, normal grain that is rarely obtrusive and clear, sharp definition. They work best on slower emulsions but should be tested on the fast and hyper-fast emulsions as well. Once the model and target are in place before the camera, shoot the sequence of different exposure brackets but, instead of confining the test to a bracket of three exposures, make one a normal, one at one stop under, then one at two stops under, then the same for over-exposure, making a total bracket of five frames. Develop these as recommended by the developer manufacturer at 20°C (68°F) using a strictly controlled technique of time and temperature. Use great precision in monitoring these two factors. Dry the negatives and print them on normal contrast bromide paper. Then make a further test bracket but this time dilute the developer 1:1 and raise the temperature 1°C (2°F) and increase the time of development by 20 per cent. Process and print the result,

17

TECHNIQUES FOR REDUCING CONTRAST

Colour
*Use high-speed film, process normally
*Use ultra-speed film, push 3–4 stops
*Introduce flare to camera
*Pre-expose film to 18% grey card
*Use diffusing gauzes or desaturating filters
*Use diffusers on light sources
*Keep highlight/shadow ratios close together
*Add extra fill light in shadow area
*Use axis lighting

Black and white
*Over-expose film 30%, under-develop 20%
*Use diffused or reflected light
*Use diffusion on lens
*Use low-contrast developer
*Use compensating developer
*Use axis lighting
*Keep lighting ratios close together
*Use low-contrast print papers

strictly timing the negative and print processing to conform with the first test.

Now make two more five-frame brackets identical with the first and, using the 1:1 dilution and the increased temperature, reduce the developing time by 30 per cent for one bracket but increase the developing time by 50 per cent for the remaining bracket. Strictly control time and temperature and make certain that it is known how each bracket was processed. Note that whenever developers are diluted from the normal working strength, they must be discarded after processing each batch of film. If the above tests are made rapidly, the discard may not be necessary between brackets but, whenever working with film from actual assignments, follow the discard rule absolutely.

Assess carefully both prints and negatives from the above tests, using a magnifier where necessary and it will be seen that considerable differences exist. Contrast and tonal scale will probably be better in the over-exposed section of the 30 per cent under-developed bracket. Highlight separation will perhaps be better in the under-exposed section of the bracket which has had a 50 per cent increase in development but, in this case, shadow detail may be lost. Once a decision is made as to which exposure of which bracket is best for the average indoor subject, check the notes which refer to the chosen bracket and assign a personal exposure index (EI) for that frame.

If it was developed at the manufacturer's designated speed, this becomes the EI – for example, 100ASA. If it is one stop under-exposed, the EI becomes 200ASA; if it is over-exposed (more light was used) the emulsion is considered to be slower than the maker recommends and one stop over-exposure makes the EI 50ASA. Whenever this film brand and type is used, expose it at your personal EI and process it in exactly the same way and in the same developer as used in the test. If film brand or film speed changes are made, or different developers or dilutions are used, new tests are called for. Note that black and white exposed to tungsten light only is less sensitive and needs a lower speed rating, and this is also true of very short exposures from very small electronic flash units.

Once a standard developer is experienced for some time (and D76 diluted 1:1 is one of the finest) the indoor photographer should move on to other developers, particularly the compensating type, and make the same careful series of bracketed tests. These tests may seem tiresome but they need only be done once and they provide the photographer with the precise information needed to acquire an excellent technique in black and white photography.

Compensating developers greatly assist the control of contrast in most indoor situations, especially in existing light, as their formulation tends to activate development in the shadow areas at a faster rate than the heavily exposed highlight areas. This increases considerably the tonal scale in high-contrast conditions and, if used with a re-rated film speed to give a lower EI than the manufacturer's rated speed and with 30 per cent under-development to compensate for this over-exposure, amazing control may be exercised over contrast.

Such developers also tend automatically to increase film speed and those which do this include May and Baker Promicrol, diluted 1:2; Paterson Acuspecial for 5–200ASA film; Paterson Acuspeed for ASA400 and over; Edwal Super 12; Ethol U.F.G. (this developer gives phenomenal speed increase with Kodak Tri-X 400ASA film), or Ethol Blue. It is as well to choose one developer type as a standard means of working, but precise knowledge of the behaviour of other formulas may be useful if the photographer is confronted with very difficult or unusual lighting problems.

Those wishing to have more detailed information about both colour and black and white technical matters can find this in *The Photographer's Dictionary* (B.T. Batsford Ltd, 1982) by the same author. References of value in the order in which they should be read are:

For colour information
Vision, light, basic photography, colour photography, colour film storage, colour temperature, filters, fluorescent lights.

For black and white information
Vision, light, basic photography, camera types, darkroom, mixing solutions, black and white photography, negative test, push-processing, exposure, enlarging, filters, multigrade paper, reciprocity, Scheimpflug principle.

2 The Management of Light

The foregoing chapter briefly mentions one of the overriding problems frequently encountered in indoor photography: contrast. Contrast is inherent in almost all 'existing' or ambient light conditions, whether the light is daylight which enters a room in considerable strength but highlights only specific areas and leaves the rest in comparatively deep shadow, or whether the light is artificial, reaching the subject from above and arising from fixtures on the ceiling, or whether the lighting is in patches near the subject, emanating from lower level room fixtures and shades. All such existing, or available, light leaves large areas underlit and, although the wonderful mechanism of the eye easily compensates for the high-contrast conditions, and the complexity of the brain identifies, subjectively but accurately, objects in mere thresholds of light and darkness, the camera and its chemistry cannot cope with these problems.

By the choice of film type, film speed, exposure and processing, much can be done to lessen contrast in available lighting situations (and this method tends to support the mood of the subject), but in many assignments it will be found necessary to augment the light in some way. For photographing individuals within a room, a large 100 cm sq. (40 in. sq.) of white or silver cardboard used as a reflector to bounce the key light back into the shadows may be all that is needed. Larger subjects, such as a group of people, may require a softly diffused floodlight or flash to light the shadows. Full interiors and many other subjects, particularly in professional photography, will require a complete lighting plan, knowledgeably and sensitively conceived, which shows the subject at its best and its most natural.

Rudolf Arnheim, the famous physicist, says in his book *Art and Visual Conception* (Faber and Faber Limited) that 'the contemplation of light is perhaps the most spectacular experience of the senses and it remains an important prerogative of all artists to preserve the access to wisdom which may be gained from this activity.'

THE LAWS OF LIGHT

However richly subjective this concern for and appreciation of light may be, light is a law - possibly the most absolute. Light travels in straight lines at a constant speed of 299,783 kilometres (186,282 miles) per second in the vacuum of space and a little

18 *Average interiors will have mixed sources of light and these will vary in strength. They must be evaluated and, where needed, as in this example, general light from photographic floods may be added.*

slower in air; even slower as it passes through glass or water. When its passage is unobstructed or the influencing impediment is removed, it flows on returning to its original speed and its original nature.

Visible light is radiant energy which is part of the electromagnetic spectrum. This spectrum also contains the non-visible but photographically important radiation of infra-red, ultra-violet and X-ray. The visible spectrum radiates both in particle and wave form and is measured in thousandths of a millionth of a metre called nanometres (NM). In the reddish-orange colours, the wavelength is in the 600–700NM band; in the yellowish-green it is in the 500–600 band; in the blues and purples, in the longer wavelengths of 400–500NM.

Light may be reflected, absorbed or transmitted or a combination of these activities. It behaves precisely and measurably, being reflected at the same angle as the angle at which it strikes the reflector. The sum of the reflected, absorbed or transmitted light always equals the total energy of the light which strikes the object.

If the light is reflected in equal amounts and none is absorbed or transmitted, we see a white object. If the light is totally absorbed and not in any way reflected or transmitted, the object is seen as black; the light disappears within the object and generates a lower form of radiant energy which we call heat. If most of the light is transmitted, none absorbed and very little reflected the object appears transparent and clear. When only

19 *The visible spectrum. Visible white light is a small part of the spectrum of radiant energy and is composed of separate wavebands of colour from cool to warm.*

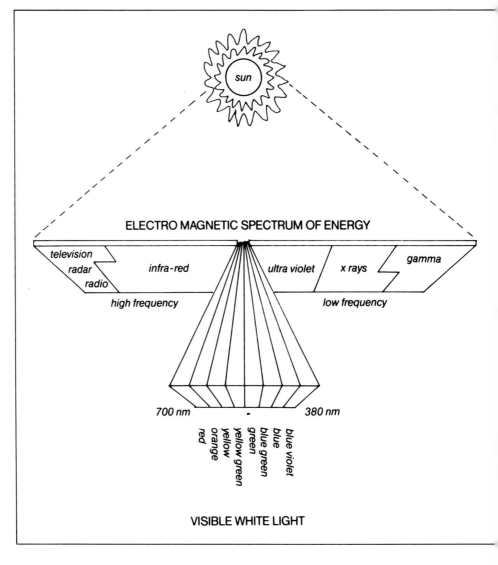

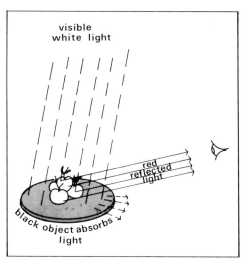

20 *Red apples on a black dish are seen as red when only the red end of the visible spectrum is reflected. The black dish absorbs almost all light and reflects none. Every object has its own colour character based on the colours and quantities of light which are absorbed or reflected.*

red light is reflected and the other wavelengths of orange, yellow, green, blue and purple are absorbed, we see the object as red. If only blue is reflected, we see the object as blue, and so on. The mixtures of reflection, absorption and transparency provide our eyes with the sensation of colour.

The sun gives light and energy to this earth and from this infinite source of radiant power, light reaches us in a dominant single direction. It travels to us in a straight line and is called 'specular' light (see also p. 27). Where the progress of specular light is interrupted by semi-transparent objects, such as clouds, rain, fog, tissue paper, opal glass, wire screens, and so on, the straight lines are broken up, turned in multiple directions or 'diffused' (see also p. 28).

When light of any kind falls on an object from a measured distance and then that distance is doubled, the quantity of light is not halved but quartered. This is known as the Inverse Square Law, applying in theory only to a point source of illumination but in effect, small electronic flash units fulfil the needs of the theory and this accounts for the very rapid fall off of usable light as the photographer retreats from the subject when using a camera-mounted flashgun.

Once such laws of light as are imposed on

the photographer are understood, they may be exploited to good effect. Lighting indoors is a matter of observing existing light, augmenting it where possible or replacing it with artificial light and so controlling it that a natural effect is obtained.

21 *Placing of accent highlights. Note the difference created by a very slight change in position of an accent light in the background.*

THE QUALITY OF LIGHT

Considering the measurable and precise behaviour of light, it is amazing that light and the effect of light is primarily subjective when it is beheld by man. Since the eleventh century it has been recognized that seeing is not an easily described scientific activity, but

25

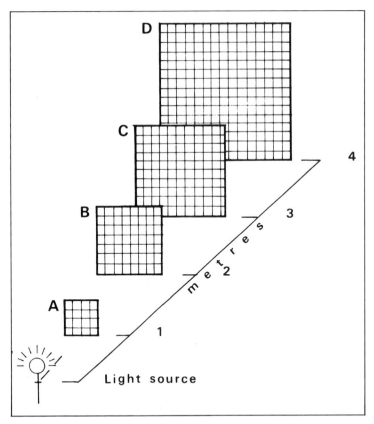

22 *Inverse square law. Light reaching the subject varies inversely to the square of the lamp-to-subject distance. Object at A is lit by a concentration of light over a small area and receives all the light from the light source. Objects at B, where lamp-to-subject distance is doubled, receive only one-quarter of the amount of light because it is spread over a wider area. Objects at C receive one-eighth of the available light while objects at D, four metres from the light source, receive only one-sixteenth of the light falling on A.*

By controlling the fall of light, the force of light, its direction, size, shape and general character and colour, the photographer can most effectively transmute the cold stare of the camera machine into something richly different for the beholder: an image which excites, dramatizes, diminishes, tranquillizes or mesmerizes according to the wishes of the creator and the subconscious involvement of the spectator.

The light by which indoor photographers work will include daylight, fluorescent, tungsten light from household fittings, tungsten or tungsten halogen light from photographic fittings, electronic flashlight, expendable flashlight and other sources such as candlelight and firelight. Each of these types of light has its own special character and its own 'colour temperature' measured in degrees Kelvin. All of these light sources may be further categorized into light which exists already – available light – and that which is placed there by the photographer – artificial light.

Available light

All available light will have a noticeable, dominant direction and within an interior lit by existing light it will be noticed that a hierarchy of light establishes itself. The strongest source, dominating the subject and setting the mood, is given the role of lighting the main elements and is called 'key' light. The second most important and the next in strength allows details to be seen in the darker areas which are not touched directly by the key light. This secondary light, which may be reflected light from walls, floor, furniture or other lighting fixtures, is given the name of 'fill' light, filling in the dark areas with light but never competing in strength with the key light. Other lights present in the hierarchy are called 'accent' lights and these are always smaller and less significant, but can be as strong as the key light.

Such accent lights may be highlights in shiny surfaces, reflections of small lighting fixtures in elements of the subject, candlelight, firelight, and so on. They generally reveal only a tiny area of the subject but disclose that area's nature, surface and texture. They tend to assist the eye in separating one form from the other, particularly in darker areas.

an essentially subjective one. Light, therefore, will not only have a measurable quantity and direction, it will also have a desirable quality. The photographer can learn to control light to such an extent that those who behold the result identify not only the tactile values of the subject photographed, but also the mood, ambience and atmosphere which the photographer wishes to convey. Lighting control is not solely a documentation of the subject achieved by providing enough light to activate a specific amount of photo-chemistry; it is a revelation of the essence of the subject: a means by which the photographer can bestow on the subject all the hidden and abstract properties that he has taken the trouble to identify and understand.

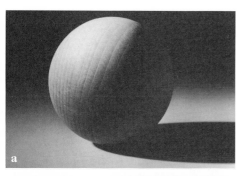

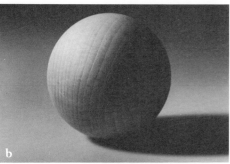

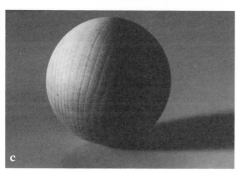

23 *Lighting qualities from different sources: (a) specular light throws sharp, strong light and creates dense hard-edged shadows; (b) directly diffused light creates an open light with soft-edged shadows; (c) reflected light is also diffused but is even softer and shadows are almost imperceptible.*

Artificial light

Artificial light, deliberately placed and controlled by the photographer, must conform to the same hierarchy: key light (which dominates), fill light (which supports), accent light (which emphasizes); and the skill with which this is done is critical to the communication between the creator of the picture and those who behold it. All perception depends on the separation of the form (object) from the ground (environment), and all lighting skills are directed towards creating this se-

paration wherever the photographer and the viewer need to complete the communication. There can be no perception without separation.

Light, both available and artificial, may be further sub-divided into two main qualitative categories: 'specular' and 'diffused' light.

Specular light

Specular light is radiated by the sun and travels in straight lines. Objects struck by this light will have a compact highlight area, within which may be seen an incident highlight. Where the fall-off of bright light begins to meet the unlit contours of the object, a lighting core is seen, a dark but transitional area where much detail is seen. Where this core loses detail in growing darkness, the object develops a distinct shaded area, in which little detail, texture or contour may be seen. This is the shadow side of the object. Specular light also creates a sharp edged, dense black shadow of the outline of the object, and this is called the cast shadow. Specular light richly reveals texture and form and gives objects a distinctly heroic and yet introspective character and separates individual contours from those nearby and other objects and backgrounds.

Available specular light within an interior can come from sunlight entering uncurtained windows or open doors, from unshielded

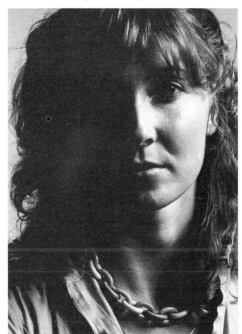

24 *The lighting core, where the light falls sharply into shadow, is clearly demonstrated here. By watching the placement of the core, form may more clearly be drawn with the key light and unpleasant shadows may be avoided, particularly with regard to portraits.*

bare lamps or spotlights and from sunlight reflected from mirror surfaces. The photographer can create artificial specular light with floodlamps in shiny reflectors, spotlights, bare lamps and household fittings, or with mirrors or mirror foil reflectors.

Diffused light

When the specular light of the sun is interrupted by clouds or water vapour, the straight line path of light is broken up into multi-directional waves; the greater the density of the translucent barrier, the more the straight lines are deflected and dissipated. This is diffusion of light and objects lit by this type of light will disclose a much larger but softer highlight area with poorly defined incident highlight, very little lighting core, more open shadow side and very little, if any, cast shadow. Diffused light reveals glossy surfaces very well, creates an objective but open character in the subject and tends to suppress texture without destroying larger contours.

Available indoor light which is diffused will come from daylight entering through net curtains or partially opaque blinds, daylight from overcast weather, or reflected or 'bounced' from outside walls into the room. Diffused existing light also arises from light reflected from walls and objects within the room itself, from planes within the subject or from shaded lamp fittings and fluorescent light fittings. Diffused light also has varying colour temperatures according not only to the colour of the light source itself but also to the colour of the diffusing medium.

The photographer's artificial light is often diffused deliberately. This can be done by the use of large white reflectors, by acrylic diffusers on flashlight, by white polyester or plastic screens over large light sources or windows, or by bouncing light on to fixed surfaces within the interior. Such light will take on a colour which is related to the colour of the diffusing medium and to the colour of the light source. Diffusing specular light, although it creates a different character in the light also creates a loss of light, weakening the light which reaches the subject in direct proportion to the opacity of the diffuser. This loss of strength in diffused light often means that the photographer must use faster film, more vigorous developers, slower

25 *Qualities of light: (a) direct light travels in straight lines, creating sharp shadows; (b) diffused light is scattered by the translucent diffuser, giving soft shadows; (c) reflected light gives almost no shadows, being even more scattered. Note that the colour and character of a reflector will alter the nature of the light reaching the subject.*

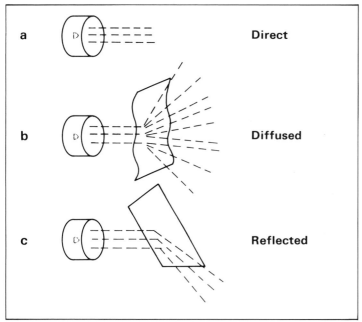

26 *A single-source flash aimed at right angles to the subject produces very strong contours and 'low-key' pictures, very suited to masculine subjects.*

exposures, or increase the strength of the original specular light if that is possible.

Light can also be high key or low key. High-key light is pale, airy, fresh and introverted, and is without texture or pronounced contour; a feminine and delicate mixture of creamy whites, very pale grey shadows and no cast shadows. Diffused light is most frequently used to create the effect. Low-key light is heavy, symphonic, dramatic and dark with few highlights but those there are, are brilliant and decisive. Deep, concealing shadows, few whites or greys and strong textures and contours are typical of such a light.

KEY LIGHTING POSITION

Photographers who have come to terms with the light of the natural world and have enjoyed any serious contemplation of that light, will be aware that the character and performance of light varies greatly during the day and according to the position of the sun in relationship to both the subject and the camera. Although the permutations are infinite, and in the skilled photographer's repertoire will remain so, for the purposes of creating artificial light and building a hierarchical system within a structured lighting plan, certain 'key light' positions of the sun can be categorized and named. This allows the photographer to recreate lighting plans which have been found suitable for certain subjects, whenever similar occasions arise.

As the sun progresses in an arc and as the position of the camera is changed in relation to the sun, so, theoretically, meridians may be drawn to define a hemisphere consisting of arcs along which the sun moves. This theory helps us to identify positions for the photographer's own artificial light sources within a hemisphere and to name them in relationship to the camera position. Note that if this theory is to be followed, no lighting position is found below the horizon and, with the exception of copy lighting, one named key light provides the predominant force of lighting in the plan.

Key lights

1 and 2 Side left or side right (sunrise to early morning, late afternoon to sunset)

3 and 4 Top left or top right (mid-morning to lunchtime)

5 Top (noon)

6 Top back (mid-afternoon)

7 Top front (mid-morning)

8 Axis (sunrise or sunset)

9 Off-axis back light (late afternoon to sunset)

10 Off-axis front light (sunrise to mid-morning)

Two other lighting positions not found in nature are those from below the horizon level (grotesque)-11 and from two sources of equal strength either side of the lens axis (copy light)-12. So there are 12 key light positions to remember, plus the fact that each will not only reveal the subject in a particular way but disclose many of its hidden characteristics, how it relates to its environment and both subject mood and environmental mood.

cupy the stated lighting positions and a total plan built up of dominant key lights, supportive fill lights and emphasizing accent lights. Manipulation of artificial light in this deliberate way may eventually be carried out with almost all the finesse to be found in nature, and nature should always be the photographer's mentor when considering lighting. Artificial light has no need to appear synthetic.

Once the key light positions are known and observed it is useful to understand some of their more abstract attributes.

Side lights

The side lights, both left and right, encourage a frank ambience around the subject and disclose texture and detail with both elegance and strength. A left side light creates a different impression from a right side light, according to the subject and a certain subconscious attitude in the viewer.

Top side lights

The slightly higher position of the top side light (both left and right) reduces detail texture somewhat, loudly emphasizes contour, dramatizes the character of the subject to a point of heroism. The top right position, arising out of that part of the format which is optically more attractive to the eye, will tend to be the most dominant light of all. These top side lights tend to be more masculine in character than the others.

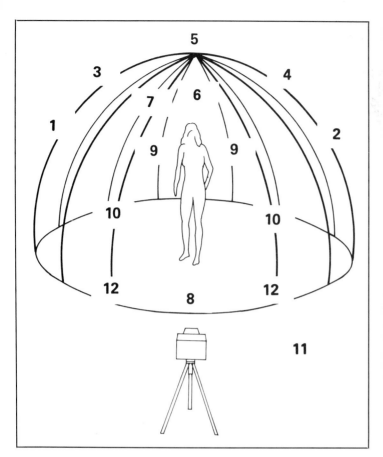

1

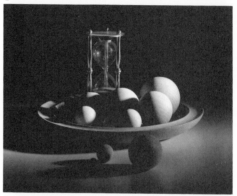

2

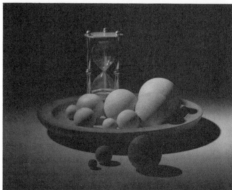

3

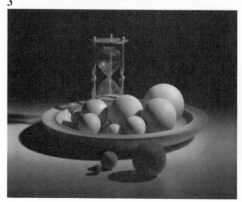

4

27 Above *Placement of lights in key light positions is indicated here and reference to the text and the accompanying photographs will indicate the lighting effects which may be achieved by the use of this system.*

28 Right *These are the primary key light positions and by referring to the meridian diagram above, the position of each light can be visualized.*

Back light

The back light, with the mood of sunset and the approach of evening, is a quiet, romantic light, touching the edges of the subject, concealing forward-facing contours in a shroud of darkness. The light source itself must be hidden behind the subject or flare will affect the result in the photograph.

Top back light

The top back light, however, is much more active than the back light, although still tinged with a certain sense of romanticism. This light strongly separates form as it

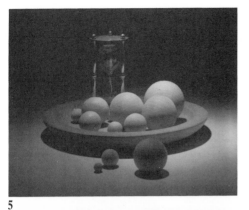

5

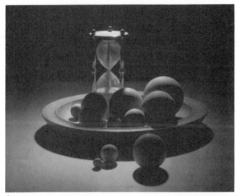

6

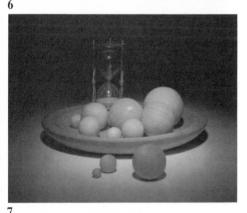

7

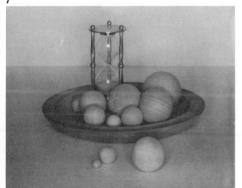

8

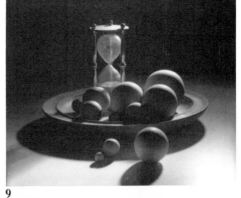

9

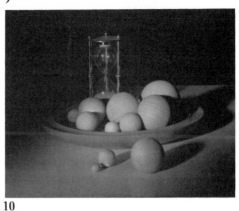

10

recedes from the camera, highlighting the top of contour after contour. As a key light, this is the richest and most revealing of depth and perspective in the subject, and there is an element of wisdom and psychic balance, in the ambience it creates.

Top light
There is little wisdom or romance in the true top light, even when it is diffused. This is the harsh light of noon: brash, full of vigour, revealing strongly all the contours projecting towards camera. This light creates dense shadows within the subject and attaches a strong cast shadow at the base of it. This is a documentary light to indicate action, reality, truth, social injustice or despair.

Top front light
The top front light, moving along the same meridian but forward and over the lens, is totally different. This is the glamour light used by the masters of cosmetic lighting to flatter the female face or glamorize certain products. This light minimizes contour to some degree, reduces texture, eliminates de-

tail; almost a retouching light. It produces a fall-off on the outside planes of the face which can be very interesting and is alive with female characteristics.

Axis light
The axis light is beamed along the lens axis, either by the use of a beam splitter or by a ring light which surrounds the lens with a ring of light. This axis light is a specialist light, to flatten contours which face camera; to light the dark interiors of tubes and cylinders facing camera; to light metal and small objects; for medical photography or simply to fill in shadow areas. Glossy surfaces on right-angled planes in the subject tend to throw back a noticeable ring-shaped reflection which is often undesirable. A deep shadow line generally surrounds the perimeter of a subject when this light is used and this has been used frequently for creative effect in fashion photography and graphics.

Off-axis light
The off-axis light used as a back light, facing into the lens, eliminates some of the problems of flare to be found when using a true back light; it often is used as an accent light to emphasize the hair or profile, or to separate a dark form from a dark background. When the off-axis light is used as a front light, it operates quite close to the camera and, as a key light, throws shallow shadows on to the subject, gently and discreetly disclosing form. A fill light is very frequently used in this position, generally much diffused.

Grotesque light
The grotesque light is not found in nature but is natural to the theatre where it arises from footlights. Its presence in a lighting plan promotes the feeling of unreality or surreality; it frankly acknowledges an artificial element in the photograph and, because it is unexpected in real life, it acts as an attention-getting device.

Copy light
The copy light is one very often needed by photographers, but should be confined solely to copying flat objects. Two lights of equal strength are placed in the off-axis meridians, level with the camera lens. They must be exactly equidistant from the subject and angled in such a way that the fall of light from each overlaps slightly.

Fill light
Fill light is generally more diffused and of a larger area (and certainly weaker) than the key light. It is at its best when it is applied along the lens axis or very near it, wherever the key light position may be.

Accent light
Accent lights may occupy most positions on the lighting hemisphere but they are usually found in the top or the top back positions. They are never more important than the key light but provided they are very much smaller in area, they could sometimes be equal in strength to the key. The background light is devoted solely to the background in order to increase separation between the main subject and its environment. On plain

29a Left *This is an example of rich textural studio lighting with a carefully balanced fill light from along the lens axis. Technically this is 'broad-lighting', with a main light concentrated on that side of the subject nearest camera.*

29b) Right *Here, the photograph has been taken in subdued natural light and no fill light was used. By over-exposure and under-development, contrast has been controlled successfully. This is an example of 'short' lighting, where the key light is falling only on the side of the face away from camera.*

30 *A wire scrim, used on tungsten spotlights and floodlights to slightly diffuse the beam.*

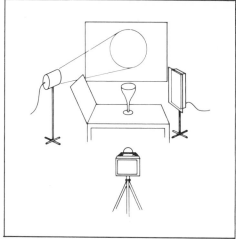

31 *A normal lighting plan for glass.*

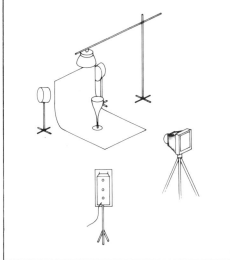

studio paper-falls, a delicate transition of light is ideal, never as bright as the key light or fill and, in fact, barely discernible. On more complex backgrounds such as full interiors, these must be lit to emphasize the necessary detail which relates to the subject. The brightest fall of light from the background light should be seen behind the darkest part of the subject which stands before it and, where the background light falls off, it should do so behind the brightest part of the foreground subject. Only edges of the lightfall from a reflector should be used and these lights are often heavily scrimmed or diffused and should rarely be thrown into tight spot patterns.

SPECIAL LIGHTING SUBJECTS
Although the above lighting code will assist in analysing the existing light, or help to create the photographer's own light, two special subjects need a somewhat modified approach: the lighting for translucent subjects and that for shiny or metallic objects.

32 *By arranging on a dark background a light that does not add any light whatever to the glass object and then by using a very diffused key light only on the subject itself, the glass is shown very brightly against a dark field.*

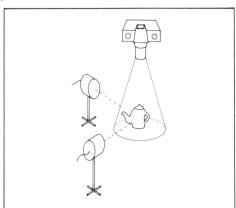

33 *Using a translucent cone to soften all harsh shadows.*

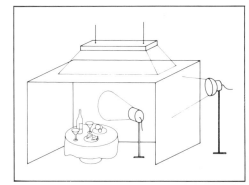

34 *Using a large tent of translucent or opalized material to provide soft, shadow-free lighting for large objects.*

Translucent subjects

Translucent subjects, be they macro (a dragonfly wing), small (a glass of liquid) or large (acrylic furniture), need to appear translucent. This means that some degree of back-lighting is required; some front reflection is also necessary and no small specular highlight hotspots should be found in the subject to suggest other sources of light. Back-lighting may be achieved by the bouncing of light on to a light-coloured background, with lights in copy position, or aiming light through a white, translucent screen somewhat larger than the subject itself. An accent light is positioned in the off-axis front position and this should be a large, long, narrow light, heavily diffused or reflected.

If a light, high-key effect on transparent objects is not wanted, a 'dark field' may be constructed whereby the object is placed against a dark background and lit strongly from top, bottom, or side. It may be that small mirror foil reflectors will be needed behind some translucent objects in order to produce the required transparent brilliance.

Metallic and shiny surfaces

Metallic and high-gloss surfaces readily pick up every possible reflection of specular light, creating distracting hotspots on the surface. Normal photographic lights, even when diffused, may be inadequate in rendering fully the nature of the material being photographed. This problem calls for 'tent' or 'cone' lighting, or the use of such large diffuser boxes on the light sources that great power is needed in the lamp itself.

Some metallic surfaces can be 'matted' using a fine face powder or dulling spray, but this technique is rarely suitable for

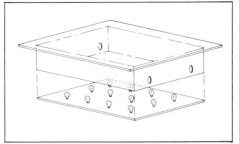

36 *A Lighting Box for Shadow-Free Lighting. To build a lighting box on which small objects are back-lit to remove shadows, a wooden box is made with suitable ventilation holes and a number of diffused household lamps are connected to a switched circuit. A sheet of opal glass or opal acrylic is placed over the box and objects to be photographed are placed on the glass. These objects are lit by the correct front lighting, but the under-lighting, if it is sufficiently strong, will wash out all the shadows.*

close-ups of a primary subject. It is, however, useful in a large interior where only a few distant objects are picking up annoying specular reflections from photographic lights. By looking through the viewfinder these may be identified and individually treated. Dulling spray may be obtained from professional photographic suppliers and the powder should be a very fine translucent make-up powder obtained from a theatrical supplier.

In order entirely to eliminate cast shadows from small objects as is often needed in industrial catalogue photography, a translucent lighting box may be made. Objects are placed on the opalized surface and under-lit with sufficient strength to wash out the shadow from the key light. If this becomes difficult to achieve, the key light is given as a first exposure and then, as a second and much longer exposure, the under-lighting is turned on while the film remains in place in the camera and the subject is totally unmoved during the process. This double exposure method is very easy, provided the camera is fixed firmly on a tripod and the subject is totally stable on the lighting box.

COMPENSATING EXPOSURE

The best intentions and the best understanding of lighting control are all useless unless the photographer also masters exposure. Highlights must not be over-exposed, either

35 *Metallic objects require special lighting which is diffused but definitely directional.*

in colour or black and white and, in safeguarding this upper part of the lighting scale, many photographers lose shadow detail, often disastrously. Shadows must have adequate light and the photographic process is immensely deceptive. The eye scans and flickers around a darkly lit scene, easily adjusting to violent changes of light levels, but the film chemistry cannot. Although properly processed black and white negatives of perhaps long-scale, panchromatic material developed in a compensating formula, may achieve a luminance range of 500:1 (eight or nine 'f' stops); the print from that negative may be down to 100:1; colour transparencies may be down to 60:1 and reproduction in an expensive glossy magazine may be finally appearing on such a page at a ratio of only 30:1. There is always tone compression in any reproduction of photographs, a small loss being apparent as each step unfolds, with each transfer, negative to positive or positive to positive, condensing tones a little more each time. Allowance must therefore be made in the original lighting and subsequent processing to anticipate this loss. For good print quality generally (and always if the results must be reproduced in a photo-mechanical process such as off-set litho, letterpress or serigraph, lighting ratios must be brought closer together and highlight to shadow relationships must not be too far apart.

Remember also when lighting and subsequently when calculating exposures, black objects absorb light like a sponge and must either be given extraordinary amounts of light or be subject to special compensatory processing, or both. White objects, of course, reflect much more light and these must be selectively screened in the lighting plan so that these lighter objects do not lose detail.

Scrims and flags

Screening is done by interposing wire or tissue scrims between the key light and the white object. This gently cuts the light in a localized area around those objects allowing more light to reach other parts of the general

37 *To photograph a black object and a white object together requires special control of lighting, exposure and processing if good results are to be achieved. Here, light has been increased on the black object and decreased on the white object by adding a small sharp spotlight which affects only the black object. Exposure has been 50 per cent over and development 30 per cent under the norm to achieve detail in both objects.*

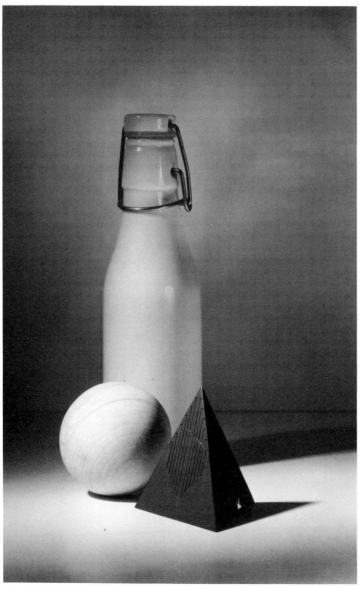

38 *A lighting 'flag'.*

subject. The lighting 'flag', either partially or wholly opaque, is also used to cut off the full force of the key light from selected parts of the set, and barn doors are used on reflectors to trim carefully the fall of light so that it falls off from the reflector in a gentle and natural manner. The best of lighting is always about transition – the intermingling of light and dark, the imposing of dark form and edges on light backgrounds and vice versa and this is achieved by the use of specially shaped reflectors of varying size; each casts its own characteristic light.

Filters

Light itself can, of course, be modified in other ways apart from diffusers, scrims and flags. Filters may be used either to change the colour of light or to alter its behaviour totally. Where strong colour changes are made, special non-flammable, gelatin sheets may be obtained from professional photographic suppliers and these are either attached by metal clips to hot lights containing tungsten lamps or by rubber bands to small electronic flash units. Where very small shifts of colour are needed to correct individual lights, these are made by weak filters similar to CC (colour-compensating) camera

filters or sprayed on to reflectors or diffusers from aerosol packs.

Where light is falling on a very glossy, non-metallic surface in such a manner that nothing which is beyond or below that surface may be seen in the camera, a polarizing filter may be applied to the lens or a polarizing screen can be placed on the source of light if this is possible, or a combination of these devices may be needed. Light normally vibrates in all directions but from such glossy surfaces it tends to vibrate only in a single plane – i.e. the light is polarized. Polarizing filters are made of minute crystals suspended in plastic, which are aligned in a parallel configuration, thus allowing light to pass in controlled single-directional planes. Single plane vibrations of polarized light arising from glossy surfaces may reach the film as long as the polarizing filter is kept in parallel orientation with this plane of light. As the polarizing filter is rotated, a gradual cut-off of polarized light occurs, as it cannot now enter the disorientated filter. At 90° rotation, no polarized light passes through the filter and the reflection from the glossy material disappears entirely. Non-polarized light passes through the filter normally, but exposure increases are needed to compensate

39 *Control of reflections from glossy non-metallic objects. Ordinary light vibrates in all directions. Non-metallic glossy surfaces reflect polarized light – i.e. lighting vibrating in a single plane. A polarizing filter admits light through a microscopic parallel grid of crystals, passing single-plane, polarized (reflected) light*

when the grid lines are in the same plane as the reflected light. By rotating the polarizer the grid turns across the plane of polarized (reflected) light, stopping transmission of single-plane light, but admitting all ordinary light. This eliminates highlight reflection from glossy surfaces.

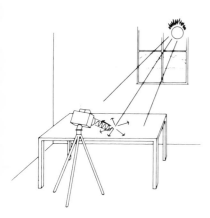
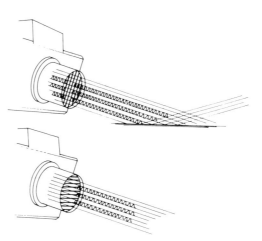

for the filter density. Colour is not affected.

For the control of glare and reflection arising from shiny objects or glossy impasto copy material, light the subject with two identical lamps - one on either side and each equipped with a polarizing filter. The camera is also equipped with a rotating polarizing filter. Turn on the first light and rotate the polarizing screen to allow polarized light to escape only horizontally. Rotate the camera filter until the glare is minimized and turn off that light. Without altering the setting on the camera filter, rotate the screen on the second light which has now been turned on until the glare disappears when seen through the camera lens. Turn on both lights and make the exposure, allowing considerable compensation for the loss of light due to the three filters. Eight to twenty times normal exposure may be needed but colour will not be altered. When copying, the results have to be perfect and full camera tests must be made, especially if the material is in colour. See Chapter 10 for more information on copying.

PEOPLE INDOORS

The foregoing remarks about lighting and lighting plans all apply with equal value to photographs of people indoors, but perhaps need some modification in order to improve the ambience or illustration of character. Lighting for individual portraits needs the same categorizing of key lights, the same use of fill lights along the lens axis, and the use of accent lights and background lights. Both specular and diffused light is used singly or in combinations, but the lighting plan may further be sub-divided into two categories, namely 'broad' and 'short' lighting. Broad lighting is light that reaches that side of the face nearest the camera, often from the top front axis or front axis positions. It tends to minimize contour and texture and can help to make thin faces look wider and rounder. Short lighting occurs when the main force of the lighting strikes that part of the face turned away from camera and this increases the effect of contour and texture and reduces apparent weight for heavy faces and bodies. Short lighting can also conceal unsightly skin blemishes on the side nearest the camera and can mask, for example, large ears when the face is in profile.

While individual sitters may be given the photographer's complete attention and light may be very tightly controlled, performing exactly as the photographer has planned, this is not often true when photographing groups. The constant interaction of members of the group with each other, with the environment and with the photographer makes it necessary to have a wider somewhat blander, light, and the 'wrap-around' light is probably ideal. This is a very large key light in the top front position and a series of fill lights placed along both sides of the camera or slightly above. If strong top side or side lights are being used on such assignments, the cross shadows falling on some members of the group may be very unpleasant. Where the group is part of an important interior which must also be shown, it is sometimes possible to tilt a large top light back slightly and light some of the background, but it is usually necessary to light the environmental areas quite separately. The key light on the group may not then always be the key light for the whole picture.

LIGHTING RATIOS

Once skills are built up and confidence is gained in handling equipment and lighting concepts, photographers should begin to understand thoroughly lighting ratios. In the finished photograph there should always be

40 *Two ways of using an accent lighting: (a) shows a 'chisel' light being used as a key light to delineate the profile and also light the background, with the accent light on the hair; (b) shows the same lighting positions, but with the body turned to face camera. The key light now becomes a top side light to produce strong contours. The accent light is arranged to light the hair, neck and shoulders and to separate the figure from the background.*

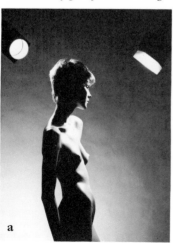 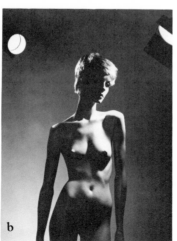

a

b

a b c d

41 *Lighting ratios: (a) A lighting ratio of 1:2 is ideal for most black and white portraits indoors; (b) The ratio has been decreased to 1:3 which is usually considered perfect for colour film; (c) The ratio has been increased to 1:4 which gives much more compelling results in black and white and is particularly suited to editorial work (the shadow being four times darker than the highlight); (d) A very dramatic or theatrical result in portraiture happens if the ratio is further extended, as here, where the highlight to shadow ratio is 1:8.*

a highlight area, lit by the key light and, consequent to this, there will be a shadow side where the key light does not reach. This shadowed area may be left unfilled, in which case the highlight to shadow ratio is large. If, for example, it is 20 times darker than the highlight, then the ratio is expressed as 1:20. If substantial fill light is placed in the picture, the ratio drops perhaps to 1:10. More added fill lights can bring this lower, perhaps to 1:5 and this is a good ratio for modern black and white photography, especially for portraits. It may not reproduce in coarse screen reproduction such as newsprint. At 1:4 and 1:3, the values come closer together and suit negative and reversal colour materials respectively, while at 1:2, most, if not all, details may be seen in the shadow side of the subject but contour is not as pronounced and the mood could become somewhat bland. At 1:1, where the highlight value equals the shadow value, an even, flatly lit picture results. This is usually only for record pictures of the most basic kind or for copies. The 1:1 ratio is typically produced in a portrait by a flash-on-camera situation.

The acquisition of good lighting control is basic to any form of photographic communication and the photographer's objective should be to make clear every texture, contour, form, personality, ambience and hidden structure which exists in the original scene, and then to render this faithfully in a photographic way, or at least as much of it as he or she believes is needed. The eye grasps all well-lit objects in an almost tactile way, mentally fingering and exploring all of their properties. Paper should crackle, glasses should ring, fur be soft, wool be warm, people should breathe, all because the photographer achieved the right lighting. This physical control of light may take more than six months of constant practice, and any subconscious interpretation of the fall of light which is bound to follow in depth, may take years of effort. When this stage is reached, the photographer can create harmonies, discord, fear, peace, agitation, sadness or any mood considered necessary to make the image speak more emphatically to those who view it.

3 Colour Control

Colour as we see it is not a precisely measurable scientific entity although it is based on probably the most absolute physical phenomenon: the law of light. As mentioned in the previous chapter, light moves at an unvarying speed of nearly 299,783 kilometres (186,282 miles) per second. It may be bent, refracted, absorbed, reflected or transmitted and visible light is considered to be composed of unequal but continuous bands of red, orange, yellow, green, blue and violet with the broadest bands being red, green and blue. These spectral bands interact and are influenced by their neighbouring colours within the visible spectrum. They are transmitted from the light source in wavelengths which are given a tiny unit of measurement, called the nanometre.

The retina in the human eye is filled with densely packed receptors of rods and cones. Rods are extremely sensitive to low levels of light, are affected by all colours, but see them only in monochromatic shades of grey. Rods are found in their greatest number in the outer (peripheral) edges of the retina. Cones are concentrated in the critical area of vision in the middle of the retina and are less sensitive to light levels but are filled with pigments in red, green and blue colours. A cone pigmented in red, for example, is selectively sensitive only to light of that colour, and so on. From these colour cones, sensitive only to three colours, the whole multi-colour spectrum is discerned and perceived as white light.

The foregoing description relates to the physical behaviour of light and vision, both of which may be a matter of agreed fact and, in most cases, indisputable measurement. But, ultimately, perception is a psychological activity, open to many persuasively interacting factors, most of which are extremely subjective and intensely individual.

One cannot generalize about them or analyse them and they often change from moment to moment, and certainly from person to person. Seeing colour is effectively, therefore, a translation of the physical facts as they may be interpreted by the health, culture, circumstances, experiences, and mood of the viewer concerned. Many of the male population for example are colour-blind. People who have marked preferences for the warm colours will tend to discriminate against blues; people in certain cultures prefer primary reds, blues and yellows; others are at ease only with intellectually appeasing neutrals of grey, misty green, black and earthy browns. We see largely, what we are prepared to see and no two individuals' assessment of named colours is likely to be identical. Colour alters physically according to scale – large expanses of colour are not scientifically the same as small ones and bright patches of complementary hues vibrate and attract attention but quickly tire the mind of most observers. Small, intensely saturated spots of colour can alter our perception of bordering colours, especially if these are desaturated and diffuse.

Add to these psycho-physical factors, the photographic considerations of film type, age of film, storage conditions, warm-up times, exposure, processing, lens glass and type, filter type, and it will be seen that there are really no rules which may be set out to help achieve perfect colour. By taking certain steps to eliminate as many technical variables as possible, however, simplification of this problem is bound to follow.

TECHNICAL CONSIDERATIONS
Choice of film

First, the photographer should minimize the number of colour film types in use. Most serious photographic needs are served by a slow daylight emulsion, a medium-speed tungsten Type B emulsion and a medium-speed daylight film, a high-speed (400ASA) film and an ultra-speed Type B film with a rating of perhaps 1000ASA plus. These could conceivably all come from different manufacturers and my personal choice would be Fujichrome 50 Prof. D (RFP), Kodak Ektachrome (32–80ASA) Tungsten; from Agfa 100S (100ASA daylight); from 3M, 400ASA daylight and 1000ASA tungsten film. Processing should be established as a standard and as recommended by the manu-facturer. The photographer should also be familiar with push-processing in one- two- and three-stop increments but only resort to these alterations under extreme conditions or for special effects. The examples given are all for reversal (transparency) film and push-processing is not recommended for negative colour film as it contributes nothing of value, except grain, to the final result. My preference for transparency film is based on the ease with which filtration variables may be assessed and the instant editing which may be used to eliminate unwanted or failed exposures, thus saving print costs. In passing, it must be said that the Kodak 1000ASA negative colour film which is of phenomenal speed, is also a marvellous film to use in available tungsten light.

COLOUR TEMPERATURE OF VARIOUS LIGHT SOURCES

Light source	Approximate colour temperature in Kelvin	Conversion for 3200K Type B film	'f' stop increase	Conversion for 5500K daylight film	'f' stop increase
Firelight	1000	80B	$1\frac{2}{3}$	80A + 80B	4
Candle flame	1500	80C	1	80A + 80B	$3\frac{2}{3}$
60W house lamp	2500	82C + 82A	1	80A + 80C	$3\frac{2}{3}$
100W house lamp	2900	82B	$\frac{2}{3}$	80A + 82A	$2\frac{1}{3}$
150W Par 38 reflector spot	3000	82A	$\frac{1}{3}$	80A + 82	$2\frac{1}{3}$
500W projector lamp	3200	nil	—	80A + UV	2
Sunrise–sunset	3200	nil	—	80A + 10C	$2\frac{1}{3}$
Tungsten halogen studio lamp	**3200**	**nil**	**—**	**80A + UV**	**2**
275W photoflood	3400	81A	$\frac{1}{2}$	80B	$1\frac{2}{3}$
Fluorescent, warm white	3500	30M + 20Y	1	50C + 30M	2
Clear flash, aluminium	3800	81D	$\frac{2}{3}$	80C + 82A	$1\frac{1}{3}$
2 hours after sunrise	4000	85C	$\frac{2}{3}$	80C	1
2 hours before sunset	4000	85C	$\frac{2}{3}$	80C	1
Clear flash, Zirconium	4100	85C	$\frac{1}{3}$	82C + 80C	$1\frac{2}{3}$
Fluorescent, cool white	4500	40M + 50Y	1	82A + 5M	1
Carbon arc, white	5000	85C	$\frac{1}{3}$	nil	—
Blue flash lamp	5000	85C	$\frac{1}{3}$	nil	—
Noon sunlight temperate zone	5200	85B + 10Y	1	82A	$\frac{1}{3}$
Sun arc, hi-intensity	**5500**	**85B**	$\frac{2}{3}$	**nil**	**—**
Studio flash, professional	**5500**	**85B + 10R**	**1**	**nil**	**—**
Daylight, noon, reflected	**5500**	**85B + 20Y**	$1\frac{1}{3}$	**81**	$\frac{1}{3}$
Fluorescent, blue/white	6000	85B + 30M + 10Y	2	40M + 30Y	1
Direct sunlight, 10am–3pm	6000	85B + 81C	1	81A	$\frac{1}{3}$
Sunlight and skylight, other times	6500	85B + 81D	1	82C + 82C	$1\frac{1}{3}$
Overcast sky	7000 +	85B + 81EF	2	81EF + UV	1
Amateur electronic flash	7000	85B + 81EF	2	85 + UV	$\frac{2}{3}$
Reflected light from blue sky	10,000 +	85B + 85	2	81EF + 85	2

Note

These filter suggestions are for first trials. Factors such as film type, storage, age, lens type and condition or personal colour preferences will all decide final acceptable results. Complete tests are advisable. The 85 and 81 series filters are yellow to amber in colour and are placed on the camera lens to *decrease* colour temperature. The 80 and 82 series are blue to pale blue in colour and *increase* the colour temperature of light reaching the film. Filters indicated are from the Kodak Wratten range of thin gelatin filters.

Colour film of any type is affected by its age and the conditions under which it has been kept. Manufacturers will always date the film, but storage by the retailer can often leave much to be desired. Film left on a sunny shelf in the shop is deteriorating rapidly and should be avoided. Buy film from professional shops, if possible, or those with rapid turnover, or from a store that keeps it in deep-freeze or at least in refrigerated conditions. Heat of any kind when applied to colour film, if it is more than 24°C (75°F), can begin to change the colour characteristics of emulsions, especially after they have been exposed. Always purchase film, where possible, from recommended sources in reasonable quantities of the same batch number and keep it unopened in deep-freeze conditions. After exposure, process within one week and, in the interim, keep cool. When travelling by air, note that the effect even of low-dose X-ray radiation, supposedly safe, is cumulative and the more inspections (the more stop-overs *en route*), the more the film will be affected. Always minimize this problem by keeping film in lead-lined pouches such as Sigma Filmshield bags. Exposed films and electronic camera bodies should also be given this protection.

Film which is kept under refrigeration or deep-freeze conditions must be brought to ambient temperature (see table) before opening the hermetically sealed individual packages. This is true also of colour paper. Once these sealed packages have been opened, however, they should never be returned to deep-freeze conditions.

Equipment
When the photographer is confident of the quality of the original material to be used for colour photography, attention can be turned to equipment. It helps to have all lenses, for example, from the same manufacturer, as

43

PRECEPTS FOR GOOD COLOUR PHOTOGRAPHY
1. Buy film from a dealer who keeps stock under refrigeration.
2. Deep freeze until needed.
3. Warm up at least 2 hours to room temperature.
4. Test one roll of film with a colour test chart held against the subject's face, with various CC filters and exposure combinations.
5. Process at once, view on a 5000°K rated light box for transparencies.
6. For negatives make test prints.
7. When shooting reversal material, bracket exposures
8. Always use the same processing routine or lab.
9. Hold part of the exposed material from assignments until the client sees first tests.
10. For reproduction work, under-expose by half a stop.

44 WARM-UP TIMETABLE FOR PHOTOGRAPHIC MATERIAL HELD IN COOL STORAGE

Film	From a refrigerator at 10c (50f)	From a deep freeze −18c (0f)
135mm cassettes	1 hour	2 hours
135mm bulk roll	3 hours	5 hours
120 roll	½ hour	1 hour
Polaroid s × 70	½ hour	1 hour
Polaroid other packs	1 hour	2 hours
25 sheet box large-format film	1 hour	2 hours
50 sheet box large-format film	2 hours	3 hours
Paper		
100 sheet box 20 × 25cm (8 × 10 inch)	2 hours	4 hours
50 sheet box 40 × 50cm (16 × 20 inch)	2 hours	3 hours
50 metre roll, any width	4 hours	10 hours

Lay all packages out individually, with some space between each, while thawing takes place.

each will have a certain standard of colour balance to which that particular maker will conform. Often, for example, European lenses are slightly cooler and more contrasty than those made in Asia. Each lens should be fitted with a high-quality glass UV filter. This eliminates a lot of unwanted bluish cast in colour photography, particularly for subjects exposed in late afternoon, on overcast or rainy days, or at altitudes in excess of 1000m (3500ft). The UV filter is screwed into the lens and left in place as it also gives maximum protection to the delicate surface of the lens itself. Other filters which are needed for precise colour correction may not always be glass; indeed the industry's standard conversion and correction filters are probably the Kodak Wratten series, in their 75mm or 100mm gelatin squares. It is as well for consistent results to use matching filter sets also, and other reliable filter makers include B+W (Germany), Hoya (Japan) and Tiffen (USA).

Avoiding flare

Colour images on film are improved by 'saturation', where the colour is reproduced at its most vibrant and complete hue, and the enemy of such desirable results most often is flare. Flare arises from light sources from outside the camera, particularly when the sun is in a backlit position, or it can be caused by reflections from bright metal within the camera body itself. Internal flare must be cured by an application of matt black to the affected parts, preferably carried out by a professional camera repairer. External flare can be cured largely by the use of an effective lens hood and maximum focal length for the chosen lens. In conditions of extreme back-lighting, long lenses and long lens hoods are the ideal combination, but this is not always possible in indoor photography. Flare is reduced for ultra-short lenses if the light source is far enough away and, in the case of extremely short (20mm and less) 35mm SLR lenses, the light source, even if it is the sun itself, can be included within the picture format without too much desaturation.

Flare can be present also in bright reflections from water, glass or glossy, light-coloured objects, and to obviate this a rotating polarizing filter may be needed. This should be of glass and should be of the highest quality. By rotating one of the two lenticular filters within the mounts any polarized light emitted in a single plane from the reflection is eliminated, while other, less reflective, surfaces are rendered without change. The overall transparency will, in consequence, be richer and more intensely saturated than would otherwise be the case. Very glossy surfaces, such as car windows, are made more transparent and it is then possible to see beneath the surface of such objects.

When lighting small, shiny objects with multi-source lighting, the hot-spots of the specular reflections may be removed the same way but, in some cases, a contra-polarizing screen is placed on the light source itself.

Testing for colour balance

Once standardization of equipment, processing, storage and film type has advanced to some degree, comprehensive testing should be undertaken to explore the subjective values of various practical problems. Notes should always be taken of new tests and results kept in a studio log book.

A point overlooked by many workers in colour is that of the critical evaluation of tests. It is essential, if the subtleties and skills of colour compensation and correct colour balance are to be learned, that tests are evaluated only under correct viewing conditions. For colour transparencies (reversal) a light box should be bought or built which has a guaranteed light emission of 5000–5500K colour temperature. This is for viewing both daylight and tungsten film. For colour print material, it may be necessary to consider where the final print will be viewed, the intensity of the lighting and its colour but, in general, a good, bright, white light in

45 *When viewing transparencies on a light-box, correct density and colour values are only seen if most of the extra light is masked off as shown in this diagram.*

the colour temperature range of 4500K to 5200K is desirable as a viewing light. These light sources are generally fluorescent, diffused by opal glass or acrylic, and manufacturers give precise Kelvin ratings for all their products. There is absolutely no point in becoming involved at any depth in colour photography if these pieces of basic viewing equipment are missing.

Exposure Obviously one vital factor in correct colour balance is exposure. Half-stop increases or decreases in exposure make considerable difference to colour values and saturation. It is as well not wholly to trust camera automation for exposure control as most systems can be fooled in difficult lighting or contrast situations, and many meters are calibrated to provide an average of the scene at which they are pointed, and take no special note of the emphasis or highlight or shadow. Judgement of exposure indoors is particularly difficult for most normal camera automation and in almost all cases, where there is doubt, it is wise to bracket exposures. This means that besides the normal exposure, a second is made a half a stop lighter (over-exposure) and a third is made half a stop darker (under-exposure). This bracket of exposures should fall into the basic, correct exposure spectrum but gives added choice of lighter shadow areas (over-exposure) or better rendering of light colours or highlights (under-exposure).

Processing Processing of colour film, particularly of reversal material, is a critical matter when seeking perfect colour, and manufacturers' recommendations should always be followed implicitly. After some experience, it may be interesting to experiment with push-processing, but these departures from standard are usually accompanied by some alteration in film characteristics. Grain may be increased, for example, colour values altered – usually towards increased yellow or red – contrast can be increased or, in the case of excessive pushing – three or more 'f' stops – contrast can decrease, with considerable loss of density in the blacks. While push-processing is rather a normal technique, with most colour film it is not advisable to attempt to compensate for over-exposure by reducing development time. Results are usually disappointingly cool with a very rapid deterioration of the light and neutral tones which easily begin to take on blue and green casts; far better that exposure is judged in terms of slight under-exposure and, after the tests are received, compensation can be made by increasing development with little risk to the colour values.

Many photographers will make a final check on exposure by the use of Polaroid, and it is often misleading to use colour materials for this as they never relate precisely to the camera film which is to be exposed. The most useful is a black and white Polaroid material which has an ASA rating close to that of the chosen film. With a little practice, judgements become very easy to make in terms of exposure, contrast and general optical quality and, of course, the camera mechanism, flash synchronization, focus, etc., can all be inspected minutely for faults.

If care is taken then to match the colour of the main light source to that which is correct for the film and great precision is achieved in exposure and with processing norms, it will follow that very accurate results in colour photography are possible – always provided, of course, that film storage and shelf life are as they should be.

Lighting contrast
The most difficult problem to be resolved in colour photography, apart from colour balance, is likely to be that of controlling lighting contrast. Colour film of any reliability has only been widely available for the past 30 years and, although great improvements have been made, colour film is still

46

CORRECTING COLOUR BALANCE
The eye receives sensations from three basic primary colours which when combined form visible white light. These are the additive primaries of red, green and blue and all colours may be made from a selective composition of these colours of light. Photographic colour emulsions achieve their colours by the use of the subtractive primaries magenta (M) cyan (C) and yellow (Y) and these are the primaries used to derive CC (colour compensating) and colour printing filters. These filters are arranged in rising densities beginning at .05 and reaching .50 in the case of CC filters and .90 in the case of colour printing filters. For enlarging, the colour printing filters are the most used and generally only in magenta, cyan and yellow. CC filters are used only in colour printing if it is necessary to use filtration at the lens instead of in the lamphouse.

inherently incapable of handling very contrasty lighting situations with any degree of delicacy. While the eye can easily accept luminance ratios of 2000:1 and panchromatic black and white film can be processed to handle about half that value as a negative, colour film may not easily be able to produce ratios of 200 or even 100:1. Most acceptable results achieved by colour reversal film are within a seven-stop range, with colour negative handling contrast a little better, with an eight-stop range. Most attractive colour results would be achieved in the four- to six-stop range, with a luminance ratio of between 20 and 60:1. This low ratio is almost never present in indoor situations lit by available light and is only possible in very controlled, artificially lit photography or in a studio.

Unlike black and white film which may be exposed and processed to alter contrast so that it falls within the film's latitude, colour film at present cannot be processed to give lower contrast. In indoor colour photography, the only possibility is to bring the highlight and shadow values closer together by augmenting the shadows with extra light. This can be done by large white or silver reflectors, at least 1 m sq. (40 in. sq.) square for a portrait and twice that size for a standing figure, or by the use of floodlights or flashlights. Whenever the photographer is faced with the contrast of ambient light indoors, an exposure reading must be made of both highlight and shadow. If the two 'f' stops are found to be more than six stops apart, the shadows (if detail is needed in them) must receive extra light until the two values are brought nearer together. For professional or reproduction purposes, the values may need to be within a four-stop range.

Fluorescent lighting

One possible source of concern in indoor photography is the problem of obtaining a critical colour balance when the main light source is fluorescent. Many of these fittings have high green content, operate at widely different colour temperatures and, because they are emitting a discontinuous spectrum with unpredictable surges and pulses, colour values and intensities are rarely constant. The first step is to identify, if possible, the manufacturer of the tube and obtain precise colour temperature figures, or broadly to classify the visual appearance of the light into warm white, cool white, daylight or blue light and then add filters to the camera lens as suggested by the table below. The commercial composite filters – FLD for correcting bluish fluorescents to daylight film or the FLB filter for use with tungsten film – are reasonably practical in an emergency, but not ideal for making critical colour-balanced exposures. Far better that the photographer works with a series of Kodak Wratten CC (colour conversion) filters which are made in small squares of thin gelatin, which fit standard filter hoods. It is of course possible, particularly if the fluorescent light is not in the picture area, to tape large pieces of filter material over the lights themselves. Such filters may be found in good professional photographic stores or be obtained from Rosco Company in many parts of the world (see Appendix).

Mixed lighting

When the indoor area to be photographed is lit by mixed light sources of mixed colour, the photographer must decide which compromises to make. If daylight is strong and entering many large windows, then it is prudent to load with a medium- or slow-speed colour film of daylight quality and augment

TRIAL FILTER PACKS FOR EXPOSURES TO FLUORESCENT LIGHT

Tube colour	Daylight film	f stop increase	Tungsten 3200k film	f stop increase
Cold blue	50c + 30m	$1\frac{2}{3}$	85b + 15y + 20m	2
Daylight spectrum	40c + 20m or FLD filter	$1\frac{1}{2}$	50m + 50y + 80b	2
Blue-white	30m	$\frac{2}{3}$	40m + 50y	$1\frac{1}{2}$
White	15c + 30m	1	40m + 40y	$1\frac{1}{3}$
Warm white	20b + 10m	$\frac{1}{2}$	30m + 20y	1

Note Table is based on shutter speeds of $\frac{1}{30}$ second and is for tubes in diffusers. Kodal Wratten CC filters are indicated.

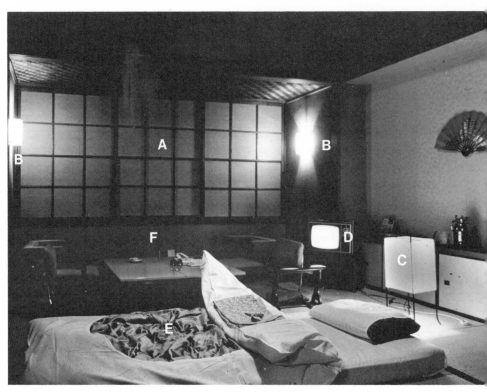

48 *Before considering the photography of any interior, take careful note of the position, strength and colour of all light which will enter the picture area. In this picture there is light entering through a window at A which is blue from the dusk outside, there is very yellow tungsten light from small wall fittings at B, bright – almost white – tungsten light from the floor lamp C, bluish light from the television at D, an overall yellowish light from the general room lighting E, and even the shadow area at F has subtle lighting characteristics and colours.*

the natural light by the use of daylight colour flash. Exposure is first calculated for the natural daylight values and this shutter speed and aperture setting are selected on the camera. Then sufficient flashlight (usually electronic and of some power) is introduced to give correct exposure in the other areas, calculating the intensity of light to match the same 'f' stop which has already been found for the existing daylight conditions.

Where daylight is less obvious or at a reduced strength and the interior has considerable existing light from tungsten sources, such as household lampshades, then high-speed Type B tungsten film is loaded, which has a colour balance of 3200K, and any extra photographic light needed is introduced by tungsten halogen floodlights. Of course, the daylight will be rendered as excessively blue, but this is generally not unattractive as it tends to promote a mood of romance and

warmth if the brightly lit interior is contrasted with cool, evening light from outside the building. If this excessive blue value from window light is not wanted and the window is in the picture, a filter screen must be made exactly to fit the shape of the window and be fixed in place during the exposure. A suitable choice would be Rosco 'Sun' materials obtainable in rolls 148cm (58 in.) wide from professional photo stores or direct from Rosco. An alternative but slightly more troublesome method would be to use black-out curtains on the *outside* of the windows which are seen in picture, make the tungsten exposure first with the camera securely locked on to a strong tripod, then double-expose a second exposure just for the daylight on the same piece of film. The tungsten lights are, of course, turned off during this second exposure, the blackout material taken down and an 85B Kodak Wratten filter must

be placed on the camera to convert the day-light value to 3200K colour temperature. This method is more suited to large sheet film cameras than small format or automatic equipment.

Where the subject in the above lighting circumstances is not a full interior view, or is a portrait or a small group, it is often unnecessary to filter out the light which is not correctly balanced for the film type, provided a key light of the correct balance and strength is lighting the major part of the subject. The eye will easily accept small areas of incorrect colour in this case and, in fact, such coloured light as does strike parts of the subject may add to a feeling of naturalness and immediacy.

Tungsten as key light

Where a large amount of existing light is tungsten (3200K) value, this becomes the key light and if it is found necessary to use a camera-mounted electronic flash to augment the available light, this flash must first be filtered to restore a compatible balance. This filter is likely to be a 100mm Kodak Wratten 85B gelatin filter.

49 *The use of colour gels on spotlamps is most interesting for experimental colour work. If the key light A is given a dark red gel and fill light B near camera is given dark blue, the accent light C could be, for example, a green gel. The resulting colour mix in the shadows will represent the influence of the accent and fill light and, by careful adjustment of the intensity of the lightfall from these two lamps, very creative colour results will be produced.*

The method would be as follows: place the camera on a tripod, load with a medium- or high-speed tungsten (Type B) colour film and calculate the correct exposure for the existing tungsten light. Judge exposure values in the areas on which the tungsten light falls, not on the lamp itself. This combination of shutter speed and 'f' stop (for example it may be $\frac{1}{4}$ second at f8) could produce natural colour on a transparency but there may be many areas which would be underlit or in heavy shadow. These may be improved by the use of flash as a fill-in, fired during the slow exposure which records the tungsten light. The flash guide number (GN) if known, is divided by the selected aperture which is to be used during the slow tungsten exposure. The resulting number indicates the distance in metres or in imperial measurement at which the flash must be placed for correct exposure. If the GN is not known, refer to Chapter 2 for the method of obtaining it (*see p.* 13). The electronic flash, giving out a bluish light somewhere near 7000K, will, as said before, require a Kodak Wratten 85B filter plus, possibly, an additional 81C or even an 81EF. These filters are taped to the flash-head so that the entire light output must go through the filter pack. Large studio flash systems or the small Multiblitz range work at 5000-5500K and usually require only an 85B filter. Camera tests should be made first if accuracy is required in the final transparencies or if colour balance is critical.

Colour balance for skin tones

Whenever the subject of the photograph is a person or includes people, the primary efforts of colour balance will have to be directed at achieving a good skin tone. Film manufacturers usually find this the most difficult technical matter to resolve as what is considered a suitable skin colour will vary from person to person. Most people prefer skin tones to have a healthy, warm, slightly tanned colour value rather than be excessively red or excessively bluish. This may mean that other colours are compromised by biasing them away from perfect colour balance in order that the skin tones do not suffer. Each film type will have different characteristics in respect of skin colour, and must be tested. Where a skylight filter is fitted to the lens to help control UV light, a

light amber Kodak Wratten 81 or 81A could be added to improve skin tones, even when the light sources seem perfectly to match the colour temperature suggested for that film.

In the studio or in very controlled indoor photography, the light sources themselves can be warmed up slightly by the use of a gold reflector behind the lamp or by fitting a suitably mild Rosco Cinegel filter, (MT1) for example, over the entire lamp. Where skin tone is not a factor and the primary objective is to reproduce the colour of the indoor subject as accurately as possible, it is first necessary exactly to balance the light source to the same colour temperature as that which is correct for the film chosen. This may be done with absolute precision only if

a spectrum of colour swatches and a scale of greys are photographed in the same light as is to be found in the interior, and the resulting test is then viewed under correct conditions on a light box of the approved colour temperature. Once the lighting balance is achieved by adding CC filters, it will be necessary to make separate tests of any important fabrics, dyes, paints or ceramics, as these very often do not come out in a photograph as they appear to the eye. Only when such comprehensive tests are finished, should the final interior be photographed.

Colour-compensating filters

It is easier to make corrections when transparency material is used and CC filters are placed over the processed transparency test while it is on the viewing box. CC filters as supplied by Kodak are the industry's standard and these come in density values from 0.05 to 0.50 and in colours of cyan, magenta, yellow, red, blue and green. Not more than three such thin gelatin filters should be in the filter pack and not more than two colours should be used at one time. Once the filter pack looks visually accurate, it is placed on the lens and a further test is made, using identical processing. This time-consuming technique is the only certain way in which the truest colour balance may be obtained and it will, if the search is for absolute accuracy, mean testing several film types and different brand names in order to achieve the most perfect rendition of the colours before the camera. Of course when the answer is found, the combination of film type, lighting and filtration remains available for future occasions and needs little or no testing.

Reflection

Coloured objects are seen as such by the eye because they reflect a large amount of the identified colour and absorb all other colours. In interiors particularly, objects which do not perfectly absorb colours or do so in very equal amounts will often retain a distinct colour echo of nearby colours. This happens particularly in the shadowed areas or if the object is light toned or neutral grey. These delicate shifts of colour arising from neighbouring walls or objects can be part of the attraction of the final result or can be disastrous. For example, when photographing a person or group standing near a green

CORRECTIVE FILTERS FOR COLOUR FILMS

Conversion filters for large shifts in colour temperature

Filter number	Exposure increase	Degrees K	Filter colour
*80A	2	+2300	Blue
80B	$1\frac{2}{3}$	+2100	Blue
80C	1	+1700	Blue
80D	$\frac{1}{3}$	+1300	Blue
85C	$\frac{1}{3}$	−1700	Amber
85	$\frac{2}{3}$	−2100	Amber
†85B	$\frac{2}{3}$	−2300	Amber

*converts daylight film for tungsten use
†converts Type B film for daylight use

Conversion filters for small shifts in colour temperature

82	$\frac{1}{3}$	+100	Pale blue
82A	$\frac{1}{3}$	+200	Pale blue
82B	$\frac{2}{3}$	+300	Pale blue
82C	$\frac{2}{3}$	+400	Pale blue
81	$\frac{1}{3}$	−100	Brownish yellow
81A	$\frac{1}{3}$	−200	Brownish yellow
81B	$\frac{1}{3}$	−300	Brownish yellow
81C	$\frac{1}{3}$	−400	Brownish yellow
81D	$\frac{2}{3}$	−500	Brownish yellow
81EF	$\frac{2}{3}$	−650	Brown

Where cold or bluish light (daylight) is used to expose type B colour film, *use the minus filters to* balance colour correctly.

Where warm or reddish yellow light (tungsten) is used to expose daylight colour film, *use the plus filters* to achieve colour balance.

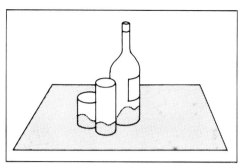

51 *Colour echo. Nearby colours create echoes of themselves in other objects: the lighter the object is in colour, the more the colour echo is visible.*

wall on a green carpet, this colour is often very noticeable in the shadow areas of the face and will produce a most unattractive skin colour in the final picture. To prevent this reflected coloured light from interfering, large areas must be covered up with white paper – even newspapers will help – or with kitchen foil if a high degree of reflection is thought to be necessary. To increase contrast and saturation but also reduce colour reflections, black absorbers would be used instead.

Colour photographers work frequently with neutrals: those colours which reflect almost equal amounts of all colour, and with modern colour photography they can be most attractive. Whites, greys, beiges, pale blues and medium greys create an intellectual mood, delicacy and refinement, and act as screens against which stronger colours may more readily be seen. These neutrals must never be over-exposed and they may be easily biased by the use of low-value CC filters with very small alterations of exposure or processing. Apart from a totally neutral white, neutral greys will be either cool (bluish) and seem to retire from the eye, or be warm (reddish) and appear to advance to meet the eye. These factors may be used to compose colour more effectively.

Once the technical facts of colour are fully known and some considerable experience has been gained in judging results from practical work, it will become a matter of routine for the serious photographer to render any indoor subject in colours which are close to their visual value. But colour, as is well known, is a very individual affair and each of us assesses any given colour in our own unique way. Once the physics of colour are

understood it will be found that there exists a very complex overlay of psychological modifiers which affect the final acceptance of the colour image and what we make of it.

THE PSYCHO-PHYSICAL FACTORS

Serious colour photographers, particularly those who choose to photograph indoors, should begin to understand some of these psycho-physical factors and make use of them in constructing colour compositions. When faced with an outdoor scene, the photographer can choose selected viewpoints, time of day, perhaps alter certain colour values by filtration or special effect, but very little else. The indoor photographer, however, may not only do this but can also create totally controlled colour situations where the visual effect arises solely from an arbitrary decision by the photographer. When such designed and managed images are placed on display, they will usually involve an unconscious response from the viewer and this response may be deliberately triggered off by the way the photographer has put the image together.

A colour image of any value rarely succeeds if it lacks optical structure of some strength or if it is weak in visual concept or content, and in this it is no different from black and white photography. The added attribute of colour is a marvellous addition to the complexities which may be attempted. Naturally, colour composition succeeds only when the colours are photographically rendered as accurately as possible and follow the intentions of the creator in terms of hue, brightness and saturation.

Colour is a language and the photographer must acquire a considerable vocabulary and pay some attention to the grammar. By reading the books of early pioneers such as Isaac Newton, the poet Goethe, the Frenchman M.E. Chevreul, and studying the writings of Jung, Helmholz, James Clerk Maxwell, Albert Munsell, Wilhelm Ostwald, and later writers such as Faber Birren, Rudolf Arnheim, Walter Sargent, Max Luscher and Joseph Albers, a much deeper understanding of colour control in a psychological sense will be obtained and much will be learned about the naming of colours and the manipulation of colour harmony. These men theorized about, classified, enthused over and explained a great deal about colour.

Colour harmonies

Isaac Newton was probably the first to take the visible spectral band of colours and wrap them into a circle, thus indicating the infinity of interaction which is so evident in colour; later workers gave names to colours appearing on this circle or wheel. These are generally expanded somewhat to stress the fusion of colours between primaries, and in this book I have chosen always to work with 12 main colours which include the photographic primaries of yellow, magenta and cyan (see figure 52). By constructing such a wheel the photographer may use it as a reference when making colour harmonies. Colours found exactly opposite each other on

52a *The colour wheel. Formal harmonic systems may be found on the wheel by first choosing a dominant key colour and then seeking the other components of the colour scheme by following the selected system. Note: a complementary colour is always to be found exactly opposite on the wheel to the chosen main colour or key colour.*

52b *Harmony, using the complementary colour of the key colour, plus an adjacent.*

52c *A triadic system using the complementary adjacents only and the key colour.*

52d *A classic triadic harmony based on an equilateral triangle.*

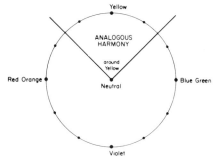

52e *An analogous harmony or 'tone on tone', where all colours are chosen from adjacents near to the key colour.*

the wheel are given the name complementaries, colours found on either side of a chosen colour are called adjacents and those to be found in any quadrant of the circle are considered analogous colours. Harmonies which most people will find pleasing can be made from these very few simple facts.

Choose a colour together with its direct complementary and, although there is no modulation possible in two colours of this kind and the eye is quickly tired of viewing them, the complementary harmonies do attract instant attention. The photographer should use this type of colour harmony in designing poster photographs, book covers, record covers and so on. But choosing, instead of the complementary, two colours adjacent to the complementary, a three-point harmony is introduced and, therefore, more sophistication without losing the intense competition between the key colour and the supportive ones. By looking for three colours together an analogous harmony is formed or, as it is sometimes named, 'tone-on-tone'. These analogous harmonies are the reverse of the jangling complementaries, creating low attention, introspection and intellectual activity. These should be used only when there will be time for them to communicate with the viewer, such as is in the case of book illustrations, wall pictures, large magazine photographs, portraits for domestic use, and so on.

Harmonies may be built upon other geometric forms, such as the equilateral triangle or the square. These forms are imposed over the wheel and one point is located against the key colour which is already in existence in the picture area or is to be placed there. All the other colours denoted by other points on the wheel become the supportive colours which may be located with, or in relation to, the key colour. Most people will view the results of these structured compositions as harmonious and attractive. Photographers will often introduce neutrals into such harmonies as these create dynamic, interactive components within the whole colour scheme.

For most colour harmonies reached by any trial and error method using the wheel, when they look right they probably are right because our intuition is very much to be followed in the matter of composing with colour.

The psychological effect of colour harmony can, at the elementary level, produce certain immediate effects. Juxtaposition of brilliant primaries can create confusion, attention, revulsion or excitement. Cool colours suggest rest and thoughtfulness. Warm colours promote participation and excitement. A large area of cool colour behind a warm colour creates apparent depth. Complementaries seen together intensify each other, attracting attention. Bright, pure colours are seen first and the eye travels more slowly over textured colour than flat colour. The combinations available to the indoor photographer are infinite and, when faced with a colour subject, it is as well to make a conscious effort to co-ordinate all of the image colours for the best possible effect.

The symbolism of colour

The symbolism of colour is deeply rooted in all cultures and in each individual and a preference for any given colour or harmonic grouping of colour will vary accordingly. We may well change our preferences for certain colours during the course of our life and it is certain that a child will have a different favourite on a colour wheel than when it reaches adulthood. Some general rules exist, however, and these conclusions can be used to draw attention or maintain communication between the photographer and the observer.

Most preferred of colours the world over is thought to be blue – a receding and diminishing colour. It can tranquillize, dissipate anxiety or fatigue, and symbolizes the unknown but comforting infinity of the soul: of hope, logic, holiness, perfect love, empathy. Since every colour has a negative attribute also, blue can signify boredom, emptiness, and introversion.

The most 'visual' of all colours in all circumstances of illumination is probably yellow. The eye identifies even small amounts before any other colour. Hence its use for commercial signs and traffic management. When surrounded by a large expanse of complementary blue or medium grey, it has immense recall value in the brain, creating an after image of great intensity. In the East it symbolizes nobility and culture and can suggest excitement, wisdom, imagination or serenity. It can also suggest tension, cowardice, instability and scandal. Yellow is explosively expansive, advancing to meet the eye

and spiralling out towards the edges of the format, especially if it is seen on an analogous screen of greys.

Red is the most positive of colours for most people; too strong for some who find its active, masculine authority too threatening. It is warm, advancing and maintains its area with stability. It can symbolize daring, sensuality, maturity, autonomy or danger but also, cruelty, disgust, anarchy or hatred. Used with green in equal area and intensity the combination can become unstable and loudly dominant of all other colours.

Green, the colour of the dark forest, is a refuge, a balance and a psychological resting place for the emotions. It can indicate indecision, laziness or lack of ambition but to many people, green symbolizes calmness, natural values, charity, freshness, reliability.

The neutrals of brown, black, white or grey accept, or are influenced by, many of the attributes of colours found near them. By themselves they have their own symbolism; brown, for example, could suggest wisdom, trust, appetite or experience, but also indicate decay, greed or obstinacy. Black, totally absorbent, is mysterious and majestic and can be masculine or feminine. It is a colour of unity or deep structure when deliberately used in an image. It can also indicate conflict, cosmic emptiness or terror.

White is the lightest and brightest of colours and signifies innocence, purity, divine attributes and health. It can also suggest immaturity, boredom and sterility. White is most easily influenced by neighbouring colours and accepts some of the symbolism which they inspire.

Grey is rather a special photographic colour, since it has a long attachment to the monochromatic silver image. Used in a colour composition it can be either warm or cool, but is generally considered negative and receding in nature. Grey can symbolize intellectual restraint, femininity, elegance or sophistication but can also suggest fear, exhaustion, pathos or doubt. Greys tend to reach areas in the viewer's consciousness where deep introspection takes place and any large areas in a well-managed colour photograph will generally provide a visual screen on to which the beholder may project self-constructed pictures from the unconscious which have been stimulated by the photographic imagery presented by the photographer.

Colour photography indoors is, therefore, a complex but captivating specialization; very much more than just the acquisition of a facile technique. Each area of interest, be it portraiture, interiors, still life and so on, will bring its own intriguing characteristics and, once the premise is accepted that colour can be manipulated to suit a desired response in the final beholder, it will provide the photographer with endless satisfaction.

4 People: the Inside Story

THE FORMAL STUDIO PORTRAIT
The formal studio portrait against a plain paper-fall or 'limbo' background requires of the photographer an exemplary lighting skill, a sensitive understanding of the sitter's character, and a flawless photographic technique, which does not, however, impose on either the subject or the viewer of the photograph any sense of being part of a merely technical exercise. The result must appear effortless, the photographer must seem an invisible witness.

Lighting is explained in the previous chapter and this information should be re-read in detail. Early efforts at controlling a full lighting plan and the nervousness or exuberance of the sitter within such a plan, will often at first produce false and artificial results. If the lighting is drawn too tight about the subject, movement will be inhibited and personality will, in consequence, be suppressed. If the lighting is too open, particularly if the key light lacks certainty of direction or is too diffused, then the subject may be more at ease but the photograph usually appears bland, lacking in visual concept and without a deliberate compositional structure or lighting force.

Putting the sitter at ease
Two technical matters may be noted, both of which bear considerably on a sitter's unconscious behaviour and consequently on the degree to which the portrait appears lively and real. If the lights and stands are small in size, few in number and are handled with confidence by the photographer, the sitter will relax considerably. It may be that some people are more nervous when photographed by flash than if a continuous source of tungsten light is used and it is as well to become expert with both systems of lighting. An ideal suite of lights for portraiture is made by Multiblitz GMBH of West Germany. This consists of electronic flash units, each of which is fitted with a variable switch to reduce power and each also has a high-intensity tungsten halogen modelling lamp built into the same unit which burns at 3200K, the colour temperature most suited for Type B film. This modelling lamp is linked precisely to the flash so that the lightfall can be previewed even for flash exposures while, for tungsten lighting alone, the flash may be turned off. The Profilite, in particular, has considerable advantages because it will accept many thoughtfully designed accessories, including barn doors, snoots, honeycombed diffusers, broad reflectors, umbrellas, and filters. Power sources may be simply varied by detatching part of the lamp house and plugging in alternatives, including a battery pack or an adaptor for use with a 12-volt car battery. The Profilite flash recycles in one or two seconds, even in the full power mode, which is very helpful in a lively portrait session, and delivers a useful metric guide number of about 50 with 100ASA film. With the advent of high-speed colour film rated as high as 1000ASA and push-processing of fast black and white film, there is even, perhaps, an over-abundance of lighting power from this equipment. In any case, there is certainly enough for professional portrait assignments with medium- and small-format cameras or to suit the complete needs of the serious amateur.

The second factor in putting the sitter at ease during a portrait session is perhaps less well-known. Each of us is sub-consciously

equipped with a primordial psychological barometer which determines an instinctive response to unusual conditions if they should suddenly confront us. Some psychologists refer to this as a 'flight or fight' condition and it is identifiable in all animals, particularly those in the wild and those of shy disposition. A decisive moment arrives when the animal either escapes the unusual circumstances or agressively defends itself against them.

The same instinct is deeply rooted in humans also, but has been somewhat modified by successive overlays of cultural growth through many thousands of years. However, each of us still carries an invisible zone about us into which we admit strangers with watchfulness and care. The zone is variable according to temperament, cultural background and even day-to-day health. Nervous or shy individuals or those from conservative or inhibited societies, extend this zone to maximums of as much as 1.5m (5ft) with regard to close body proximity for strangers and, in the case of eye contact alone, a zone of 3–4m (10–13 ft). More extrovert people, those from sunny, effusive cultures, or those who have accepted the professional needs of intrusion within this zone - actors, models or public figures, for example - can tolerate very close proximity of strangers or strange situations.

The nature of portraiture, especially in the studio, requires the photographer to fill the frame and emphasize the head, and with shy or nervous sitters it is sometimes difficult to come close enough. Much better results will be achieved by retiring outside the primary zone, or even outside the eye-contact zone, and placing lighting units as far away as possible. Long lenses are then essential. As the sitter relaxes and becomes more used to the strange situation, nervousness tends to disappear and it should then be possible to use shorter focal lengths but, of course, these may radically alter the sitter's appearance.

53 *A good portrait will require a main key light which illuminates most of the face, a fill light which opens up the shadows caused by the key light, an accent light or hair light to emphasize the colour or texture of the hair and a background light which separates the figure from the background and gives a more three-dimensional effect.*

54 *The psychological bubble: (a) relaxed or extrovert people allow close intrusion into the psychological bubble; (b) anxious or introverted people do not allow close intrusion within their much extended bubble. For these people, use a long lens and place the camera at a considerable distance from the subject.*

The ideal lenses for portraits are those of about twice the normal focal length (a 35mm camera needs 80–90mm lenses, a 6 × 6cm camera needs 120mm lenses and a 6 × 7cm requires 180mm), as these produce the least distortion in the features and allow the photographer to fill the frame with the head yet remain some distance from the subject. With uneasy sitters it may be necessary to use much longer focal lengths – up to four times that of normal – in order not to intrude physically into the personal zone of psychological insecurity. These long lenses will however alter the perspective of the features to a noticeable degree, sometimes with flattering results.

Glamorous lighting effects

Apart from the full use of a comprehensive lighting plan which controls the placement of the key light, the portrait photographer may identify two other principles in directing the lightfall: broad or short lighting. Broad lighting concentrates the main lighting force on the side of the face nearest the camera and will minimize skin texture to a considerable degree. Such lighting also may appear to add desirable weight and roundness to thin faces. Broad lighting can, of course, emphasize hair (or the lack of it) and ears, and it is often necessary to decrease light on this area of the face by the use of barn doors. Short lighting is the term given to a situation where the main light fall is directed to the side of the face which is furthest from the camera. This shrouds the near side of the face in shadow, concealing prob-

lems which may be found there, and heightens the sense of drama and unreality in the photograph. Such lighting can also accentuate texture and contour and suggests a reduction of the apparent weight of the facial structure, making round faces visually thinner.

To minimize texture and wrinkles or to produce a flatteringly soft light for feminine subjects, a diffused top front light is often used. Such a light is placed directly over the camera by the use of a boom stand (see figure 55a) and must be high enough to produce noticeable shadows under the contours of the face which project toward camera, but not so high that the eyes are left in pools of shadow. Such a light is excellent for portraiture because it allows a great variety of head movement and the diffused light is relatively comfortable for the subject's eyes. This light characteristically produces noticeable shadowing on the outside of the face and the planes of the cheekbones and in consequence can be extremely flattering to many faces. It is considered a little too glamorous for most male subjects.

An extreme variation of this 'glamour' light is axis lighting, usually delivered by a ring flash directly along the lens axis. This type of light has lately become fashionable amongst some editorial photographers and produces a more two-dimensional effect than other forms of lighting, flattening contours on the face and minimizing texture. Provided it is not over-exposed, a photograph using such a light can suggest a more graphic and vivid treatment for certain people. Using the axis light, the subject may be placed well away from the background which is then given separate strong lighting of its own to eliminate any cast shadows, thus producing a thin black line around the outside edges of the face. Using axis lighting, a portrait may also be taken with the head of the sitter touching the background and with no lighting other than the light along the lens axis (see figure 56). This produces an emphatic shadow on the background rather than face, which can be particularly interesting when using a coloured paper background. When using axis lighting it is better not to use glossy backgrounds, which tend to reflect the shape of the light source, and the photographer should be aware that the ring light will generally be seen in the sitter's eyes and can,

55a *A boom stand for the key light allows precise control of a 'glamour' light. This is particularly flattering to female subjects.*

55b *An example of the glamour light.*

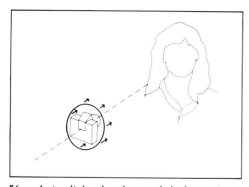

The importance of eyes

Eyes are extremely important in a portrait and must not be masked by deep shadows. This is usually avoided by placing the key light with care and adding sufficient fill light

56 *A ring light placed around the lens axis produces a distinctive, shadow-free lighting, not always suitable for portraiture, but very interesting for special effects and fashion photography.*

57 *An example of axis lighting, delivered along the lens axis by a ring flash (note the typical black line around contours and the dark shadow around the perimeter of the figure).*

to produce translucent, open shadows in that area. To give an added sense of liveliness to a portrait photograph it may be useful to add a 'catch' light solely for the eyes. This is a very low-power light, without reflector, placed near the lens axis line but slightly above and well behind the camera. The light from this bare lamp should not cast a noticeable additional shadow on the face but should be weak enough or far enough away only to create a pinprick of light in the eyes (see figure 58 for the arrangement). Eyes, of course, should always be the point of focus in portrait photography and must be critically sharp in order to create the illusion of life in the picture. Focus should be struck, if possible, on the pupil itself and refocusing should be carried out before each exposure, particularly if there is considerable volatility in the sitter's movements. For this purpose, an SLR camera is the best type of equipment to use.

Backgrounds

The illusion of depth or spatial dimension behind a sitter who is posed against a plain paper background can be a dynamic compositional factor in itself and is achieved by placing the subject as far as possible from the background and then arranging a discreet light which supports the main lighting on the subject but does not intrude as a separate element of its own in the picture. This is done by creating a delicate but noticeable transition of light behind the subject and over the background which is at its lightest where the subject is most deeply shadowed and at its darkest where the principal high-

59 *This picture demonstrates the classic arrangement of background lighting. Highlight in the background against shadow of the figure, shadow in the background against highlight in the figure.*

light is found on the subject. This transition in the background from light to dark in inverse proportion to the highlight shadow ratios in the portrait subject, creates drama, heightens the illusion of depth and dimension and increases separation between subject and background. Separation is the primary ingredient in all perception.

High- and low-key pictures

The studio portrait, either informal or otherwise, may be produced as a high- or low-key picture. The high-key photograph is light and airy with no distinct blacks and is much used for feminine subjects, especially if there is any association with the cosmetic industry. By dressing the subject in light clothing, posing against light, brilliantly lit backgrounds, and using broad, diffused key lights, high-key effects are easy to obtain.

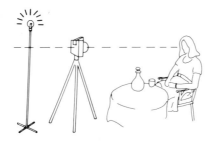

58 *To produce a 'catch' light for the impression of sparkling eyes, place a small lamp (60-100 watt), without a reflector, slightly above the camera and well behind the photographer.*

60 Right *This is a low-key portrait of a different style. Apart from the bright background, all the rest of the picture is in shadowed blacks and greys. Note that, even in shadow, subdued light has a definite direction and acts to draw contours and form.*

When working in black and white a 30 per cent over-exposure of the film and a 20 per cent under-development could improve the light, silvery-grey tones. For colour, a half-stop over-exposure may be needed, plus the addition of an 81 Kodak Wratten filter to warm the white areas. It is important to note, however, that, although the lighting has an open, diffused feeling, a definite direction should always be evident in high-key lighting. From a practical point of view, such lighting also permits a great deal of head and body movement in a subject without creating awkwardly controlled lighting problems.

The low-key portrait, on the other hand, is often used for masculine or theatrical portraits and masks the subject in dense black, with just a few brilliant highlights gleaming through as accents, plus a finely and tightly drawn key light used in the short position and carefully controlled by barn doors. This key light is usually very sculptural and is sometimes called a 'chisel light' for that reason. Texture and contour in the area of the key light are both greatly accentuated. A 50 per cent under-exposure of black and white film and an extended development of 25–75 per cent can improve the final print. For colour a third-stop reduction in exposure could be useful.

Conveying character

Although most subjects of the photographic portrait are probably hoping that there will be some degree of flattery in the result from the photographer or, at least, that the photographer will produce a visual which comes close to the mental image in the sitter's own mind, the photographer has a duty to his craft and his own impressions of the sitter to impose a singular visual concept on the final image. Naturally there must be some compromise in the direction of flattery in the case of many portrait subjects or there would be no sale or fee for the photographer, but it should not be carried too far. Editorial portraits should, uniquely, show an imperious, directorial concept which belongs to the photographer's own private vision of the subject and this is often only possible after

61 *An animated portrait is always to be preferred for editorial use, particularly where the subject's character is noted for volatility and expression.*

researching in depth the character of the sitter, having a preliminary interview with him or her and, possibly, an exploratory photographic session where different optics and lighting techniques may be tried out.

Although, in former times, the slowness of photographic emulsions required, as a matter of technique, that the sitter should strike and hold a pose, thus appearing rather static and stiff, the reverse is now true of most modern portraits. Using flashlight or brief exposures (1/15th to 1/25th second) to tungsten light or existing light which enters the shooting area, very lively and compelling photographs are possible. When the photographer is in full command of all technical matters and moves with confidence about the portrait area, the subject will be more relaxed and usually more volatile.

It could be that some subjects react better standing up; others if they are seated comfortably. Most will respond to conversation and questions from the photographer, particularly at the moment of exposure. A surprise question or a deliberately provocative remark often draws an impromptu response which, in the photograph, becomes a dynamic expression of the person's character. Always, the photographer should know enough about the subject and be genuinely interested in him or her, even if only for the duration of the session, so that active two-way conversations may take place throughout the sitting. While this communication is being achieved, however, the photographer must constantly be alert for the moment when an expression is interesting enough to be caught on film. The light must be watched and the sitter gently directed to reach the position where the light is ideal and the pose satisfies the photographic concept. The hands are an important element in such vivid portaits and should be observed or directed until they are felt to contribute the right element of character completion.

Head and shoulders

For single portraits of the head alone, considerable perspective control may be obtained by moving the camera very slightly up and down in relation to the sitter. For normal perspective of the head the lens should be 50 per cent longer than normal with the camera located at chin level. To widen a narrow chin, the camera should be

level with the bottom of the throat and pointed upward; to minimize a heavy jawline or double chin, the camera is positioned slightly above the sitter's eyes and pointed downward. These small movements make considerable differences in the final picture and, together with lens lengths and controlled key lighting with correct lighting ratios, much may be done to disguise physical problems or accent special attributes found in the sitter's face. At the beginning of any session with a new subject, it is wise for the photographer to look through the camera which is fitted with the lens most likely to be used throughout the session and observe what optical values are brought about by slight changes in camera position. By racking the camera up or down carefully on a tripod, by angling the camera this way or that, noticeable differences in the 'drawing' of the face will become obvious; during the following session, the photographer can give maximum concentration to these areas.

Lighting ratios
Lighting ratios in portraiture are very important in setting mood or character within the picture and if the final image is to be photo-mechanically reproduced they must be considered most carefully. For children,

female subjects and advertising photographs for the cosmetic industry, the highlight to shadow ratio is brought quite close together – 1:2, 1:3 or 1:4. For colour portraiture, it is generally in the region of 1:2 or 1:3 but, for dramatic effect or to conceal unwanted areas of the face, the ratio could rise to 1:5 upwards to 1:8. For highly theatrical results in black and white, the ratio could be 1:9 or even as much as 1:16. The strength of the fill light in relation to the key light controls the lighting ratio and, in this book, the highlight is given the symbol of 1. Thus the lighting ratio of 1:4 indicates that the shadow is four times darker than the highlight. Wherever the photograph is being offered for reproduction, for example in magazines or newspapers, lighting ratios may need to be altered. Expensive magazines can usually reproduce shadow detail very well but there will always be some loss, while newspapers and cheap magazines in high-volume production, may not handle shadows well at all. This means that the fill light must be overemphasized to increase shadow detail and, in many cases, to offset an inherent loss of contrast in photo-mechanical reproduction, prints must be made on a paper which is one grade higher than would be the normal choice for exhibition or room display.

Full body portraits
When working against plain paper-falls in the studio it may be of interest to add symbolic items in the background in order to suggest activities or achievements which are relative to the sitter. Surrealism may easily be introduced this way and the camera may be drawn back to include most or all of the subject's body. Once the full body is to be included in the picture, more complex lighting problems arise and directorial concepts must be arranged to include hands, feet and body attitudes. Sometimes the language of the whole body can convey character more effectively than mere facial expression, as many of the theatre's masters of mime and dance readily illustrate.

62 *Making a high-key vignette for colour portraits. A serrated hole is cut into an opal acrylic sheet about 1mm ($\frac{1}{16}$in.) thick and 15–20cm (6–8in.) square. An off-camera flash is fixed to skim the back of the sheet. The camera is brought very near to the acrylic and the photograph taken through the hole. The bright light will wash out all detail around the face. A lens hood is essential.*

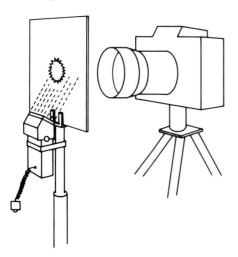

63 Right *A character actor provides rich material for the portrait or editorial photographer. Note the tonal quality of this photograph, induced by very careful control of lighting, exposure and processing.*

THE DOUBLE PORTRAIT

The double portrait lies somewhere between the normal portrait and the group and it offers a considerable challenge to the skills of the photographer. First comes the technical problem of lighting. As in all pictures, the key light must be dominant but each face must be equally presented in terms of compositional structure and strengths. Key light positions, therefore, should be chosen to illuminate each face with the same degree of lighting force. A side left or right or top left or right position are probably the easiest to begin with. With such key lights one sitter could be in profile, the other full-face to camera and so on.

In all double portraits the subjects must interact with each other – for example be linked by touching, by light or by expressive exchanges – yet, at the same time, they must be individually characterized to such a degree that each sitter can be strongly identified in his or her own right. It is surprising how much more difficult this is to achieve compared with the single portrait. A change in head or body position can make one of the sitters more dominant or more subjective, a shadow on the face of one can elevate visual importance in the other. Expressions will flicker between the two, and one face in total repose may lose its visual impact when compared to the volatility of the other. Focus points must be chosen carefully and sufficient depth of field must be employed to ensure that both heads are of equal sharpness. Gestures and body attitudes must be directed by the photographer to contribute the proper character value for each sitter and to fit into the graphic structure of the picture in a pleasing or dynamic way. Obviously, apart from certain depth of field problems, the close cropping of two heads may be the easiest as a beginning in double portraiture, but a far more satisfactory result is likely when the photographer's confidence and skill permits more of the body to be used.

ENVIRONMENTAL PORTRAITS

Whatever has been said so far about portraiture within the formalized environs of a studio, applies with equal relevance to portraiture in other indoor situations. Modern portraits, particularly when they are to be used editorially, are often set within the sitter's home or working environment or some-

64 *Lighting a double portrait is often very difficult as the lightfall must do equal justice to both faces. The photographer's control of the two subjects must also be precise and watchful as moments when two characters are in pictorial harmony are rare. This is from a colour transparency intended for magazine use.*

where which helps to define the character to be drawn and, while this naturally involves further technical complications which must be understood by the photographer, it can produce powerful emotive factors in the final image which are not present in the studio portrait.

Technical complications

Sitters will usually be much more at ease in locations which are familiar to them than in the strange limbo world of the studio, and this relaxation often offers better opportunities for striking pictures. On the other hand, the photographer can be decidedly ill-at-ease in these strange surroundings and, to offset this problem, it is always advisable, if possible, to visit the location at least once before the sitting takes place. During such reconnaissance visits, the photographer should

study the room through various lenses, measure the natural or existing light and note the direction of the light fall at particular times of day. If daylight entering the chosen room creates problems, it may be better to suggest a night-time shot when more lighting control would be possible. At this preliminary visit the photographer can locate power points, look for good view points for the final picture and perhaps get to know the potential sitter, if this has not already been done.

When assessing the value of the location in an environmental portrait it is well to consider the use of existing light as the main key light. This makes the setting appear with validity and authority and usually encourages a natural reaction from the subject of the photograph. If the key light (for example from a window) is of sufficient strength and character to provide the technical and aesthetic needs for the photograph, it is as well to use it, probably augmented by some additional fill light from bright reflectors or, if necessary, from photographic lights. If the portrait is in colour, care must be taken to balance the daylight with any additional lighting introduced by the photographer, and this is done by putting a large filter over the windows or filters over the photographic lamps. (See Chapter 3.) The easiest solution is probably to use flashlight to augment the natural daylight but this can sometimes produce coarse and synthetic lighting effects. The whole concept when working on location should be to achieve as much reality and believability in the light as possible. For technical explanations on colour problems, see also the chapter on Colour.

Where all of the interior is to be artificially lit and daylight is to be totally excluded, the normal room lights should be turned on and a careful assessment made of the light fall from these elements. The photographer's more powerful lights are then aimed to produce a similar pattern of light and the room fixtures are left burning during the photography. In some cases, normal household lamps are replaced by photographic lamps, which burn at much higher levels of light, or the 60- or 100-watt normal lamp might have to be replaced by something much less – for example a 15- or 7-watt pigmy lamp – to create very low light levels. This balancing of strengths and colour values of existing artificial lights when they are to be used in

conjunction with photographic light sources is an essential preliminary to the environmental portrait.

Any light source evident in the picture must appear natural, bearing in mind the lightfall elsewhere in the image, but should not be visually dominant or distracting to the eye. The sitter can be lit in such a way that it appears that light reaching the face eman-

65 *A typical result of using only natural light from a window and a large white reflector to lighten shadows; the print was made through a textured screen.*

ates from some noticeable light source in the picture and this, of course, makes the final image appear more reasonable and real. The photographer should always be extremely careful when using photo-floods and tungsten halogen lights in any interior situation as they do generate considerable heat, with consequent danger to soft furnishings or valuable woods and veneers. Where any such lights are to be used near open windows or in cold draughts, the reflector housing must be fitted with a wire safety screen as these lamps, under extremes of temperatures, can shatter.

Normally, for work on locations using ambient light, cameras should be loaded with film of a rating of 400ASA or more, and in the case of black and white film, a compensating developer could be used which doubles film speed but also lowers contrast, and this

66 *Here a small group has been lit by strong cross light from a tall window. A dramatic situation has been carefully developed under the photographer's direction to allow a vivid interaction between the subjects. Natural light with very little fill light is often the best for this type of editorial portrait.*

will always be found to be advantageous. Within naturally lit interiors, contrast is one of the main enemies of successful technique and, in black and white, over-exposure and under-development in the region of 20-30 per cent of normal could be advisable. Colour cannot be treated in this way, although high-speed films are normally lower in contrast anyway. Shadow areas in colour photography indoors should be augmented by reflectors and/or extra fill light from artificial sources. Exposures are best judged in these ambient light situations by a separate hand-held meter, rather than trusting to camera automation, but those cameras equipped with a memory hold on the metering system may be used with a good chance of success.

The human element

Once all the technical aspects are considered, only then should the sitter be put into position, if there is to be any degree of formality in the session. The social documentary or *vérité* type of photograph has, of course, to have a flow-through of action and should appear as observed activity rather than directed activity and this means that tech-

nical matters are solved as the session develops and lighting is mostly treated as found, with a minimum of augmentation. Do not forget to consider the obvious advantages of throwing light through partially opened doors so that it appears naturally in the area to be photographed. The doorway should always be included in the picture if this technique is used.

The structure of all location photographs should be as vivid and single-minded as those in the studio although there is a much greater temptation to be beguiled by the surroundings and give too much prominence to an interesting environment. Be aware at all times that the purpose of a portrait or group picture is to characterize the humanity before the lens and, although there may be evidence of interaction with the location, the subject must clearly dominate the entire visual concept.

Many location portraits are those of artists and writers and, editorially, it has become fashionable to prop the human subject helplessly up before the inanimate adjuncts of his or her claim to fame. To avoid such clichés, employ rich key lighting and create action and interaction by having the subject play through a natural activity which only at a sub-level involves examples of work from the past; reflect work, for example, into nearby mirrors; or include only small fragments; use high 'bird's-eye' camera viewpoints with the sitter's face upturned and evidence of work minimized, and so on. Far more interesting to most observers who see a famous face in home surroundings is what these surroundings disclose about the personality of the subject and how this environment relates to that of the viewers. A typically effective example for an artist's portrait could be where the subject is carrying a picture but is obviously disinterested in the camera, perhaps is hurrying past towards a pile of other canvasses. The head in this case would be very strongly identified, the body masked, the evidence of the style of work associated with the artist would be clearly seen, yet it would be a natural action within such a setting. Always look for these more dramatic highlights in the day-to-day activities of the portrait subject and turn them to advantage. All individuals react emotionally to their own environment and this must be suggested in a good location portrait.

THE GROUP

Photographing the group within an interior, whether it is a studio session or indoor location, exaggerates some of the logistical problems for the photographer and introduces complexities into lighting and direction which may require other compromises. Even a group of three people can rarely be lit by the tight definitive lighting plans used for single portraits or even those for two people. If the light is right for one or two individuals, it is usually wrong for the others; if several people in the group are alert and attentive, others may appear distant or dispirited.

The first requirement of group photography is to have sufficient light of sufficient strength to cover the whole group and any part of the environment necessary to the composition. This certainly will rarely come from a single light source and those lamps employed will generally need to be powerful and be housed in broad diffused reflectors.

Weddings

For formally arranged ceremonies, such as weddings, planning is the key to success, whether a professional or hobby assignment is being undertaken. First the wedding photographer should contact church authorities and permission should be obtained to work on church premises. Also matters of protocol and custom, such as the use of floodlight or flash during the ceremony itself can be cleared at this time. During the first visit, measurements can be made of lighting strength from windows or interior light fittings and power points may be located if floodlight is to be used. A full discussion is then needed with bride and groom to establish precisely their photographic requirements and some idea of their preferences in the way the images are presented can be settled at the same time. Fees must be agreed at this meeting also.

A written list is then made, scheduling itinerary times for all personalities and essential groups to be photographed, and technical details may also be entered on it, showing lens lengths, exposure details, camera viewpoints, and so on. Equipment must be checked, spare lamps provided, flash synchronization tested, because technical failure during wedding photography is the one thing which is never forgiven either the photo-

graphic guest or the visiting professional.

Activities which could be included on the shooting list for the wedding day might be: documentary pictures of the bride and bridesmaids as they prepare for the ceremony; pictures of the bride's father; the groom and friends; the arrival of the bride at the church; the groom waiting in the church; the ceremony itself; giving of the ring; signing the register; long shot of the church interior; the congregation; the couple leaving the church; the reception; cutting the cake; leaving for the honeymoon and so on.

All weddings are very personal occasions, all are very differently conducted, but the documentary-type picture is always of tremendous interest. A very fast tungsten film for all interior work, for example 1000ASA and an automated SLR which is equipped with a battery video floodlight on the camera body, is an ideal combination. With such film, church windows will burn out white or blue and more elaborate set-ups are required if this result is thought undesirable. Zoom lenses are particularly useful for weddings and long focal lengths are the most suitable for most occasions.

To record properly a large church window and the events inside the church, a daylight flash of considerable strength is needed to augment the light in the church interior. This should be of professional type, at least 2000 watt/seconds in power, and should be used as a direct light in bright reflectors. First an exposure reading is made of the window, and the shutter speed and aperture combination set for this, using for the shutter speed, the highest flash synchronizing speed which is permitted on the camera. A 400ASA speed film is ideal. The flash exposure must be of sufficient strength to suit the lens aperture which has been chosen for the window exposure. This means using a guide number (GN) for calculation (see Chapter 2). Large, professional, mains-supply flash units may be hired from most professional photo stores on a daily basis.

For more formal pictures of the wedding party it is best to work in a big room with fast tungsten film and with floodlights in reflectors. If enough daylight is entering the shooting space, use 400ASA daylight film which may be augmented by multiple flash units off-camera. Large wedding groups need as much top light as possible, with a soft but strong light coming from both sides of the camera. Normal or wide angle lenses are needed and a tripod is advisable. A good photographer will look for romantic backgrounds for the couple, may introduce hazy diffusion in some (but not all) close-ups by using a 'centre-clear' diffusion filter or may make complex montage pictures with the aid of a matte box. Much of the general information given about taking location photographs in large interiors is also applicable to wedding photography.

Other groups

The wrap-around light is probably the most useful for photographing large groups even though there is a danger that such a lighting plan is rather bland and does not necessarily make a good photographic statement. Open, wrap-around light, probably biased a little towards being a top light, allows a great deal of movement within the group without creating shadow problems or under lighting in any part of the composition. For groups of children who are always on the move, it becomes an essential.

Where no formality is needed in the result, a party atmosphere is a good means of welding together cohesive and believable action. The photographer probably requires some help in this kind of session in order to change lighting rapidly as action flows around the shooting area, or the action could be centred around a large table. If this party activity takes place in an indoor location, make certain that lighting units are safely placed, all cords secured and out of any walkways, and that any overhead lighting is particularly safe. Lighting units above groups should always carry a safety chain to prevent accidents and all naked lamps must have wire safety screens.

Where the group is to have any formal arrangements such as in those pictures of boards of directors, wedding groups, sports groups and so on, tighter lighting may be possible but it still may conform basically to the wrap-around style. With such groups it

67 Opposite: *An example of group photography for advertising purposes. Note that all subjects are interacting with each other, yet the group itself is cohesive. Lighting is such that each subject maintains his or her own character.*

is vital to have a premeditated plan and complete all lighting and technical matters before the group is put together or even enters the studio or indoor location. Such groups, especially if comprised of a large number of people, are usually difficult to get together in the first place and most members would rather be somewhere else in any case. The least popular person in the whole situation is likely to be the photographer, and consequently the session can deteriorate very rapidly into disaster unless the photographer acts with authority and professional confidence. Do not keep such groups waiting long before exposures commence and save some high point to produce a reaction which can be caught on film. Some photographers use a close-circuit television set or video recorder to entertain and divert large groups and this could be located under the camera. Once exposures begin, it may be only five to ten minutes before group patience is beginning to falter, so quick and accurate work is demanded of the photographer. On large formal groups always use at least two cameras as there can be no room for failure and such groups may never be persuaded to assemble again.

With all indoor pictures of people, especially where more than one person is the subject, it is of great advantage to put the camera on a tripod and also to use an ultra-long cable release. This frees the photographer from the alarming association with the camera machine, which makes most sitters nervous, and it puts the whole session on to a friendlier and more relaxed basis. Even where very volatile situations are being photographed the tripod can easily be used and allows infinitely more control of the composition than when the camera is hand-held.

All expressions of course help to draw the character of the subjects but, as a general rule, groups larger than five people should be directed towards a happy and extrovert expression. Large groups with sombre expressions can be very visually depressing with consequent lack of approval from the commissioning source. On the other hand, single portraits and smaller groups often are lacking in creative character when frozen into permanent smiles and a deeper, more subjective reaction should be sought. This all comes from constant oral contact between photographer and subject and a degree of informality in the whole session.

Never over-direct the nervous or unskilled person in front of the camera and even with very experienced professional actors and models, explain the concept of the picture carefully and allow them to work in their own way towards an effective result. Remember too, that the camera gives us the opportunity to take from the infinity of time a tiny slice and hold that moment forever. Such moments are always more memorable if they appear lively, vivid and natural, yet manage to convey that there has been a meeting point during the photographic event of the minds of both subject and photographer.

5 Large Interiors

ARCHITECTURAL INTERIORS

It has been said that interiors of buildings are merely containers. For those wishing to make professional, architecturally important images indoors it is worth bearing this in mind. The container must be seen in terms of volume and structure and yet, at the same time, its function must clearly be suggested by the picture. But an interior is much more, particularly when it has been designed with sensitivity, ingenuity and architectural skill. The structure itself will disclose pattern and decoration while glimpses will be seen of its environmental setting wherever its walls are punctured by doorway exits and window viewpoints.

The volume, which the building skin encloses, must be given its correct dimension.

The spaces which lead into and away from each other within the building must be given depth and the illusion of reality. The whole photograph must suggest the intangibility, ambience and style which was the architect's or designer's intention, and the picture should clearly state the interior's function. Decorative surface, motifs and textures must be seen clearly; larger contours must interject their forms into aerial volumes; the geometry of the containing structure, whether it is a cube, rectangle, tetrahedron, cylinder, pyramid or other form, should be seen or assumed.

This may all seem something of a tall order but, by adopting a careful routine and a planned approach to the problem, by taking things step by step, many memorable photographs can be obtained.

The brief

The first step is usually the initial contact with the commissioning client in order to establish the purpose of the photographs and the function of the subject. If the photographer is on his own commission because of a primary interest as architect, designer or writer he will still need to be clear about these points. Photographs of interiors fall into two main categories: they are either recording images which disclose information, or they are illustrations which hint at inscru-

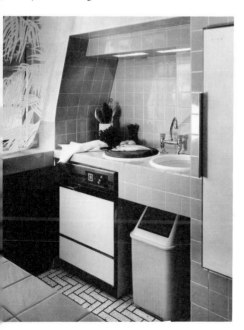

68 *This is a typical interior architectural photograph, which will be required frequently on assignments. Textures are here well reproduced, volume is clearly suggested and details are all evident. The geometry of the shot has been well controlled, by the use of a large-format camera with swings and shifts.*

table and impalpable attributes of the internal spaces: atmosphere, style, history and human aspiration. The 'briefing' (the outline of the needs of the commissioning agent) should indicate which approach is needed, should give a detailed background to the whole project and should be compiled finally as a clearly written understanding of the project. It is vital that any major architectural photography begins with this written brief which is then approved by all parties concerned and is usually accompanied by a costing for the job and a schedule of work to be done. When the photographer is working on a fee basis for location work in interiors, it is important that this fee should reflect the number of research site visits, the transport costs and the abortive visits which may follow any lack of preparation at the site or other adverse conditions which prevent photography.

Once the commission is established and fees, expenses and deadlines agreed, also in writing, the photographer must move on to understanding the designer's motivations and intentions in creating the interior. This will either come from contact with the architect or designer connected to the project, or from library research, or from studying

editorial material already available, particularly if it is found in a knowledgeable architectural magazine which includes pictorial coverage.

It should perhaps be noted, in passing, that the success of architectural photography, especially that of interiors, while obviously requiring a sound technique, depends far more on a complete understanding of the subject matter. Without this understanding and this submission to the creative intentions of the originator of the building, outstanding photographs in this field cannot be made. Any photographer who wishes to do much of this kind of work should undertake at least an appreciation course on architecture or even consider completing some formal study towards becoming an architect. Every opportunity should be taken to mix with architects, designers and editorial writers on the subject, talking *and* listening to them.

Researching the subject

After the written brief, it is absolutely necessary, unless the photographs are to be of the humblest kind of informational evidence, to visit the site at least once before photography is due to commence. During the visit, the

69 *When photographing a room by photographic floodlights, it is as well to follow the natural scheme of things to be found at the site, and merely augment existing lightfalls.*

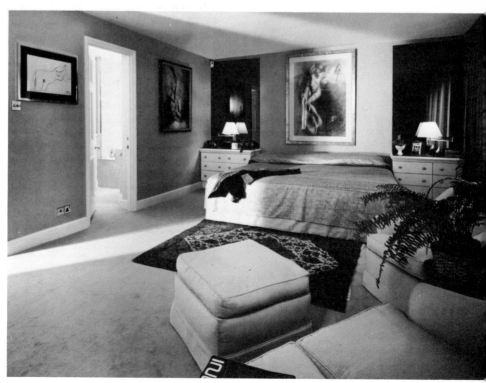

1 *A still life of rich textures and colours, based on an Arabic theme.*

2 *A very different and atmospheric still life, using mixed colours in
the lighting to enhance the intimacy of the setting. The figure was
allowed to blur to minimize attention on the human element.*

3 *Children should be photographed in warm, open lighting, preferably from diffused flash, as in this case. Action is provided by the use of an ice-cream, but to photograph the moment of greatest enjoyment, as pictured here, very careful timing was necessary.*

4 *A 35mm camera is by far the best for such moody and atmospheric lighting, which though sufficient for the metal club, has been allowed to drop away on the model.*

The best golf clubs in the world.

5 *An elegant town house dining room, lit with open spot lights. Very careful attention has been paid to setting up the room for photography.*

6 *This photograph was taken on 35mm film, balanced for 3200K tungsten light. The only source of light was from existing kitchen lights, but the fluorescent fittings were extinguished in order to increase mood and ambience.*

7 *Another type of action altogether, shot on 35mm film, in natural light. Observation of this extremely fast action must be acute, and timing absolutely precise as regards the moment of exposure. A shutter speed of 1/60th second allowed other action to blur, adding to the effect.*

8 *35mm cameras are ideal for such pictures as these. Note the warm and cosy light from coloured filters and the accent light along the shoulders of the man, which helps separate the figures from the background.*

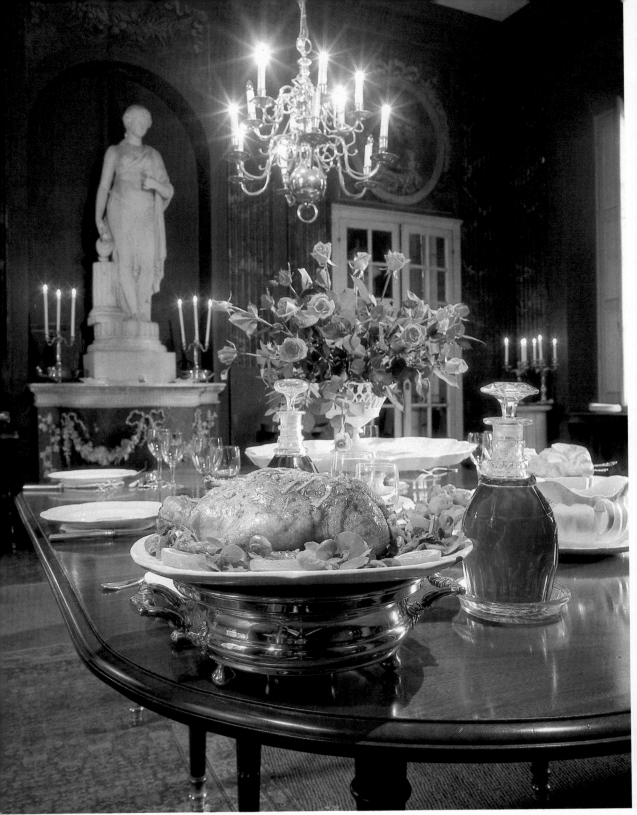

9 *This interior of the main salon of an historic chateau near Bordeaux was photographed by a mixture of daylight, flashlight and floodlight. Tungsten film, balanced for 3200K, was used.*

interior will disclose its practical details and perhaps some of the problems which the photographer will face. It is possible to analyse the textures, patterns, physical contrasts, spatial volumes, colour, decoration and, most importantly, the ambient light.

The lightfall within the building is, inherently, a major factor of design and will have been considered in depth by the architect. The addition of artificial lighting fixtures will reinforce the ambient light in the daytime and will replace it when dusk falls. The photographer should consider that the illumination of the interior for its practical use provides the keynote to its illumination for photographic purposes, and it is only necessary to augment this existing light and, if working in colour, balance the various kinds of light in terms of colour temperature and the colour compatibility of the chosen film.

It is advisable to have a floor plan of the interior; not necessarily a highly detailed one, but one which shows doors, windows, stairs, power points, and so on. This can easily be drawn by the architect's office or by the photographer himself from the extremely complex plans which guide the builders. On such a plan, which should be reduced if possible to A4 size, camera viewpoints and lens angles could be noted. During this first walk through the interior, the photographer should take a hand-held camera and try various lenses and angles, note any detailed close-ups and possibly take some photographic reference on ultra high-speed film. All of these findings are noted on the floor plan with comments to guide the taking of the photographs, perhaps even to the point of making notes on exposure and times of day when lightfalls are ideal.

Once this on-site research is completed the photographer may need a further consultation with the commissioning client, taking to this meeting the notated floor plan, any reference photographs and the original written brief. After discussion this brief may need to be amended and, if so, it should, once again, be approved by the client and perhaps revised fees agreed.

The photographer will then make up a written schedule including viewpoints, timing, progression of shots, equipment list, special needs, and a name and telephone number so as to be able quickly to reach the office or site manager or the principal site contact. This is a private guide for the photographer and is not shown to the client. This schedule also becomes the work order, detailing all planned costs and any extras which may not have been predetermined.

Equipment

The occasional photographer of interiors may not want to be faced with the fact, but a 35mm format is far from ideal for such a job. Good architectural images depend on good architectural geometry being faithfully reproduced on a large negative and, although there is room for the subjective 'look-up' wide angle view of certain details, such as atriums, it is very difficult accurately to level the small camera and get perfect horizontals or verticals for normal work when using such a tiny viewfinder. Faced with the need, if a

TWELVE PRECEPTS TO AID SUCCESSFUL PHOTOGRAPHY OF ARCHITECTURAL INTERIORS

1 Discuss the brief in detail with the client.
2 Visit the site at different times of the day and study the strength, quality and direction of the light.
3 Decide on what augmentation of the light is needed.
4 Note the colour temperature of lights within the picture area and make suitable calculations.
5 Give the client a written brief of your findings.
6 Agree the fees in writing before commencing photography.
7 On the day of work be early at the site.
8 Use only fresh film, fully tested.
9 Make Polaroid tests of lightfalls.
10 Introduce live models to give scale.
11 Be ready to photograph the ideal moment when natural lightfalls show the interior at its best.
12 Process results immediately.

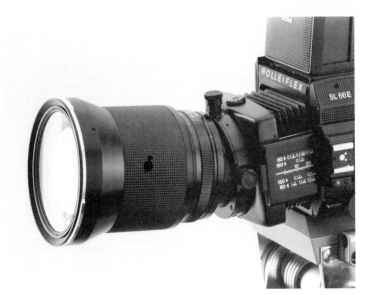

71 *A Rollei SL66E 6 × 6cm camera, fitted with an integral Scheimpflug front and a sophisticated ball joint lens, which is an extremely useful combination for interior architectural photography. (Courtesy Rollei Fototechnic).*

35mm format is all that is available, it should be an SLR, and should be placed on a tripod and levelled with a small spirit-level. To include the high rise or ceiling of an interior, the camera must not be tilted up. Fit a wide angle lens and crop out the empty foreground in the final print.

Most photographers of interiors will also need a fixed body, medium format camera, such as Rollei, Hasselblad, Bronica or Pentax. The Rollei SL66E is particularly suited to such work, having a built-in bellows extension and reversible normal lens for ultra close-ups of elements of design and structure, interchangeable lens systems and a tilting lens panel to take advantage of the Scheimpflug Principle which helps to increase depths of field (see figure 72). If such a camera is also fitted with a 55mm perspective control lens, such as that produced by Schneider of Germany, which allows vertical and horizontal movement of the lens as well as the tilting device built into the camera, the whole becomes a very flexible and portable architectural camera. The addition of the normal Polaroid instant film facility completes the specifications of what could become a perfect support camera for site work. Other specialist cameras, such as the wide angle Linhof or the Widelux type of panorama camera, may occasionally be needed, but it is far better to rent these from professional photographic hire companies when needed.

By far the most valued camera for all architectural work, especially interiors, is the view camera – in formats of 9 × 12cm (4 × 5in.) or larger. Such cameras have total flexibility of lens and film panels including swings, tilts and rises. These cameras are easily fitted with large format Polaroid adaptors, reduction backs to take 120 roll film,

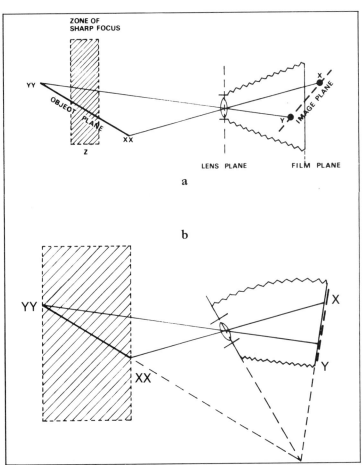

72 *The Scheimpflug principle: (a) The uncorrected, fixed-body camera cannot obtain coincidence of image plane XY with object plane XX to YY, and the zone of sharp focus Z is very shallow; (b) when the lens plane is tilted to be more nearly parallel with the object plane, angles will coincide, bringing objects, image and film planes into sharpest focus. Zone of sharp focus is substantially increased to take in all of YY to XX.*

filters, lens hoods and interchangeable lenses. By tilting the front lens panel toward the plane of chosen focus, bringing the front of the camera more nearly parallel to that plane, depth of field is greatly increased, even at wide apertures. By tilting the back of the camera towards or away from a vertical or horizontal plane of interest in the subject, perspective is either exaggerated or normalized. By using these two facilities together, beautifully sharp details and perfect geometry are assured. The lens chosen should be the *longest* possible, taking into account available space for the camera and the area which must be included in the picture. In practice, in normal sized interiors, it will be a normal lens with an angle of acceptance of about 40° or a moderate wide angle of 65–70° acceptance. The ultra-wide angles are difficult to use because of the barrel distortion sometimes inherent in the lens design and the consequent destruction of straight line rendering.

A vital piece of equipment in such work is the tripod and this should be capable of low-level work below 1m (40in.) and have a high rise facility to lift the camera to a height of at least 2m but preferably 3m (6½–10ft). Such tripods are expensive, costing almost as much as a basic professional camera body, but are essential. They should be rigid enough to hold the largest camera needed at any height without undue vibration and be equipped with a universal tilting head which is strong enough to hold a heavy camera and lens without sagging.

Working in interiors with such equipment is far easier if a wheeled trolley is found to carry it. Building maintenance departments can usually lend such things or a busy interior photographer may prefer to buy the folding type and take it to each location.

Once on site the photographer, following his schedule, sets up camera, tripod and the chosen lens. The camera is then levelled both horizontally and vertically, using a spirit level and all swings, tilts and rises are placed in correct zero position. The final shot is lined up in the viewfinder and all optical problems resolved, all movements, swings, tilts operated as needed and the final camera locked in every direction.

Lighting

At this point, lighting and exposure are tested and for important photographs this could take some hours. If daylight or sunlight is entering the interior and is being used as key light, the photographer must be in place sufficiently early to complete all setting up and tests well before the estimated ideal moment arrives when the natural light is making most contribution to the picture. It will no doubt be necessary to supplement the existing light and this could be done with room fixtures or from photographic lights brought in for the purpose. The fall of light from these additional light sources should only augment the existing daylight while maintaining the mood, merely increasing the luminosity of the shadows or defining details which would appear otherwise underlit.

When working with black and white it is relatively unimportant if it becomes necessary to mix light sources of different colours such as daylight, fluorescent or photographic, the major problem then being to obtain compatibility of character of the different types of light. However, when colour film is being used, it is a much more complex affair, as all light sources should be brought to the same colour temperature as that required for the chosen film type. Fluorescent light is especially hard to control with regard to colour balance and this is explained in the section on colour control (see p. 45).

When daylight is abundant and is the key light, load with daylight colour film (5000–5500K), turn on all fluorescents and other built-in fixtures and add daylight blue flash or floodlight which has been filtered to daylight colour. Where daylight is not suitable for the key light, make the photograph near to dusk, say just after sunset, using Type B film for tungsten light which is balanced for 3200K. Details of filtration, contrast control, and colour balancing are discussed in depth in Chapter 3.

Viewpoints for the camera which have been previously decided upon must take into account the available space for placing the camera and the operator and take note of the lighting possibilities, but must attempt also to suggest the volume and spatial values to be found in the interior. This means that it is usual to include more than one wall. A single-plane composition is never revealing of a physical dimension and may only be acceptable for a concentration of detail or surface decor.

73 *Always select a viewpoint with two or three walls for extra illusion of depth.*

Two, or preferably three, planes should define the space. For example, two walls and a ceiling or one wall, ceiling and floor. While the single surface may hint at the skin of the building, the multiple planes reveal the structure and volume and are far more interesting. If these planes include windows, skylights, doorways or views into connected space, so much the better, and such openings may provide ideal points to add light. A strong floodlight or flashlight hidden outside a partially open door which is itself seen in the image area, can be a most natural way to introduce an emphatic accent and to suggest mood.

Composition

By the time the photographer has been at least twice in contact with his subject, first for research and then the actual photography, dominant physical factors in the interior will become evident and the hidden psychological aspects will also present themselves. These are the keys to making outstanding photographs of architectural interiors. What is the functional space? How is it used? By whom? What is the traffic pattern the colour forms? And so on. Does the building look out on an interesting environment or is it lived and worked in as a private, internal world? What does it feel like to be there?

It may be that, in order to suggest scale, a human figure or figures will be needed and, if so, these must be dressed correctly for the building's function. They should be alerted and cued to be available at precisely the time the written schedule indicates, otherwise, particularly if daylight is a major factor in the lighting, ideal moments may be missed. Where the activity of the space is an essential part of the brief and must clearly be seen, the human subjects must not be allowed to dominate the architectural values. Lighting should discriminate against them, colours in clothing be played down and, in some cases, deliberate blur of the action can be used. For example, where a walking figure must be blurred yet seen in terms of scale, shutter exposures will probably need to be between $\frac{1}{4}$ and 1/15th second. Remember, too, if a flash fill is used or is the key light, that these fire at speeds which stop most movements, so a deliberately attempted blur could turn out to show a sharp edge.

For all photography of interiors it is important that the whole space appears well maintained and cared for. The photographer may need to 'dress' the subject area with fresh flowers, extra drapes or cushions, more or less furniture, throw down rugs or add light fittings. It may be necessary to have

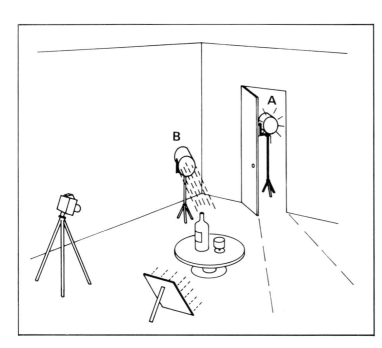

74 *Scaling of interiors can be suggested by the inclusion of small objects or a still life arrangement in the foreground. A flood or flash beamed into the picture area from behind a half-open door can be a suitable way of creating a natural lightfall of extra brightness. This increases the three-dimensional effect in the background.*

75 *In this photograph of a very complex glass screen, scale is suggested by the shadowy blurred figure, deliberately photographed at a slow shutter speed.*

repainting carried out or other basic maintenance. This must all, of course, be agreed with the client, but is worth the trouble and expense, particularly if any publicity or advertising use is to be made of the picture.

Large interiors

Very large interiors call upon the photographer to provide huge amounts of light and these can rarely come from electronic flashlights, due to their weight and size in comparison to their light output. The old-fashioned, expendable flashlight comes into its own on these occasions, either with a daylight blue or Type B colour balance. The

> **Safety note:** Never use camera sync. leads directly connected to any circuit of expendable flashlamps which is being fired by household current. These camera leads are not built for such voltages and short circuits in the shutter mechanism could cause fatalities. Camera shutters should only be used with low-power, DC *battery*-powered circuits or those modified by professional flash generators.

only reliable way to use these is to fit standard, spun-aluminium reflectors with screw-based photo-floods and construct the necessary lighting plan. After this is perfected and the lightfall is accurately understood, mains leads are removed and battery leads and batteries plugged into the equipment. The AC photographic lamps are replaced with expendable flashlamps and a DC battery circuit is connected to the camera shutter by the standard sync. cable.

Estimating exposure with multiple units of expendable flash is not easy even when guide numbers are known. Final accuracy is possible only when a Polaroid test is run first. Obviously this costs at least one set of flashlamps, but subsequently only two or four sheets of film will be needed for the final camera image.

For extremely cavernous interiors, such as auditoriums and theatres, where flash is needed, the British firm Bowens Limited, London (see List of Suppliers), make an ingenious multi-flash reflector called the 'Blaster' (see figure 7, p. 77). This allows enormous amounts of light from four expendable flashlamps either to be directed from high rise stands or to be hand-held and either synchronized to the camera or used as an

open flash technique. Polaroid tests are necessary in this case also.

Where the interior is dimly lit and does not include windows to the outside or photography takes place at night, the shutter may be locked open in a 'T' setting and, provided that neither the lamp unit nor the photographer is in the picture area, the photographer may walk around aiming the Blaster as needed, firing successive lamps, or all four together. The camera must, of course, be securely fixed to a tripod.

The above technique is much more cheaply achieved by the use of a single tungsten halogen floodlamp, hand-held and preferably battery-driven. Video floods are ideal and the Multiblitz Profilite fitted with a ni-cad battery pack is even more useful, as either daylight flash or Type B flood may be used, depending on the colour temperature needed. The camera must be secured to a tripod. Using a single-source lamp, the light is slowly washed over the areas needing exposure while the shutter is left open on the 'T' setting. All other lights must be extinguished and any daylight excluded by black-out curtains (on the outside of the windows). Polaroid tests are again advisable. The light must be thrown in slightly overlapping patterns and be kept moving. The degree of overlap depends on the fall of light from the reflector at its edges. If a fairly bright hot-spot is evident in the reflector pattern, more overlap is called for, or perhaps diffusion. Where the light is even or diffused, edges only need to overlap slightly. The photographer should not be in the shot during actual exposure, but, in order to reach new lighting points, the lamp may be turned off and the photographer can then move into the picture area without any need for the shutter to be closed. No one passing through the picture area should remain even momentarily still or they will record, while lamps moving in the same picture area will show as trails of light.

Hand-held electronic flash can also be used to paint with light, particularly to highlight specific details of any interior. Once an accurate guide number is known, the camera is opened on the 'T' setting or, if synchronizing is needed, it can be done by multiexposures on the same piece of film. The flash is then directed from outside the picture area or hidden out of sight behind furniture or the building structure, while light is thrown into previously planned areas. The light accumulates in one area if needed to build up shadows, or washes across large unlit areas by the use of overlapping flash exposures.

STUDIO SETS

In professional photography it is quite commonplace to use a constructed interior or room set, particularly where people or products are involved, or where any special effects are essential to the picture. This is generally built in a large studio or on a television or film stage. Here, so much more control is possible, especially in terms of light and colour balance but as the set is for practical purposes a real interior, even if only a temporary structure, it must be given a surface decor and be 'propped' (equipped with items which would be found in such a place) in great detail. Much of the early part of this chapter still applies to the studio room setting, particularly as regards the illustration of volume and the control of geometric perspective. Where this exercise differs from the genuine interior on location is that anything and everything can be made to suit the photographic need. Walls can be angled slightly, ceilings lowered, floors raised and windows put in ideal positions. The photographer usually works with a set designer or model-maker on these occasions and, apart from giving precise details of camera position, lens angle and lighting, will often contribute to the aesthetic management of the entire set.

Lighting the constructed set is usually much easier than doing the same job on location, as heavy-duty, professional lighting of the right colour balance is available in most studios. Attention must, of course, be paid to rendering textures and surfaces and a particular effort must be made to create a believable lighting mood which avoids the stark overlit studio look most often caused by an over-abundance of readily available

76 *A typical shop interior photographed through a large window. Care must be taken to avoid reflections in these street windows and this is often done by raising a very large black cloth behind the photographer to eliminate street lights and those from passing cars.*

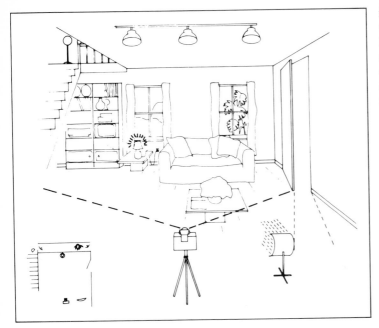

77 *A typical arrangement for lighting a built-up studio set; note the top lights, the small table lamp, the well lit scenes through the windows and the lightfall from a special light placed at the head of the stairs, which is situated out of camera range. General fill light usually comes from beside the camera.*

iage, flowers or trees are placed, then the whole scene is lit to resemble natural light. It is, of course, vital that no shadows are cast on the backdrop itself. Further refinements could be made by partially opening the window and using a wind machine or powerful fan to make curtains blow into the room. Such action elements add reality and credibility to the constructed interior. When planning the construction of an interior in a studio, the photographer must take note of the studio hire costs which accrue during the building and standing time and the set strike time, together with transport costs of all products and props. Models should be hired to be on the set only when needed, plus reasonable time for dressing and make-up. On many such occasions this might, ideally, be about three in the afternoon but starting so late may run the session into expensive overtime. A shot with five models is not uncommon with family scenes and, with a 200 per cent increase for overtime after a certain hour, extra charges can be very heavy.

Physical hazards on these built-up sets can be numerous, especially if fireplaces are lit, gas appliances are burning or special effects involving any open flame are being used. Always make certain that full fire protection is immediately to hand, including CO_2 extinguishers and fire blankets and that qualified safety personnel are brought in to supervise all unusual props or activities. In most countries, laws governing working areas such as photographic studios place liability on the photographer if any accident takes place. This usually includes damages due to disability and loss of earnings. It is important, therefore, that insurance cover is obtained against such eventualities. Where location work is undertaken the liability for most problems may pass to the owner of the site, but this should be checked before bringing models and assistants to the scene.

light. Dominant key lights should be established, and generous fill lights with sharp accents should support them.

Where people are included as models in such sets, lighting must take note of this and be so arranged not only to suggest the environment accurately but also to allow the models to carry out their required task. Lighting fixtures seen in the picture area are often fitted with photographic lamps, such as photo-floods, and windows are especially important.

One convincing way to suggest that the interior is real is to imply that it belongs to an identifiable place and the glimpse of a suitable scene through a window is then most effective. Such windows must be given complete fittings, including glass, and in all respects *be* windows, complete with blinds and drapes and with a full set of hardware. Some distance behind the window a backdrop is arranged, perhaps of a simple blue sky, but usually a projected transparency or large photographic print which precisely recalls the correct setting for the inhabitants or the products to be found in the interior. Between the backdrop and the window wall, real fol-

INDUSTRIAL INTERIORS
When the interior is an industrial one, it will be advisable for the photographer to begin setting up such work along the same lines as the architectural photographer.

Equipment
Much the same equipment will be needed as for architectural photography – a medium

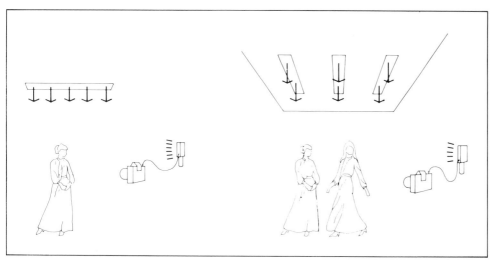

78 *When using fluorescent light as an ambient light it is possible to obtain a good effect by bringing the figure forward into a shadowed area, perhaps by turning off any overhead lights near the camera. The figure is then lit separately by diffused flash, while* *using a shutter speed slow enough to record the lightfall from the fluorescents. If the camera is placed so that overhead fluorescents are over both camera and subject, as in the second diagram, a very close approximation to daylight quality light will be achieved.*

format camera, for example, but, in this case, it might be better to switch to the automatic Rollei 6006, which is totally electronic and can be remotely controlled but may still be fitted with the Schneider perspective control lens, plus some long focal lengths, such as 150mm and 250mm, but the 35mm SLR is also much more useful for industrial work than it is for highly controlled architectural photography. Both these fixed-bodied cameras can catch action moments in the industrial process which are essential to telling an interesting story and can provide support camera facilities for large formats. However, many of the best industrial photographers still rely on the large format view camera and a battery of lenses and accessories.

Lighting

Lighting in most industrial areas is usually at a high level and is certainly enough for the ultra-speed 1000ASA films used in small cameras, but the character of such lighting is usually very even in order to minimize eye strain on the part of the operators of machinery and is almost always fluorescent. This can create bland, unappetizing light for the photographer. Fluorescent lighting may be used in these circumstances as the key light but a soft fill-in from somewhere near the lens axis may be needed and this can be supplied by a diffused or bounce light from a low-power flash which is synchronized to suit the exposures for the fluorescent fixtures. To explain this technique of working with fluorescent and flash in some detail, the following may be of interest. First load the camera with 400–1000ASA film, use a small flash unit off the camera and diffuse it by attaching a handkerchief tissue over the lamp-head (probably a single thickness is enough). Calculate the exposure needed for the fluorescent light, for example 1/30th second at f5.6. Divide the flash guide number (GN) by the aperture setting but, instead of f5.6, use as a divisor one full stop under – i.e. f8, in order to under-expose the flash fill-in. The paper tissue will take it down a further half to one stop so that the fill is almost two stops under the level of the key light exposure from the fluorescent. If the flash guide number is for example 50, 5–6m (15–20ft) would be a suitable distance for the fill-in flash. If colour film is being used a filter starter pack from the table 'Fluorescent filter guide' (see p. 45), should be made up and placed on the camera, and a suitable filter added to the flash-head as well. The flash filter when using tungsten colour film might possibly be an 85B, for example, while for daylight film balanced for 5500K, a small electronic flash would probably need an 81C

filter over the lamp-head, but for critical work full camera and processing tests should be completed. If much work of this kind is needed a really tiny, low-power diffused flash on camera is all that would be needed and should be bought just for work involving top-lighting with fluorescents.

For industrial photography, especially when working in heavy industry, very powerful lights are often needed. Tungsten halogen floods, film lights, arc lights and flashlights generating 6–10,000 watt seconds should be considered. Even with depth of field improvements from camera and lens tilts, apertures need to be reasonably small, and factory interiors soak up enormous quantities of light and are perhaps more cavernous than any other type of interior. Unlike architectural interiors, it is rarely possible to use light cumulatively by adding successive exposures or by washing large areas with light, as most industrial subjects have inherent action, however ponderous this may be in some cases.

Those who illustrate industrial subjects rarely use existing light in the manner of other interior photographers but will normally set up their own powerful lights which are almost always directly reflected from concentrated beam reflectors and never diffused. Even fill light is sometimes not possible and much of the finesse of lighting is passed over in favour of a theatrical or dramatic result. Very fast films are often needed and grain is rarely an inhibiting factor in the judgement of industrial clients. Obviously, sufficient light is needed clearly to see all the details in the subject or actions which are required by the client.

Preparation

Beginning somewhat in the same manner as does an architectural photographer the industrial photographer will need to arrange several detailed briefing sessions or discussions with the commissioning client (from whom should come a written brief agreed by all parties), plus an equipment list and a carefully timed shooting schedule. This schedule must be agreed by the factory liaison contact and must be strictly followed. Any major action listed will need pre-arrangement with both workers and management, and time on these occasions is of the essence. The photographer must be in place,

all lighting plans completed, and be waiting for the action to commence before the time given on the schedule. The action will not generally await the photographer.

Safety is a priority in industrial photography. All those concerned must wear full protective equipment where needed, with particular care being taken of the eyes and head. No member of the team or any equipment should be placed at risk and the photographer should assume a serious responsibility for seeing that this is so. All cabling to lights, all light stands, ladders, tripods, and so on, must be carefully placed for safety but also must not in any way interrupt the flow of industrial work. The photographic team are guests in the plant, and not always especially welcome, and should act accordingly. The timed shooting schedule, it must be stressed, should be followed precisely as agreed.

Most industrial sites are equipped with several levels of electric power, sometimes using both DC and AC electricity and high and low voltage. Serious accidents are possible if photographic equipment, particularly heavy duty electronic flash generators are plugged into the wrong power source; it is therefore vital to have the works electrician approve the placing and connection of all photographic lighting units.

Vibration in large factories, especially those concerned with heavy industry can be a photographic problem of some magnitude. Heavy vehicles, large presses or ponderously moving assembly lines can easily cause vibration and blur in slow exposures. Shoot within the rest cycles of machinery or when the plant is momentarily still. Load with ultra-fast-film and hand hold the camera, if exposures permit, whenever vibration is very pronounced.

Visual concept

Although many of the practical problems may appear similar to those encountered in architectural photography, the visual concepts for either informational or illustrative industrial photography are usually very different. The certainty of the geometry and perspective, the texture and detail, required for architecture gives way in industrial photography to a search for bold forms, brilliant but simple lighting and striking camera angles, which often include people and their

activities. Industry normally operates in the theatre of power and high drama, with careful routines leading to momentary peaks of action, and these must be identified and caught by the photographer.

In some industries, especially the electronic and pharmaceutical, the grittiness and chiaroscuro of the factory floor is replaced by aseptic benches, bright, bland lighting, and light-coloured clothing. Often tiny objects are the focus of attention: equipment is more related to the laboratory than designed for hard physical labour. These circumstances often call for a change in lighting to a more detailed, finer, perhaps high-key approach. Macro techniques may be needed, possibly human action integrated with it to suggest scale, and this imposes a considerable extra burden on the photographer, who must still attempt to find some sense of action to highlight the image however technically difficult the photography may have become.

The only way for industrial photographers to succeed is to be totally familiar with the process and the product produced, even sometimes with the marketing targets for the finished article. This comes from thorough background research, often from several visits to the site, and from long conversations with technical personnel. Do not, in any way, minimize the time taken to become familiar with such things. If possible, see the whole activity in sequence from raw material input to final packaging, and make a rough flow chart as a guide to establishing photographic schedules. Mark possible photographic targets onto this chart, noting times and best angles, likely lenses needed, special items, build-up time needed to place photographic equipment, and so on. Show this to the factory management and listen carefully to comments before amending any relevant points. Only when such a plan has been thoroughly completed and time taken for a last re-appraisal of all factors, should a final shooting schedule be written. Copies of this final schedule must then go to all parties concerned.

Industry exercises powerful political and philosophical pressures on modern society and the sensitive industrial photographer will be aware of this and use it to trigger off ideas. Perhaps no other type of indoor photography offers such a vast range of sub-

ject matter or has the same opportunities for combining design concepts and dramatic action into striking images. Certainly no other special area of interest in photography calls for such technical expertise, meticulous planning or problem-solving as does industrial photography.

THE HOLIDAY PHOTOGRAPHER

In many ways, much of what has been written in this chapter about architectural or industrial photography could apply with equal force to the photographer on holiday who

79 *Small, hand-held, 35mm cameras are normally used on vacation and, if loaded with high-speed colour film, it is surprising what rich detail can be recorded.*

finds it of interest to make photographs of large interiors. These memories of places seen are an important part of such a holiday and the visual notebook compiled by the amateur, becomes a proudly shown memento of these occasional events.

When photographing any interior, the problems are essentially the same. The building structure and its decorative skin must be geometrically rendered, its texture explored and its volume suggested. The light which enters it or intrinsically belongs to it, should be the keynote to the mood of the picture and human scale should be introduced, if possible, while colours should also be accurately reproduced. But whereas even the part-time photographer of industrial and

architectural subjects should and usually does, approach these activities with professional style, planning and equipment, the amateur photographer or holiday maker rarely has the time or the inclination to do so.

Interior subjects which present themselves in the course of a holiday are photographed quickly and often with little attention to basics. The normal equipment is likely to be the 35mm SLR and, although technical compromises must always be made with such equipment on such a subject, much can be done to improve the final result.

Equipment

Lenses likely to be needed are a normal 50mm, a wide angle 28 or 25mm and possibly a macro zoom in the 85-200mm range. These should all be of the highest quality affordable and have the widest aperture possible without impairing optical performance. A small lightweight tripod which folds to fit into the camera case, a cable release and a flashgun capable of being manually fired as well as synchronized, would complete the package. Accessories might include an FLD and FLB filter for fluorescent light and a set of Kodak Wratten 80 series (bluish) filters and a complementary set of 81 series (yellowish filters), both in gelatin rather than glass. High-speed and ultra-speed film should be used in the manner discussed in Chapter 1 (see p. 9).

Whenever entering an interior for the first time, before any photography actually begins, stand perfectly still for a few moments at a good vantage point and let the eye range around the internal space. Note the direction and strength of all the available light, details of the decoration, key structural features and so on, and only then decide, more or less intuitively, the dominant mood and character which presents itself. Now, still without moving, try to identify one suitable camera viewpoint to show this at its best. Go to this point and, with a lens of the right field of view, look through the camera for the first time. If the camera image does not please, look for other possibilities, using the camera as a finding frame, trying other lenses perhaps, looking up and down, and so on.

It may be necessary to use a camera on a tripod because of low light levels and in most buildings permission is needed to do this.

80 *In the gloomy interiors of great cathedrals it is often a good idea to suggest scale by the use of a well placed figure.*

81 *Where light is so sparse in these large cathedral interiors that it seems no reasonable long shots could be made, attentive photographers should perhaps turn their attention to local parishioners, who may be going about their normal routines within the church. Provided that the photographer's presence doesn't interfere, very fine character studies can be made from the dramatic lighting which is often to be found.*

Make sure the tripod is equipped with rubber boots to avoid damage to precious floors. Whenever working with speeds slower than 1/60th second, even when hand-holding, use a cable release to fire the shutter gently and use wide apertures and short focal length lenses to offer brief exposures without loss of focus depth. Remember that whenever a fixed-body camera such as an SLR is pointed up, verticals converge towards the top of the frame, especially with wide angle lenses, and when pointed down they converge at the bottom of the frame. Such optical distortions can be dynamic or intriguing, but can also be disastrous. By holding the camera perfectly level and using a wide angle lens it may be possible to avoid some of this problem yet still see enough of the loftiness of large interiors. With wide angle lenses, when they are perfectly levelled, there is usually an exaggerated foreground area which, if it contains nothing of real interest, may be subsequently cropped out of the final print. Line the edge of the viewfinder up on any strong vertical lines in the subject, tilting the camera minutely up and down until major verticals appear perfectly parallel to both sides of the viewfinder and horizontal lines appear to be level.

Once a general view has been obtained, search for detail shots or pictures of people within the interior, perhaps with a long focal length lens. Remember that major increases in focal length increase the effect of camera shake, and hand-holding shutter speeds slower than 1/125th second may not be advisable. Resting the camera on balustrades or heavy furniture could be helpful, or a tripod and cable release must be used. With normal and longer lenses it is less likely that perfectly aligned verticals and horizontals will be possible if much is to be seen of the interior detail and volume but such changes in compositional details can be watched closely in the viewfinder.

As in other interiors, the holiday photographer should choose a viewpoint which gives two or even three planes in the picture and should avoid the single wall unless it is a dominant decorative feature. Blurred human figures are excellent for suggesting scale without disclosing too much detail but blur is likely only at speeds around 1/15th second or slower and at these speeds the camera must be on a tripod or other firm support and the cable release should be used.

Lighting

The transient location photographer, whether an amateur or professional, usually cannot carry photographic lighting equipment and is consequently faced with the primary problem of strong lighting contrast, which is always to be found in available light indoors because no balancing fill light exists, or can be brought to act upon the harsh shadows often found in such conditions. When working with black and white it is a fairly simple matter to handle contrast by 30 or 50 per cent over-exposure and 20-40 per cent under-development but, with colour film, unhappy compromises must be made because of its lack of response in terms of

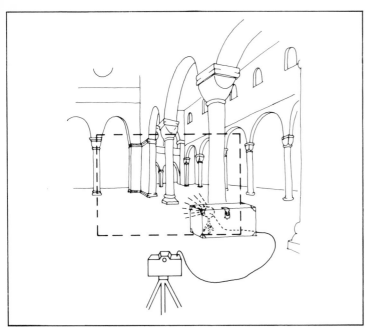

82 When it becomes necessary to add flash from a long extension cable into a large interior, it is useful to conceal the unit deep within the picture area behind furniture, pillars or other fixed features.

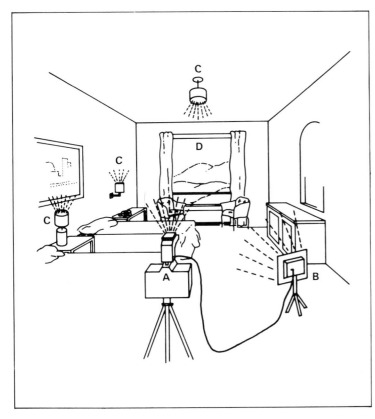

lighting ratios and because processing does not offer any contrast control techniques. Automatic cameras will probably record the key light areas quite well but with a definite loss being obtained in the shadows. By using plus or minus half or one full stop on the estimated exposure from automation, detail can be held in either the lights or darks of the scene but, of course, at the expense of the other end of the scale (see Chapters 1 and 2 for more information).

Consider the use of fill-in synchro flash technique in an interior such as a large church, for example, which is poorly lit by daylight, and suppose that exposure for this available light is estimated with fast daylight colour film to be 1/30th second at f4. If the flash guide number for this film is let us say, 30 for metric measures, divide f4 into this GN figure of 30. 7.5 represents the distance in metres where the flash may be placed to give correct exposure. It is possible that for fill light it could be backed off a further 2m to create about the right fill light value. So 10m (33ft) may be the maximum flash distance for any effective light to be added in the shadows. But in this distance, with normal lenses, not enough of the interior can be included. If a wide angle lens is selected, this, of course, means that, without moving camera or flash, much more angle of view is obtained and this is why such a lens is useful in vacation photography. If an ultra-long sync. lead is carried, say 10m (33ft), the camera may be brought back this further distance with the flash left at the GN distance and the unit hidden behind furniture or architectural columns, etc. Make sure the sync. lead is not included in the picture.

Photographing a hotel room is a little easier, but if a view from the windows is wanted

83 On vacation, it is often of interest to photograph the hotel room, including the view outside. It is necessary to calculate the colour and influence of all light sources within the picture area. This diagram shows a typical arrangement: A is flash-on-camera augmented by a further flash at B; C is a wall fixture, a table lamp and ceiling fitting all turned on during the exposure and all yellowish tungsten light; D is the outside scene, and this light needs to be accurately assessed by exposure meter for inclusion at the selected flash aperture.

plus details of the interior, it is best to attempt such pictures late in the day or very early after sunrise when the daylight is at its weakest. Use the synchro flash fill-in techniques described above, load with daylight film and estimate the daylight exposure which is necessary to record the scene outside the window. Use a wide angle lens and the flash off the camera and angled inward or upward (see figure 83). The aperture estimated for the daylight exposure is divided into the flash GN and this answer is the distance at which the flash should be placed from the main wall areas which are to be included in the picture.

Night-time exposures, just after sunset, with all the room lights turned on are also most successful. Here the camera is on a tripod and a longer exposure is made to record the bluish daylight outside. Flash is fired but only to open up the shadows in the interior a little as the room lights will add considerable fill light. If the interior is to be rendered in perfect colour, regardless of the outside view, load with Type B tungsten film, place a Kodak Wratten 85B filter over the flash-head and make the exposures with the room lights as the key light. Any daylight will be recorded as a deep blue but this may not be an unpleasant result as it could help to create mood.

Frequently on vacation a photographer will be interested in making photographs from inside a moving vehicle, recording the interior and occupants and the outside scene at the same time. But the difference in light values is usually enormous and either the exposure is adjusted to the exterior values, leaving the inside figures in deep shadow, or the exposure is arranged to give good results of the interior and occupants with the consequence that the scene outside is washed out from over-exposure.

To bring these two very separate values together in some balance, more light must be added from inside the vehicle, preferably using synchro flash fill-in if shutter speeds are within synchronizing range. First, calculate the shutter speed needed for the effect chosen. From planes and trains, very high shutter speeds are needed to record any very close objects, say under 30m (100ft), and these speeds will possibly be between 1/500th and 1/2000th second, depending on the speed of the vehicle and the closeness of

the object. Distant landscapes and clouds would however need only 1/125th or 1/250th second in order to be sharply seen. From moving cars, depending on speed and the closeness of the object, 1/125th to 1/500th should give good results. It may be that the visual concept calls for a sensation of speed around the occupants without identity of the outside environment at all and this is done with slow shutter speeds of $\frac{1}{4}$ to 1/30th second. Blurred scenes create a feeling of forward movement, particularly effective in colour, and the slower shutter speeds are the best means of achieving this.

Next, estimate the aperture co-ordinate to be used with the selected shutter speed and this then controls the placement of the flash fill-in on the foreground object. Low-power flash, heavily diffused or bounced, is generally needed because the vehicle interior allows no room for the photographer to keep well back or to place the flash well away. For the same reason a wide angle lens is often needed and, because these frequently do not stop down to lower than f16, it may be necessary to load with slow film or use neutral-density filters on either the flash or the camera. Avoid reflections of the flash in any window which may appear in the picture. When photographing cars or other accessible vehicles during elaborate professional photography, which includes the interior as well as the exterior, neutral-density film or Rosco-Sun filters may be carefully cut to the window shape and fixed to the outside of the vehicle in order to reduce the daylight exposure to manageable proportions. Vehicle speed must still be taken into account, however, with regard to final exposures and the effect desired.

Whenever photography takes place in moving vehicles, always ask permission before using the flashlight. Any unexpected flash from inside a vehicle, especially a small car, could temporarily blind an unprepared driver. If flash is not possible, a bright aluminium reflector about 30-40 cm sq. (12-16 in. sq. square) would help considerably if a portrait is being made. Catch the incoming daylight and beam it back into the main part of the face. Calculate exposure for the highlight area.

Photographing in museums, galleries and privately controlled areas such as country homes is often greatly restricted and can only

84 *A simple way of photographing the inside of a moving vehicle using an extension flash.*

take place when special written permission is obtained. This usually means that the camera is taken from the visitor at the entrance and returned on leaving. Do not be tempted to breach this rule surreptitiously as security guards may, if the photographer is working without permission, impound the camera and strip the film from it, ruining all that is on the roll.

If it is possible to photograph in such places, it is best to visit the building at a time when daylight is at its weakest, load the camera with ultra-speed Type B film, such as Kodak or 3M 1000ASA, and expose only with the lighting which is used to show the exhibit. Do not use flash unless this is specifically granted by the controllers of the building and, if it is being used, it should be off-camera and on a sync. lead of at least 2–3m (6–8 ft) so that considerable lighting angle is produced (top side or side light is called for). Where possible use identifiable human form to scale any large areas and do not attempt to photograph any paintings unless using the techniques suggested in Chap-

ter 10 (see p. 157). Casual snapshots of such works of art will rarely be successful in terms of colour and perfect geometry unless the works of art are very small.

At theatres, pop concerts, ice-shows and so on, it is again normal that management controls photographic rights, and permission is usually necessary before photography can take place. Sitting in the audience and letting off successive flash exposures is disturbing to those nearby, to the performer and, usually, to the management who will often eject the photographer. Even if flash is permitted, never use it in large auditoriums unless it can be placed 15m (50ft) or closer to the performer. This is likely to be only 12–15 rows from the front at maximum – less if there is a large orchestra pit and stage – and at all distances in excess of this, a normal flash will not add any light whatsoever to the film.

Where small objects are being quickly photographed on vacation, use natural light and preferably work close to a window. By using a macro zoom or macro lens of normal length, expose for highlights only but, using a small cosmetic mirror – preferably a magnifying type – beam the key light back into the shadows. Use the hand, perhaps, to scale the object and give some sense of proportion.

As discussed above, it may be difficult for the holiday photographer to photograph interiors and render them prefectly, as this generally requires very controlled conditions and considerable time for planning and shooting but, by remembering that a tiny tripod, a flash on a long sync. lead, a wide angle lens and ultra-fast film, can vastly improve the chances of a good result, it will be found that very good photographs can be brought back home with a minimum of interruption to the holiday.

6 Action Indoors

Modern photography gives us a unique and simple technology with which to illustrate or analyse action and will provide those lasting memories for modern families of growing children, animated pets or volatile dramatic events. Once the best co-ordination of shutter and lens aperture is properly understood it is a relatively simple matter to obtain fascinating action shots, even indoors. With fast shutter speeds, movement may be analyzed, frozen into a frame where the subject is totally sharp. The camera reveals something the brain only suspects and for many, this breathtakingly clear record of unseen, rapid action is both the wonder and the rationale for the picture. Others, however, are more interested in synthesis and subjectivity in action pictures, where the sensation of flowing action is suggested by blurred outlines and fused colours and this is achieved by slow shutter speeds.

EQUIPMENT AND TECHNIQUES

Where the subject is to be identified, as with actors, rock and pop stars, children or pets, shutter speeds must be at least adequate to give a clear picture of the head. Where psychological movements are explored with blur, and the essence of action writes itself on to the film, identity of the subject as an individual is not usually wanted and shutter speeds need only be sufficient to show the structure of the subject and the nature of the movement in a most generalized way.

Shutter speeds to stop action change rapidly under the influence of four main variables: the direction of the subject in relation to the camera; the distance from camera at which the action takes place; the speed of the subject, and the focal length of the lens used.

Subjects moving at high speed at right angles to the camera under 3m (10ft) from the camera and photographed with long lenses would need phenomenally high shutter speeds such as 1/2000th to 1/4000th second. Conversely, slow-moving subjects approaching directly towards the camera from 30m (100ft) and photographed with a normal lens would probably be clearly sharp at speeds as low as 1/15th second.

Within these two extremes the photographer must choose from the infinite variables available. If the action can be arranged or rehearsed, it is easy to select a comfortable compromise, but if it is candid activity of any kind the photographer must thoroughly understand the background to the action, its likely progression and the purpose of the event. Action photography of any kind is about anticipation and this can only come from rehearsal or research.

Indoor photographers have one particular advantage over those who take action shots outside and that is the use of electronic flash. Small, amateur-type flash units flash at high speed, probably between 1/1000th and 50/000th second and, if fitted with dedicated or automatic exposure circuitry, the closer they are to the subject, the higher the speed of the flash. Most small focal plane shutters synchronize only at speeds of 1/125th or less and this may not be fast enough in some action situations where synchro-daylight is attempted indoors. Where stop action indoors is needed it is sometimes better to use ultra-speed film and tungsten light of sufficient strength to permit higher shutter speeds.

In outdoor action work very long lenses are useful even though they require higher

85 *Correct action, harsh light and an active subject are here used together for a narrative portrait of great interest.*

hutter speeds than normal but indoors they re unlikely to be helpful and a lens of two o four times the normal focal length is most commonly the maximum used, except in the ase of very large auditoriums. A good zoom ens may be helpful but it should be 'one ouch' where focus is automatic throughout he zooming action. It is better if it has a macro mode as well as normal, so that good close-ups may be taken easily. Although normal lenses are often used for action indoors here are very few occasions when wide angle enses are needed. The ideal action lens is one of one and a half to two times the normal ocal length for the chosen format and oprating at maximum apertures of at least f3.5 r faster with a stop-down capability of at east f22.

There is no doubt that an SLR with a entaprism is the ideal specification for an ction camera indoors and this could be 5mm or medium format, 6 × 6 or 6 × 7cm. Automatic metering is not especially helpful or active individual subjects unless particuar equipment has been tested thoroughly nd the photographer has total confidence in ts ability. It is, however, of great help for hotography under existing light conditions, vhere action takes place in a fairly large area

and photography must be a mixture of long shots and mid shots of several individuals involved in intensive action.

Lighting for fast-moving action which ranges about the shooting area is best devised as a 'wrap-around' plan (see p. 68) and can come from bounced floods for use with Type B film, from powerful flash units preferably with a modelling light built in, or from existing overhead fixtures such as fluorescents.

Where action can be reasonably contained or is already restricted, multi-flash from two or more electronic flash units can be the light source. Once the GN (guide number) is known for the flash and film combination chosen, a flash meter is not needed, but great care should be taken when aligning the flash. The distance from flash to subject should be accurately measured with a tape over any distance which is under 5m (16ft).

Where the action itself must be stopped but the background can be permitted to blur,

86 *Action indoors need not of necessity mean violently mobile body movement. Here an appetizing moment when the roast is being basted in a steaming oven, provides a perfectly active subject, full of technical challenge.*

parallel course. Exposures are made during
the progressive action. Where colour balance
is not vital or can be arranged by filtration,
it is also possible to fire a small flash at the
precise instant the overall slow shutter speed
makes the exposure. Very interesting mixes
of sharp action and blur can be made this
way, almost amounting to a double exposure
effect.

Stroboscopic action is another way to an-
alyze and to stop action and this can be
achieved by the use of electronic flash units
which emit multiple flashes per second
while the shutter on the camera is left open
for the duration of the action sequence. An
interesting alternative is to use a Rollei 6006
6 × 6cm camera, equipped with a multiple
exposure accessory. This small unit plugs
into the electronic shutter release of the ca-
mera and creates multiple exposures on the
same frame, using ordinary tungsten light as
the illuminant. Exposures are made every
1/10th second or more and ten exposures per
frame may be accumulated, giving a result
which, although not as comprehensive as a
true strobe, is probably more interesting in
the creative sense.

*87 A pause in action is an ideal moment to
make the picture. Notice the structure of the
picture and the implied action and interaction
between the two men.*

Action of any kind is not an isolated hap-
pening. It has a beginning, a flowing but
measurable time span, and an end; all
actions, however abrupt, have these charac-
teristics. Actions arise from other previous
actions and interconnect with actions yet to
happen. The photographer can, of course,
isolate one tiny moment in time and safely
record that, but still photography of action
subjects borders closely on the nature of
film-making, which creates an appearance of
action from a 'sequence' of still pictures. The
sequence is most natural to active situations,
showing a progressive and interacting evo-
lution of events, and it is one of the most
interesting ways for a photographer to de-
velop a theme.

'panning' the camera is likely to give the
most interesting results. With this technique
the subject is focused accurately and slow
shutter speeds of 1/30th second or less are
used, while the camera is swung in an arc to
follow the progression of the movement or,
alternatively and more effectively where cir-
cumstances permit, the camera and photog-
rapher move with the subject in the same
direction and at the same speed on an exactly

Many sequential images grouped on a
page or treated as a montage with differing
scale throughout the frame, even when criti-
cally sharp, remind us of real life, real action.
Opportunities for these pictures can be
sought in the midst of theatre happenings,
rock concerts, children's games, group por-
traits or documentary experience. A story
line is often needed but once it is known that
an image series is going to be the objective
this usually comes easily while photograph

*88 The camera is swung through an arc to
follow the action past the photographer. At
point A the figure is closest to camera and
this is the correct moment for exposure.*

A

takes place and can be refined after the results are seen. Each picture in a stills sequence of action must stand alone as a strong image, but must interact with neighbouring images and this calls for ruthless editing before presentation.

Once decisions have been made about the aesthetics of blurred or stopped action, the necessary equipment needed has been obtained and all the action factors of the proposed theme have been thoroughly understood, it will be possible to explore some of the many opportunities to capture live action on film indoors.

CONCERTS AND THEATRES

One magnetic attraction for photographers can be the occasion of a celebrity concert in a large auditorium. The first problem is not photographic, but administrative. Most managements try to prevent photography of their artistes during concerts, and it is as well to be aware of this and seek permission if the work is likely to be used publicly in any way. Then, in fairness to the performers, no flash should be used. If it is used, this again should be cleared with the management and will only be allowed at dress rehearsals. As has already been said, flash is useless over distances of more than 15m (50ft), but if used within this distance, it then becomes extremely controlled and effective, particularly when multiple flash units are used. For the most dramatic effect and the technique least likely to offend either management, performer or members of the audience, use the available light from the auditorium spots and floods, choosing moments when the stage or performer is bathed in the highest level of light. The camera should be loaded with an ultra-fast film, for example 1000ASA, and if this is a reversal transparency film such as 3M, it can be up-rated to as much as 4000ASA by push-processing. Such a film would need to be Type B – balanced for tungsten light of 3200K. A very small tripod, or preferably a monopod, is of great help to steady the camera, and long lenses are needed unless the photographer is seated close to the stage or is given permission to stand there.

Although stage lighting appears very bright, there is a constant danger of underexposure of such subjects because of the high

89 *Montage is difficult, especially in colour, but this successfully reproduced the feeling of nostalgia and period style which the client required. (Taken from a colour transparency.)*

contrast in the lighting and the degree to which the surroundings absorb light. It is necessary to follow the action with very close attention and wait until the subject's head is turned towards the bright light or the stage is broadly lit and all performers are in an effective grouping. Measuring stage light can be a problem unless a hand-held spot meter

is used, and automatic cameras will not often be accurate under these circumstances. It is also far better to work with colour film than black and white, in order to take advantage of the lighting designer's stage effects in colour. With a 1000ASA film or a 400ASA pushed two stops, a possible exposure in a professionally lit auditorium could be 1/60th at f5.6, and this may be hand-held as long as lenses are not more than twice normal focal length.

It would be wise to bracket each exposure, using f5.6 as the last of the bracket. Apertures could then range from f2.8, f4 and f5.6. If more depth is to be obtained by the use of smaller 'f' stops, slower shutter speeds and a tripod must, of course, be used. When a particularly bright central spot is put on the performer, or the event is taking place in highly reflective surroundings such as on ice, shutter speeds for the same aperture may rise to 1/125th or 1/250th second. To capture very fast action, such as indoor athletics, even at the highest speeds suggested, split-second timing is needed. All action has a moment of poise and stillness, usually at the highest peak of action, and this is the moment the photographer should choose to make the exposure. Watch the action extremely closely and identify any point where a pause is made and yet the action appears dynamic. Action which flows past the camera continuously, such as ice shows, indoor horse shows or cycling, should be followed by a panning action of the camera while exposures are made.

Smaller auditoriums, particularly theatres, will be more rigorously controlled by management, and photography definitely forbidden without written permission. If this is given it will certainly exclude work with flash during a performance. Exposures will be as above but perhaps one 'f' stop more exposure may be needed as there is often more subtlety in the lighting and a lower level in general. If the production is not professionally lit, at least two stops extra exposure may be needed. No motor-driven cameras should be used in a small auditorium, particularly if the performance is a dramatic one, with a low volume of stage sound. The noise of such equipment can be most objectionable to those nearby and ushers will often remove the photographer, even if permission has been granted by management. Probably the best vantage point is in the aisle of the dress circle for top shots or the centre aisle of the stalls for lower angle pictures. The camera should be on a monopod or tripod and be equipped with a cable release. The photographer should kneel behind the camera or crouch even lower to avoid interrupting the vision of the audience; if the photographer wishes to remain in his seat the monopod could be used and suitably long lenses so as to avoid the heads of nearby members of the audience. Photography of these events is usually only barely tolerated by those concerned and the photographer must be as unobtrusive as possible. For professionals who must actually photograph performances, a quiet, between-the-lens shutter would be most advisable, such as those fitted to Rolleiflex twin lens reflexes and some rangefinder 35mm cameras. Early Leica rangefinder 35mm cameras are particularly suited to this work, having extremely quiet focal plane shutters and lenses which operate at their best under the adverse conditions of low levels of available light.

When the action returns to more manageable environments, particularly dramatic ones, flash once more returns as a preferred lighting system for many photographers. At least two lighting heads should be used, one off the camera, at least 2m (6½ft) away, which provides the key light and one on, or near, the camera to give a soft fill. A third flash is also most useful to light the background area or provide accents. See Chapter 1 (p. 14) for detailed information on exposure of multiple flash.

When existing room light rather than flash is used, it again suggests the need for an ultra-fast film and if it is colour it should normally be balanced for tungsten light, Type B film, preferably rated at a speed of ASA1000 or more.

THE FAMILY

Photography is the perfect medium for recording the life history of any family, and active children make the most captivating of subjects. Flash is ideal for children aged between six months and early teens, but as far as possible it should not be used on the camera. A short cable extensible by even 1m (3ft) is often sufficient to put much more style in the lighting while not sacrificing the photographer's mobility. Children in action

must be followed and the photographer will find it a help if an assistant can manage the control of the light. Such an arrangement (see figure 90) makes it a reasonably simple matter to use an effective two-light flash system provided the assistant judges the flash-to-subject distance very accurately and understands the flash guide number.

Young children usually need no prompting from the photographer and indoor action is often provided to excess. Games, toys and events such as bathing, mealtimes, bedtime, all offer moments of high action and expression. Parties, of course, are natural subjects. The flash will normally be sufficiently fast to freeze action, irrespective of the shutter synchronizing speed, but if existing light is the sole illuminant, shutter speeds of 1/125th or more will be needed. Very fast film should be loaded – preferably 1000ASA or more. Very young children may not be particularly active, but the photographer must capture the fleeting expressions, momentary frowns and smiles which help to build a record of the growing personality. At this stage of life, change is very apparent and very rapid and children should be photographed frequently, probably as often as once a week. Whenever children are being photographed, parents or other adults who may be present should be located near the camera, so any diversion of attention will be towards the camera rather than away.

Older children are often more difficult to photograph in action as they become somewhat self-conscious of the camera. It is perhaps better to initiate a serious picture-taking session, with a rehearsal of a chosen activity. For example, a spot is marked and focused upon and the subject is asked to run through the focus point. Photographs are taken at rehearsal and a reaction could be prompted at the moment of exposure by a sudden call or question or by unexpectedly throwing a prop of some kind for the child to catch. Lighting, of course, must be set up and tested beforehand and this planning can sometimes be an inhibiting factor. Really candid action is best taken swiftly and intuitively by the photographer using existing light and very fast film. As in theatre and concert photography, there are always moments of almost complete stillness within a given action, and the movements leading up to these moments can give the body great

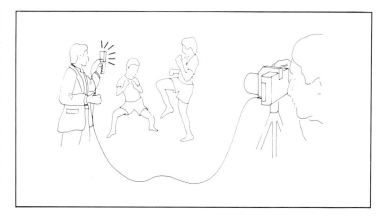

90 *Using an assistant to carry the extension flash while photographing active subjects.*

dynamic expression and yet be photographed at reasonably slow speeds.

In all action photography, but particularly where children are concerned, the photographer should aim to get good pictures of the head, particularly the eyes. Arms and legs may blur out but if the head and eyes are reasonably sharp, the personality and character of the subject will usually be easily identified. The psychic structures of the subject will be seen; the eyes express the immediate and long-term intentions, the head and its attitude in relation to a vertical axis will indicate the direction and force of the whole body attitude and movement. For that reason, lighting of the head is important; exposures are read from this area – if need be to the exclusion of all else – and focus is struck on the eyes. In very close shots focus is struck on the pupils of the eyes.

Action of any kind has, as well as explosive expression, a considerable degree of latency: a promise of power, a coiling of the spring. During this time, the photograph, if it is timed correctly, may be made at quite normal snapshot speeds, and the image is one of structure, the body skeleton, rather than any analysis or illustration of a specific action. Such photographs require split-second anticipation, but can carry immense charm and dynamism and are especially effective for young children.

ANIMALS
Animals indoors make charming subjects also and if these are either the wilderness species in captivity or the free-ranging, domestic kind, then photography is not too

difficult. The zoological kind must only be photographed with the co-operation and permission of the zoo management and flashlight must only be used on those occasions when it will not distress the animals. To eliminate the cage from the image, even if it is just a link fence, a lens at least two and a half times the normal focal length should be fitted to the camera and the widest possible aperture should be chosen for the photograph, even at the risk of a shallow depth of field. The camera is brought as close as possible to the cage and is focused on the animal's eyes. If artificial light is being aimed through the cage, this must also be brought very close up to the bars and angled in such a way that no shadows from the cage are thrown on either the animal or the background. The animal should be isolated against a natural, even-toned background to further induce the feeling of naturalness in the picture.

Domestic animals need some preparation and must usually be restricted to a defined area in front of the camera. Often all that is needed is a suitable table or other high point, particularly if the pet is very young, or the animal can be photographed in a corner. Multiple flash is the ideal lighting, with two or more units synchronized to the camera. Very active animals - cats for example - will often stay in one spot if the selective area is bathed in the warmth from a high-powered reflector spot or infra-red heat lamp. This does not record during the flash exposure and offers much better control of focus.

Fast-moving animals will often be hard to light in such a way that there is significant separation between them and the household furniture. The best solution to this problem is to use a wide photographic paper background of light tone. After they become used to such radical alterations to the domestic scene, most pets will contentedly and actively explore these plain spaces, inventing their own games while there. Props may be introduced on to the limbo paper-fall and it can either be lit in such a way to 'burn out' and become totally blank or it could be given a continuous transition of tone to make it more interesting and subjective. Such a set-

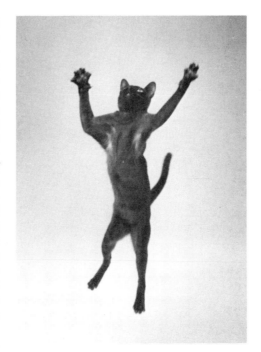

92 *Fast action by household pets can be a challenge to any photographer. Here the cat is completely airborne and, by the use of fast film and fast shutter speed (1/1000th second), the action has been stopped, even though natural light indoors was the only illuminant.*

up is particularly suited to indoor photography with ambient daylight.

Small cage birds make marvellous subjects but are hard to focus on unless a special temporary cage has been made to restrict flight. Such a cage would have a wide wire mesh in front and thin acrylic sheets as sides, top and backing. Internal dimensions should be as minimal as possible and an interesting focal point should be provided by a suitable branch or rock within the cage area. Food, but very little of it, should be placed at the focus point.

Larger, free-flying birds such as doves and pigeons make beautiful subjects, especially when photographed with people. Flashlight can be used to freeze action, but more emphatic images will come from the use of tungsten floods or existing daylight. A large, temporary flight cage is made of fishing net or thin plastic material such as Roscofrost, and the photographer works inside the netted area with the birds. The background should be plain paper or a light-toned wall

91 *Typical of a professional action shot of a child. The picture was in colour and is printed through a textured screen.*

93 *Photographing fish in a small aquarium can be done effectively with a set-up like this. Note glass partitions at A.*

but such sophisticated measures of control do necessitate an expert. Test firing of flash may may be needed to acclimatize wild animals to the sudden shock and if the animal becomes distressed or angry, photography will only be possible with a continuous light source such as tungsten.

To photograph the flight path of insects requires a highly specialized and esoteric mixture of equipment with an elaborate triggering system, optical switching and sophisticated electronic circuitry, but the results can be amazingly beautiful. A simplified system is explained in figure 94, and much practice will be needed to obtain perfect results. It will be found, however, that infinitely more control is possible in photographing insects indoors by artificial light than would be possible in outdoor environments. Translucency in insects is particularly attractive and this can be enhanced by the use of 'dark field' illumination where the subject is lit by an off-axis back light and a dark background is used.

HIGH-SPEED COMPUTER FLASH

For other high-peak actions in close-up – such as bottles pouring, balls bouncing, objects falling, and so on – use may be made of the high-speed computer flash which is a comparatively easy way to explore and analyze movement. Such small electronic units

to provide maximum separation of any blurred wing movements.

The classic way to photograph fish is in a small aquarium tank with a movable glass partition which is used to bring the fish forward to a shallow and restricted area. To avoid reflections of the glass the camera is angled slightly and provided with a black shroud through which only the lens obtrudes, while lighting is mainly from the top. Flashlight is ideal for such fast-moving subjects and the whole arrangement is clearly explained in figure 93. The camera angle of view should take in the whole tank dimension and a suitably plain background is used behind it.

If very exotic or dangerous animals are being photographed, a handler must be present at all times and anyone involved with photography must properly understand the risks and routines of such work. Comprehensive insurance must be taken out to cover public liability and specific problems which may arise for that particular session. Most exotic animals are more lethargic when cold and this is particularly useful when photographing reptiles. They can be cooled by refrigeration until they become easy to handle,

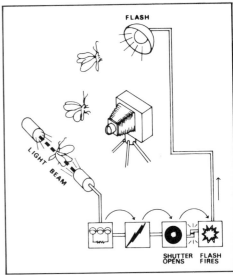

94 *A typical system for electronic triggering of flash and camera during the photography of ultra-fast action, such as an insect flying past the camera.*

can deliver exposures as brief as 1/50,000th second in close situations, but some work only in one or two aperture brackets which may cause over-exposure difficulties in really close-up conditions. By using neutral-density filters on the lens or by loading with slow film or adding diffusing filters to the lamp-head, some of the most difficult problems may be avoided, but it is worth lengthy experiments as the results can be fascinating. So-called 'quenched' circuitry in these flash units or the alternative thyristor switch-offs, incorporate a sensor in the unit which receives reflected light from the subject and transfers the information to circuit inhibitors which are programmed by the distance and film speed information which, in turn, has been selected by the photographer and fed into the unit. When sufficient light is reflected from the subject for correct exposure, the units produce no more light from the tube and switch off. Such units also operate manually and, in this mode, the guide number must be known in order to calculate accurate exposure.

The benefit of hyper-speed in the flash duration of these small, automatic units also brings a colour balance problem. Even when used at their slowest, when maximum light output is wanted over minimum distances, such flash units tend to be unacceptably high in colour temperature. Using daylight film balanced for 5500K for example, these lights produce bluish results because the output from them is often 7000K or even higher. Add to this factor the problem of reciprocity effect and it will be obvious that, if perfect, colour is needed, filtration of the lamp or camera lens will be essential.

RECIPROCITY EFFECT

The reciprocity law states that 'exposure equals the intensity of the light reaching the film, multiplied by the duration of the exposure time.' This is expressed in an equation as $E = I \times T$. This law holds true for exposures in black and white in the range of $\frac{1}{2}$ second to 1/1000th second and is somewhat more restricted in colour materials where exposures may range between 1/10th and 1/500th for correct colour rendering. When times exceed either end of the speed spectrum and become briefer or longer than the manufacturer's stated times, under-exposure can result.

In colour film failure of the reciprocity law can also bring about changes in contrast and/or colour shift. In ultra-long or ultra-brief exposures with colour materials, colour shift is most noticeable, and must be compensated for by the use of CC filters and adjusted exposures. Type B film (artificial light) is notorious for these effects and even estimating exposure becomes difficult. All manufacturers publish data on reciprocity effect for each of their emulsions and suggest filter packs to bring the material back to normal balance. If at all possible, film material should be used at normal speeds, as suggested by the manufacturer.

During lengthy exposures, a low-intensity effect may be evident, creating increased highlight density and poor shadow definition, thus increasing contrast. For black and white film, over-expose and under-develop in a compensating, speed-enhancing developer, such as May and Baker Promicrol or Ethol UFG. Where high-intensity illumination or extremes of action require very brief exposure, 1/1000th second or less, density is lost in highlights and grey tones. Shadows do not lose detail by comparison. In black and white photography, especially with high-speed film which is inherently lower in contrast anyway, the negatives lose brilliance and luminosity, giving rise to flat prints. In this situation, increased exposure of half to one 'f' stop and extended development of 15–20 per cent is needed in an active developer such as Kodak DK50 or D76 or Paterson Aculux or May and Baker Suprol which has been diluted 1:25.

As far as reciprocity failures are concerned, the greater latitude in black and white emulsions even during fairly dramatic extremes of exposure does not pose many real technical problems, particularly when making action pictures on high-speed film which is push-processed, but colour film needs some care if really good colour and accurate exposure is essential.

Correction is made by increasing exposure and by using CC filtration on the lens, because processing time changes do not contribute to any degree of control. Each film batch in professional material may require a different computation and this is indicated by the data sheet which accompanies the film, while all amateur film will also have separate information on this subject.

POINTS TO CONSIDER

Action photography indoors, it is true, creates certain technical problems but these should be challenging to the photographer rather than imposing any inhibition on normal skills. To summarize to some extent the general discussion in this chapter, consider these points whenever confronted with the need for candid or action photography:

Material: use high-speed or ultra-speed film because smaller apertures mean greater depth of field with less error in focusing. These emulsions are already low in contrast.

Exposure: give adequate exposure to shadow areas. Do not hand hold with any lens at shutter speeds of less than 1/30th second and with long lenses (three times normal or more) this minimum should be raised to 1/125th.

Colour: very brief exposures can bring substantial changes to colour balance and filters must be used to adjust.

Light: always try to use flash off-the-camera and multiple light sources.

Method: wait for the beginning or ending of action if slow speeds must be used, study the flow of action in the subject and anticipate the moment when exposure must be made. Pan the camera to follow action which passes directly across the field of view.

Other points to remember are: where possible, research the activity to a point where it is absolutely understood; rehearse action in the subject where possible and have the action run through several times while test exposures are made. Clear the active area of all obstructions and obtain an unobstructed field for the camera to move if need be. In all close-up action focus on the eyes; in other events, focus on the key point of the action itself. Compensate for the environment around the action; large auditoriums absorb light and need at least one 'f' stop extra exposure. Very light surroundings permit higher shutter speeds or smaller apertures. Professionally lit interiors and events have the same effect and need less exposure than those illuminated by ambient light or by amateur lighting equipment.

Photography and action are natural partners and are distinctly of this century. Only the camera can show us what the eye cannot perceive when it is confronted by the explosive passage of momentary action or by the river of movement which unfolds when peaks of activity blend into expanded time. Blurred action illustrates the time phase for the whole action, depersonalizes it and suggests the subjectivity of active situations; stopped motion analyses the identity of the performer, the physical structure of the activity and the environment which surrounds it. Both are acceptable to most viewers.

95 *A very strong photograph, presenting narrative, ambiguity and emotional action in one decisive moment.*

7 Instant Systems

THE POLAROID

Little more than a century after Fox Talbot, in 1844, produced the first pictorial photographic book, Dr Edwin Land offered the world a black and white image, processed without a darkroom, created in an instant. In that instant also, the ubiquitous Polaroid was born and the world of instantaneous imagery has been with us ever since. Although, in the past, other manufacturers have attempted to provide competitive processes and, no doubt in the future others will try to take their place, it is to the Polaroid Corporation that we still look for innovation and leadership in the field of instant photography. The advent of colour Polaroid systems in the mid 1960s has been, in fact, the only revolutionary advance in photochemistry since the dry emulsions of the nineteenth century.

Although undoubtedly aimed at the huge amateur market, Polaroid systems and other instant imaging techniques are also the concern of all serious photographers everywhere. At the present time, much of the colour material in instant systems is less than satisfactory for a final print, but certain subjects and certain equipment will produce unique

and original colour prints. Polaroid's ER emulsions, 18×24cm (8×10in.) and 4×5cm (9×12in.) are particularly good, while their spectacular giant print system 50×60cm (20×24in.) produces extremely satisfactory results, admittedly though at considerable cost. Black and white instant photography is another matter, however, and in tonal scale, brilliance and faithful equivalence to multicoloured objects, Polaroid material is most acceptable. Certain of Polaroid's film types also carry a negative as well as the positive print and this is retainable and can be stabilized with simple chemistry, to provide a permanent negative record.

The SX70 Polaroid camera is not a system camera and has few accessories. Its portability makes it well worthwhile in many indoor assignments, and the fundamental handicap of not having a standard flash synchronizing socket may be overcome by the use of the Polaroid electronic flash and a number of slave cells fitted to other flash units. The primary flash unit is fitted to the camera with an adaptor while other electronic flash units are either each fitted with a slave trigger unit (see Chapter 1), or perhaps even have this as an inbuilt feature. When the camera flash is fired, so the other units will fire in synchronization, thus permitting multi-flash lighting plans to be constructed and colour temperature balance to be maintained. The flash-on-camera should be diffused and used as a soft fill light or turned away from the subject and aimed at one of the slave units. This camera is an extreme challenge to the photographer/artist. Its chemistry, format, colour, size and optical geometry cannot be manipulated and remains inviolate. The challenge then is to overcome the rigid

96 *Polaroid multiflash.*

mechanical parameters, take advantage of the instantaneous wizardry of the process, yet be true to artistic and aesthetic vision. The automation inherent in such image-making requires of the creative photographer a depth of thought and conceptual vision which is quite inescapable.

Despite its small format and restricted emulsion choices and the lack of standard flash synch contacts, many artists continue to use the SX70. The square format produces an approximate image of 8 × 8cm (3 × 3in.) in area, the camera is exceptionally compact, innovative in design, focuses to close distances and is easy to use – a genuine 'notebook' type of camera where any passing visual material can easily be caught.

Aside from this visual notetaking, the camera is being used frequently for sequential photography and for mutli-print photo collages or photo mosaics where the original print ends up as the only record of the chosen subject. Painters who have been particularly active in using the SX70 include Andy Warhol, David Hockney and Lucas Samaras, but many photographers are beginning to find the challenges and advantages of this system are of special interest.

Photographers whose work with Polaroid systems should be studied include Krims, Samaras, Cosindas, Adams, La Badie, Caponigro and Silverthorne.

In the scientific world

Using instant photography as a system to achieve an end product in its own right has found great favour with the scientific community. Almost all of this work is produced by artificial light and Polaroid Corporation has produced a wide range of special emulsions including high-contrast for graphic art application, low-contrast for video image recording, ultra-speed (20,000ASA) for recording oscilloscopes and various colour and monochromatic transparency films. General purpose films are used to record images from electron microscopes, optical microscopes, diagnostic scanners and computer graphic displays. Polaroid materials are frequently used in macro (close-up) photography, vertical copy set-ups, forensic, medical and evidence submission. The instant nature of the process allows operators whose skills may be other than photographic, to make high-quality visual records and provide supportive

pictorial material without involving expensive photographic technicians and complex laboratory processing.

Whenever using Polaroid or other instant photographic emulsions, exposure and processing controls are fairly minimal. Despite this, times and temperatures should conform to the manufacturer's specifications and should be accurately checked by instruments. Polaroid has a relatively short shelf life, and black and white and colour materials should both be stored in their original sealed packages in either refrigerator or deep freeze. Suitable warm-up times must be allowed at room temperature before the packages are opened for use and any partly used packages should be kept in sealed plastic bags until just before exposure take place.

Polaroid is of considerable help in any copy process and this is explained in the final chapter which deals with that subject. Criti-

97 *Polaroid is often used to check progress during the use of a scanning electron microscope. (Courtesy Polaroid Ltd).*

POLAROID COLOUR FILM TYPES

Format	Name	Type	Contrast	Speed ASA/DIN	Dev. time & temp.	Alternative formats	No. of exposures per pack
	T809	Colour	Medium	80/20	60sec/75°F	T59/T559/ T669	15
8 × 10 Sheet	T891	Colour	Medium	80/20	4min/75°F	N/A	15
	T811	B & W	Low	200/24	45sec/65–75°F	T611	15
	TPX	B & W Transparency	Medium to high	High	60sec/45°F +	N/A	15
	T59	Colour	Medium	80/20	60sec/75°F	T669/T559/ T809	20
4 × 5 Sheet	T57	B & W	Medium	3000/36	15sec/70°F	T667	20
	T55	B & W Pos/neg	Medium	50/18	30sec/70°F	T665	20
	T52	B & W	Medium	400/27	15sec/70°F	T552	20
	T51	B & W	High	320/26	15–20sec/70°F	N/A	20
4 × 5	T559	Colour	Medium	80/20	60sec/75°F	T59/T669/ T809	8
Pack	T552	B & W	Medium	400/27	20sec/70°F	T52	8
	T669	Colour	Medium	80/20	60sec/75°F	T59/T559/ T809	8
	T668	Colour	Medium to high	75/20	60sec/75°F	N/A	8
3¼ × 4¼ Pack	T084	B & W	Medium	3000/36	15sec/70°F	N/A	8
	T665	B & W Pos/neg	Medium	75/20	30sec/70°F	T55	8
	T667	B & W	Medium	3000/36	30sec/75°F	T57	8
	T612	B & W	High	20,000/44	30sec/75°F	N/A	8
	T611	B & W	Low	200/24	45sec/65–75°F	T811	8
	T47	B & W	Medium	3000/36	15sec/70°F	T667	8
3¼ × 4¼ Roll	T42	B & W	Medium	200/24	15sec/70°F	N/A	8
	T46	B & W Transparency	Medium	800/30	2min/60°F	N/A	8
	T146L	B & W Transparency	High	200/24	30sec/70°F	N/A	8
3¼ × 3⅜ Pack	T88	Colour	Medium	80/20	60sec/75°F	T669	8
	T87	B & W	Medium	3000/36	30sec/75°F	T667	8
Integral	T779	Colour	Medium	640/29	Self processing	N/A	10
	T778/T708	Colour	Medium	150/23	Self processing	N/A	10
	Polachrome	Colour	Medium	40/17	5min/60–85°F	N/A	12 & 36
35mm	Polaplan	B & W	Medium	125/22	5min/60–85°F	N/A	36
	Polagraph	B & W	High	400/27	5min/60–85°F	N/A	12

cal changes may be made to colour and grey tones by filtration, by raising temperature and/or by increasing or decreasing processing times. Whenever employing these variations of standard techniques, a written log of methods and results should be kept for future guidance. For copying multi-coloured artwork, there is probably no easier or faster method and subsequent prints from these negatives are excellent.

For the artistic photographer

From the artist's point of view, looking for original images where the print becomes the unique and only copy, film size is most important. My own choice is to use an old-fashioned, hand-held Speed Graphic with interchangeable lenses and a back which has been slightly modified to accept the Polaroid magazine pack Type 559, single shot Type ER59 and positive/negative Type 55, as this format gives maximum emulsion choice on a suitably large format of 9×12cm (4×5in.). Those who work only with colour and want a larger format may find themselves restricted to the use of 18×24cm (8×10in.) view cameras which must be fixed to a heavy tripod. Polaroid do make a special camera accepting Type 668, 667 and 665 films but, although it has interchangeable lenses, it is not particularly flexible or well accessorized for major work. For those who can accept a single lens camera, the 195 or 190 model camera is rugged and workable, with a standard flash synchronizing socket on the shutter. These cameras do not focus under 1.5m (5ft) and therefore only suit certain subjects but, within these limitations, really high-quality work may be done. High-speed film packs such a Type 667, with a rated speed of 3000ASA, fit this camera, and for low-level available light assignments this combination works extremely well.

Those who prepare black and white prints for reproduction using any of the above systems, should take particular care if coating his film is needed to stabilize the Polaroid print. The solution-soaked pads which accompany eack pack of film should be gently wiped across the surface, in one direction only and with very little overlap between strokes. Otherwise surface textures may not settle back into an even gloss. Poor surfaces on Polaroids can sometimes create problems for the engraver.

For the professional photographer

The professional photographer could barely operate a successful advertising studio today without depending on Polaroid. Instant photography is used for checking focus, finalizing exposure, checking visual concepts, matching photographic set-ups to layouts, previewing colour harmonies, photographing story board material for television production, research into styling, and so on, as well as routinely checking lighting plans, lens and shutter performance, flash synchronization and other technical problems. All indoor photography can benefit by first previewing a possible assignment with the use of Polaroid materials.

Strangely, the informed professional rarely uses colour Polaroid for this routine work even when working in colour. Polacolor seldom matches either colour contrast or emulsion speed to that of the final, conventional camera film and, when assessing colour harmonies, can be positively misleading to non-photographic clients. The extra cost is not usually justified once the photographer has learnt to transpose full colour subjects in his mind to the monochromatic greys of black and white Polaroid. For example, when using a 64, 80, or 100ASA colour film, it is wise to use Polaroid Type 55 (ASA50) or Type 665 (ASA75). Both these are positive/negative black and white film, although there should be no attempt to save the negative when assessing correct colour exposure. Camera exposure should be set to produce the best Polaroid print possible with full details visible in highlights, including definition of the incident highlight. When this has been achieved, light is added to the shadows wherever no detail is to be seen in the Polaroid, by bringing in either reflectors or extra fill lights. When this is reproduced well on Polaroid, so it will be on the colour material. Adjust exposure controls on the camera to compensate for any differences between the Polaroid material's speed and the camera film speed and then make the real exposure.

If a negative record is needed for subsequent black and white prints, make a further Polaroid and increase the exposure for the Polaroid by at least one half or perhaps one full 'f' stop and review the negative resulting from this, after it has been cleared, on a light box with a colour temperature of

5000K. It may be thought unusual to check black and white negatives on a light source intended for viewing colour transparencies, but on such a light box greater accuracy is always possible when assessing negative tones of grey and negative film densities. When a good negative is obtained, of reasonable contrast and with reasonable densities in both highlights and shadows, it will usually be found that the accompanying print is too light and must be discarded, while the negative will print exceptionally well on normal photographic paper.

Where colour Polaroid is used to check camera set-ups, do not consider it accurate for exposure control and use an exposure meter for this purpose instead, particularly if multi-flash is being used. It is important to stress with any interested parties who may be engaged on the assignment that no value judgements about fine tuning of colour are likely to be validly interpreted from the colour Polaroid material. If colour gels are being used on any lighting units this is particularly true. Note that Polacolor is balanced for daylight and a CC filter must be used on the camera to compensate if tungsten 3200K lamps are in use. A starting test could be made with a Kodak Wratten 80A filter on the camera or a Rosco blue filter on the lighting unit, but some experiment will be needed to make any assessment of the new exposure index at which the film should be rated.

Polaroid films
Some of the general purpose films made by Polaroid and useful in indoor photography are as follows:

TYPE 667 (3000ASA): black and white emulsion; print only; image size 7.3 × 9.5cm ($2\frac{7}{8}$ × $3\frac{3}{4}$in.). Film does not need coating; some grain visible; low contrast; most suited to subjects lit by overhead fluorescents or other existing artificial light. Fits 600 series cameras, 190, 195 Polaroid cameras, Hasselblad, Rollei 6 × 6cm ($2\frac{1}{4}$ in. sq.) and certain 9 × 12cm (4 × 5in.) adaptors.

POLAPAN TYPE 52 (400ASA): print only system; black and white emulsion; image size 9 × 11.4cm ($3\frac{1}{2}$ × $4\frac{1}{2}$in.). Superb tonal gradation; no discernible grain; lustrous blacks. Responds well to copy techniques.

POLAPAN TYPE 552 (400ASA): has the same characteristics as Type 52 but has a slightly larger image size and is in a quick-change magazine pack to suit a special holder. Both 52 and 552 are used in 9 × 12cm (4 × 5in.) cameras.

TYPE 51 (125ASA TO TUNGSTEN 320ASA TO DAYLIGHT): this is a black and white high-contrast, colour blind, sensitive-to-blue-only emulsion. Very interesting graphic and special-effect film for 9 × 12cm (4 × 5in.) cameras and for all graphic arts applications.

TYPE 665 (75ASA): black and white positive/negative process; negative must be cleared in a 12 per cent sodium sulphite bath and washed (or can, in emergencies, be cleared in fast fixer solutions of high concentration). Almost grainless negatives are obtained. Film pack for use in 600 series cameras and film backs, Rollei or Hasselblad adaptors or in the 190 or 195 Polaroid cameras.

TYPE 55 (50ASA): black and white high-quality, positive/negative process; best for exposure evaluation of colour film and for making copy negatives by camera or enlarger techniques. Used in 9 × 12cm (4 × 5in.) cameras.

POLACOLOR ER (80ASA): full colour; improved latitude and lower contrast. Type 809 is for 18 × 24cm (8 × 10in.) formats; Type 59 for 9 × 12cm (4 × 5in.). It can be used for some colour copies, especially for computer graphics, single-tone colour subjects and flat artwork. Also used for colour copies by enlargement or camera techniques (see Chapter 10.)

POLACOLOR 668 (75–80ASA): full colour material in packs for the 600 series cameras, Hasselblad or Rollei adaptors and the 190 or 195 Polaroid cameras. Colour is less acceptable for most subjects when compared to the ER emulsions. Both emulsions are balanced for daylight 5500K colour temperature.

SX 70,778/9: this emulsion is generally a little contrasty and needs care in exposure. Time changes in processing for experimental reasons are not possible as this is not a peel-apart process. While wet, this emulsion may possibly be scribed, embossed or flowed to some extent for special effects.

The benefits to the experimenter in photography from the use of instant materials are many, particularly the recording of random events and the instant preview of the results

from this activity. This easily leads to a systematic probing of volatile happenings, with the camera acting as an automatic moderator of the interchange between the photographer and real life. This extraordinary photographic process offers high technology imaging facilities to anyone who has the curiosity to explore our world, but does not impose in any way the need for anything more than rough skills at a very low level, for all those who use the materials – truly a revolutionary influence on our culture and certainly a unique development of the twentieth century.

THE PHOTOGRAM

Another form of instant photography, or nearly so, which has a much longer history than that of the Polaroid process, is the photogram. With the advent of ultra-rapid processing and resin-coated paper it must be said that the photogram can now be completed dry to dry in as little as five or six minutes; and add to this the fact that no camera is needed, the photogram becomes an obvious area for creative photographers to investigate at some considerable depth. Simply stated, the photogram is a photograph made by placing objects directly on a sensitized material such as paper or film, exposing it to a suitable light source and developing the result. Using fast-drying RC paper, a photographer could allot, perhaps, 20 seconds for exposure, 90 seconds for de-velopment, 20 seconds for stop/rinse, 30 seconds for high-speed fixer and 200 seconds for washing; six minutes, in all, to a finished image. Add three or four minutes for forced hot air drying and the photogram is ready for mounting in far less than ten minutes. So results can be assessed extremely quickly. It is this rapid review of experiment which parallels the valuable contribution which Polaroid makes to the creative artist who wishes to explore photographic imagery.

The photogram predates the official birth of photography and prior to that event, in 1839, experimentalists usually began by placing objects directly on their trial emulsions which were very elementary and very slow in speed and then exposing them to sunlight, creating nothing more or less than a photogram. **William Henry Fox Talbot,** the founding father of the modern photographic concept, produced many delicate examples of the photogram. During the continuing fascination with the machinery and emulsions which made early photographic development such an explosive influence on humanity, the idea of working without a camera was unthinkable and, of course, tremendously inhibiting; so the photogram appeared lost entirely. It was not until almost a century later, within the wilderness of the Surrealists and the Dadaists, that three forceful photographers working quite independently revived interest in this form of photographic expression.

In the maelstrom of emotion which characterized art in Europe following the catastrophe of modern war and especially in the four years after 1916, artists sought for ways of coping with the anarchy of the machine. Therefore the machine-made image, as embodied by photography, received new and dynamic attention. It was of course not long before experimentalists tried to abandon the camera machine altogether but leave the automatic machine-made image behind as a visible witness of the new reality. In 1917, **Raoul Hausemann** in Berlin returned to the photogram, in 1918 **Christian Schad,** in Zurich did the same and the amazing painter/photographer, **Man Ray,** an American in Paris in the 1920s, independently took the same experimental route, deliberately seeking alternatives to manual painting. The photographers of the Bauhaus, particularly **Moholy Nagy, El Lissitzky** and **Herbert**

safe light

99 A normal set-up for using an enlarger to make photograms by projecting images over solid objects while in a safe lighted darkroom.

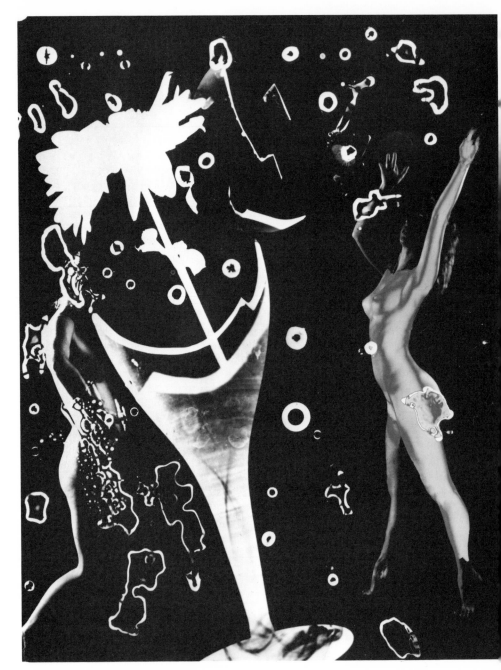

100 *A photogram which has been created in the darkroom without a camera.*

Bayer, extended the use of the photogram into many areas of art and graphic design.

Working without a camera may seem an inhibiting factor in image-making but in what is essentially a simplification of technique, it perhaps leaves the photographer's imagination and subjectivity to surface during the process of image-making, where ideas become more visible and accessible.

Photograms are best made with a vertical enlarger in a small darkroom and objects with some degree of translucency make better subjects than solid objects. Photograms of today, unlike those of the 1920s, can be either colour or black and white and can be produced as negatives or positives, or as a mixture of both.

It is important to have a certain design objective in mind, a considered concept which holds the visual material together, but

of course, accidental events can be exploited for their random effect within the image. Roughly plan the final result, assemble the objects near the enlarger and with the enlarger lamp but no sensitized paper in place, make trial arrangements while the effect is observed. These can be traced on graph paper if necessary but a better idea is to form everything up on a thin sheet (2mm [$\frac{1}{16}$–$\frac{1}{8}$in.]) of very clean glass. Once a suitable arrangement is made on the glass, the whole collection may be lifted up while a piece of sensitized material is positioned, face up, under the enlarger. The glass sheet containing the objects is now gently placed on the photographic paper and a brief exposure is given by the enlarger.

In black and white

With black and white materials such as RC enlarging paper, stop the enlarger down to its maximum (least amount of light) and make a one-second exposure. When developed this will show the trace of the objects and they will be floating in an even mid-grey tone. Further test exposures with longer times can produce successively deeper blacks or the lightly exposed sheet can be re-exposed, before development, to another series of larger, totally opaque objects which cover up part of the first image. The results are a series of tonal steps and interlaced images which may be experimented with *ad infinitum*.

Part of the attraction of photograms to the photographer is that, like Polaroid, the image so obtained is usually unique and not repeatable in exactly the same way. For those photographers who are interested in multiple copies of experimental results, the easy solution is to use a large sheet of graphic arts film, such as Fuji L100 or Kodak 2556 instead of photographic paper. Safe-lights for this material must be changed from yellow-amber to red, otherwise fogging will result, but ordinary print developer, used with less dilution than for enlarging paper, is the only other technical difference. It is possible to use lith developers but results are usually too contrasty for pleasing results.

The photogram so produced on film may be solarized and, of course, when dry becomes a master negative from which to create a print where tones are totally reversed. This negative may be used to create further pho-togram designs by interposing it between a fresh unexposed sheet of paper and other objects before switching on the enlarger for a second exposure. In areas masked by the dense parts of the negative photogram, nothing will print, whereas, in the lighter areas, objects will make interesting shapes. Simple paper photograms often contain white silhouettes on black backgrounds and, by reversing these tones, the silhouettes become black and black backgrounds become white. By tone separation techniques, where a mid-tone positive is created from the master negative and both printed together or successively in register, very complicated and sophisticated images may be made.

In colour

After some experience with black and white materials, experiments should be made with colour. Natural objects such as feathers, leaves and particularly flowers are excellent first choices. These objects have a considerable translucency near their edges but sufficient density in their centres to create entirely black shapes and the echoes of form and colour around the solid partial contours are fascinating.

Colour sheet film, usually 18×24cm (8×10in.) is ideal for creating transparencies, but negative or positive colour paper is certainly cheaper and more easily processed. These images can then be copied on to transparency material, following the method explained in Chapter 10. If using the glass technique to pre-assemble objects, it is wise to remember that most glass has a heavy green cast in it and this must be filtered against in order to produce first-class colour results.

One of the simplest colour methods for photograms is the Kodak Ektaflex system: a one-step, peel-apart transfer system which uses a single solution. Dry to dry takes no more than ten minutes to produce, thus returning colour photograms very much to the region of instant photography. The Ektaflex system can be used as negative or positive material and the best size material to use is 18×24cm (8×10in.). If a transparent image is required, the plastic print base supplied for use with Ektaflex film may be replaced with a carefully cut piece of acetate or clear photographic film. After bonding in the dark, this sandwich should be left in a light-proof box for ten minutes before peel-

ing apart as normal The Ektaflex machine is simple, needs no electricity, no temperature control and only a rudimentary darkroom with no running water, and has a low first cost.

Further sophistication

Once some experience is obtained with the simple photogram in colour or black and white, a further step exists which introduces greater sophistication to the image and almost unlimited opportunities to experiment. If the enlarger is loaded with either a negative or positive and this image is projected on to the assembled objects in the photogram, new dimensions are immediately apparent. The projected image introduces scale, perspective and apparent depth. No longer is the image restricted to silhouettes or to 1:1 contact prints of the assembly.

If the projected image is in colour, it is more suitable if it has large areas of white within the picture area; if working in black and white, subjects should be taken against totally black backgrounds in order to produce clear film in many areas. These clear areas are, of course, necessary to produce the conditions which expose the objects on the enlarger base board. File negatives, especially of organic patterns such as are found in rocks, trees and leaves, can be useful, but it is probably better to make a separate projection image exactly to fit the concept of the whole photogram. The human body, photographed in black and white against a black velvet back drop, makes a dynamic contribution to such images, richly endowing the photogram with haunting symbolism. If these initial photograms are given further abstraction by the use of graphic darkroom techniques such as bas relief, solarization, tone separation or tone compression, there is almost no end to the subtlety and complexity of the images which may be attempted.

Life-size scale

A more tedious form of photogram but one increasingly attempted by photo-artists today, are those which use the human body in 1:1 (life-size) scale. The model is placed on a large piece of mural-sized enlarging paper while in safe-light conditions and exposed to a simple light source from above or the side; or perhaps fabric is sensitized with a commercial or home-made emulsion to provide the photographic base for the experiment. Full-scale objects are placed with the body and such things as chains, bicycles, umbrellas are natural early choices. Very slow emulsions can be made up using the formulas to be found in *Photographic Facts and Formulas* (Wall and Jordan, Amphoto) or other sources of antique photographic chemistry, and these may be exposed by direct sunlight in the manner of the early pioneers of photography. Using a life-size body to make such giant photograms is a challenging technique and a rewarding one.

By using a powerful projector (at least 500 watt) or a horizontal enlarger, images may also be used as the exposing light, even with such large pieces of sensitized material. The exposing source is projected on to a wall to the size desired, the whole area of activity being under safe-light conditions suitable to the chosen photographic material. The projector light is extinguished and the sensitive material is taped to the wall in the area formerly covered by the projected image. The model and other objects are placed against the wall in contact with the emulsion of the sensitive material and the projector turned on to make the exposure.

Development of such large pieces of photographic material can take place in simply made wooden tanks lined with heavy plastic, or arrangements can be made for a commercial mural processing house to machine-process each piece. Fabric-based emulsions are perhaps more easily handled, being processed gently in a large plastic bucket; when washed and dried, they probably need ironing with a cool iron on the reverse, non-emulsion, side. By obtaining wide rolls of diazo material such as Ozalid, used in the architectural drawing or reprographic industries, and exposing these to strong ultra-violet light, life-size positive photograms are easily made. Remember, of course, when working with UV exposing sources, it is absolutely essential to take note of safety precautions, particularly protection of the eyes and skin. Such reprographic material once exposed, can be taken to a commercial diazo printer and run through their automatic machine for a small cost.

THE WAY AHEAD

As the twentieth century draws to a close, it is certain that a revolution will take place

101 *An example of a photograph direct from a computer system by the use of a simple TV camera.*

nearly as dramatic as the original invention of photography, and it will be based on non-silver, electronic processes. This does not mean that conventional silver-based imaging systems will disappear or that they may not form part of a chain in the process of obtaining 'hard copy' from electronic systems but, for utilitarian images in the field of communication, it is not in doubt that electronic instant images will replace much of the silver emulsion technology.

Under pressure from space exploration needs, a device called the 'charge couple device' (CCD) was developed which transposes light collected from a glass optic system into a system of numbers. These numbers can of course be transmitted, recorded and reconstituted electronically into startlingly accurate photographs. Definition may be en-

hanced, colour modified or intensified and there is a degree of controlled interference possible with these images not available to workers with conventional photographic chemistry.

In the commercial and leisure worlds, still pictures formed electronically and printed instantly are becoming commonplace and very advanced technology is available with pictorial computers which now provides geometric perspective and continuous tone images. These are constructed on the video screen and often permanently recorded by use of a Polaroid printer which obtains its image directly from the electronic system.

Colour fidelity and image acutance suffers somewhat in comparison with conventional silver-based chemistry and photographic optics, while the electronic image may not have great stability if stored for long periods, but the ease and immediacy of the image usually overcomes any reservations about the aesthetics and craft content. For mass use there

could well be a lowering of standards for assessing all photographic images and a general acceptability of what many serious, present-day photographers would regard as inferior quality pictures, but a revolution in visual communication is, nevertheless, certain to be with us soon.

The new electronic imaging systems make possible the recording of photographic-style still images on a magnetic disc, using an FM modulation recording system similar to that used in video cassettes and the floppy discs of computer software. The standard, solid state photographic disc weighs about 8g ($\frac{1}{4}$ oz) and measures only $60 \times 54 \times 3.6$mm (about $2\frac{1}{8} \times 2 \times \frac{1}{4}$in.) in thickness. It has very little tolerance to exposure errors and at present has shortcomings in the matter of image contrast and the image acuity, but there is likely to be a rapid progression in product improvement and marketing strate-

gies, which will place electronic imaging on a very competitive basis with normal optical cameras and silver image emulsions. It is not, thought, however, that electronic equipment will mean the demise of conventional optical photography, except perhaps in the information industries.

Far in excess of anything George Eastman ever dreamed of when he caused the massive induction of photography into our culture with his cheap roll film camera, the giants of electronic commerce have produced the means to give every family a cheap, portable colour imaging capability, the results from which may be electronically transmitted within seconds anywhere in the world or merely be reconstituted on the family television set. Visual literacy is about to take another giant step forward in the history of mankind.

8 Communication and Design

Photography has become the natural medium in almost all advertising, propaganda and commercial communication activities, influencing people everywhere, crossing barriers of language and culture. Seeing is believing. A picture is worth a thousand words. The photograph never lies. So the clichés run, but so runs also one of the traditions of our modern existence, as we pass from a word-orientated to a picture-orientated society. The camera has become today the expert, invincible witness to reality and truth. Visual evidence, in the form of photographs, has been used to exert pressure on governments; has helped to re-write social contracts; has given notice of unsuspected community poverty, or the distress of neglected nations; or has brought to our armchairs the vicarious horror of large disasters. The machine image has become the supreme and sacrosanct messenger, bringing information, explaining or glamorizing distant events, daily affairs and consumer products.

In advertising and commercial communication, the photograph has become an essential tool of the marketplace, part of a network of highly planned and complex transmissions of ideas and aspirations, without which no large company could survive. In marketing terms, when the photograph performs its role correctly, goods are sold, services are in demand, factories and people are paid to produce. However, when the image is less than effective, little is sold, lay-offs and short time reduce social standards in the community and factories have long periods of silence. In a very real sense the commercial photograph can greatly influence society.

The machine image, contrary to our steadfast intuition that it is reality incarnate, can be manipulated or organized, edited or constructed to fulfil any assigned role in media. It can be designed to perform precisely at any social level. Commercial photography, particularly in the advertising industry, is not a passive or optimistic accident in the chain of communication.

The photographer (usually professionally employed) who is selected to provide media pictures will normally be recognized as a specialist within a team of other specialists and will not often be asked to produce original creative ideas or concepts. What will be sought from the photographic team member, however, is a level of technique far above normal and a dedicated skill not needed in most other areas of photographic interest.

Until the invention of artificial photographic light, the use of photography in communication was heavily restricted. As flashlight became available to studios in the 1930s, as the film industry progressed and experimented with increasingly sophisticated lighting units and as the stills photographer demanded more and better lighting, so it became possible to photograph objects, people and complete environments successfully with controlled indoor lighting and thus dramatically increase the use of the photograph in the affairs of commerce. It is still largely true today that indoor photography is the basic functional tool of modern communication.

Those who offer their photographic expertise to this segment of the photo-market will need to have passed well beyond basic black and white and colour techniques. They must also be equipped with a medium format and large format camera with systems and accessories for both, and suitably varied sources

of light, and have a controlled environment in which to work. This studio will have to be designed to suit the main activities envisaged by the photographer, many of whom narrowly define their special interests. Large areas, for example, are needed by the car or truck photographer and a clear floor space of 90 sq.m (1000 sq. ft) would probably be a minimum, with a ceiling height of 6m (20ft). This type of studio is needed also for room-set photographers who employ carpenters and interior designers to construct complete rooms in which to photograph products or activities. Those who photograph situations with several actors or models, need a working area at least 8m (25ft) wide with a depth at least the same; say an area of 50 or 60 sq. m (500-65 sq. ft). Portraiture and character photography of individuals can be reasonably controlled in half that space and the still life photographer probably needs a

102 Left Communication in advertising can be built up by a series of visual clichés or symbols. This photograph formed part of a British parcel carrier's campaign to talk about an export service for high-value, small packages.

103 *An advertising photograph in a built-up studio set – very typical of the normal output from an advertising studio.*

clear shooting space of 15-25 sq. m (200-500 sq. ft), but with an equal amount of area devoted to storage of props.

Large spaces need powerful lights and most studios are equipped with both tungsten and flashlighting of considerable sophistication. Add to the above, costly necessities, additional space for darkroom, offices, storage and changing rooms, plus ancillary equipment, and it will be seen that modern-day commercial photography is not for the timid or the under-financed.

In one of my earlier books *Creative Techniques in Studio Photography* (B.T. Batsford Limited, 1979) the practical needs of professional photography are discussed more fully than is possible here and it may be helpful for those setting up new studios to take particular note of comments in Chapters 1, 9 and 10.

The photographer seeking professional assignments will find a generally agreed classification within the industry which has two main divisions: editorial and commercial,

with commercial being split by a further sub-division of classes into advertising and mercantile activities.

EDITORIAL ASSIGNMENTS

Editorial photography is reasonably well paid for freelance workers, and possibly less competitive than commercial photography. Contracts are sometimes given by magazines to outstanding photographers, while this is rare in advertising and most merchandising photography, making the economic life in the higher fee areas of commercial photography a somewhat chancy affair.

Editorial work for magazines and book publishers feeds the creative ego of the photographer to a far greater extent than other professional photography, as editors often seek ideas or accept suggestions for visual

104 *An editorial photograph to be used as a full page in a story about ethnic jewellery.*

treatment from their regular photographers. Provided the editorial concept is not weakened, the photographer may often decide how and where the picture is to be done and who will appear in it if models or actors are needed.

Fees, copyright and reproduction rights

Editorial clients are found by presenting a portfolio of the photographer's work to the art editor or editorial staff at the magazine. This may be done in person or by the use of a reliable agent (who also may have other photographers to represent). The agent may make a better verbal approach to the editorial market than the photographer and have more competence in discussing fees, copyright and reproduction rights and also must understand the visual material and be sympathetic to the photographer's creative aspirations. Agents generally demand 20 or 25 per cent of any fee from any assignments arising out of their efforts and normally seek contracts with good photographers. A contract between photographer and agent should not be considered until some work has been generated by the agent's efforts and should, at least in the beginning, be for a short term, say 90 days or six months' duration. Contracts should, of course, be written, be legally binding and be prepared by competent commercial advisers such as an accountant or lawyer.

Agents or photographers who represent themselves should be very wary of the intricacies of copyright and make it absolutely clear in writing where the copyright of an assignment lies and what reproduction rights are attached to the pictures in terms of time limitations and geographic restrictions. Thus, rights for one year limited to a national or continental zone, would draw a lower fee than those pictures which were to be reproduced world-wide. Limited rights allow the photographer to offer the same photographs again when the original client's rights lapse. It is particularly unwise to allow magazines to provide film material and processing as in some countries this awards copyright to the owner of the film stock or gives them control over the material, while

105 Right *A simple, strong editorial photograph full of textures.*

the photographer retains control only over the image itself.

When delivering finished work to magazines, mark every print or transparency with the word 'copyright' and the photographer's name and address. If possible, list every subject submitted and keep duplicates, which are used to check material when returned. Unused material and out of time editorial work can then be offered to picture agencies or other magazine clients provided it does not conflict with either the legal or verbal arrangements between photographer and primary client.

Picture agencies are a growing source of income to editorial photographers and will generally accept trial packages of work from any competent photographer. Frequently their preferred format will be 35mm as this is very acceptable to most of their magazine clients. Picture agencies who deal largely with the advertising industry may state a preference for 6×6cm or 6×7cm format. Almost universally, picture agencies and picture libraries only accept transparency material, as this is most easily and economically filed, retrieved and presented when needed.

The new photographer could agree to provide a theme of subjects or a complete story but most magazines prefer to commission story-telling pictures directly with the photographer. Subjects which are known to sell well and continuously in picture agencies include: pretty girls; action sports; marine sunsets; tropical scenes; high-quality nature pictures of flora and fauna; and all cliché pictures of romantic couples. Whenever a person is identifiable in the picture, a written 'release' must be signed by both the photographer and the person in question, which clearly states that the photograph may be published. Agencies and libraries will not usually accept photographs of people without such a document.

Unlike work for magazines which must be reasonably topical even if not necessarily newsworthy, the average requirement for picture agencies and libraries is for photographs which have universal and lasting appeal. This means that fashions should not date the picture too closely, landmarks should not be prominently identified, buildings should not be too clear and so on. It often takes one to two years for a picture

library to obtain a successful placement of new work for a photographer and images can often be current for more than five years. The agency and the photographer come to an agreement to share any fees arising from picture sales and this could be on the basis of 50/50 per cent or 60/40 per cent (in the photographer's favour). These arrangements should all be for a defined period and always should be the subject of a written agreement signed by both parties and witnessed.

Book publishers also form an important part of possible markets for editorial photographers and although they may not pay fees on the same scale as magazines, the frequency of work is often much greater. Editorial needs in the book publishing field usually run to jacket covers with a high degree of illustrative or narrative style and, in some cases, photographs inside to support the text. Publishers and their production services handle a large volume of pictorial matter every week and they can be somewhat careless in the way they process the photographer's work. Loss of, and damage to, transparencies is a hazard which the photographer has to accept. So, always list all submitted work by subject and description, put a replacement value on each transparency or print which reflects its true worth, and state clearly all copyright restrictions and assigned rights. All of this above information should be submitted as a written document accompanying photographic material. Keep a duplicate list of this information.

Equipment

The cameras which editorial photographers will require most, are those of small and medium formats with very comprehensive systems accessories and a selection of sophisticated lenses. Lenses tend to be concentrated on the extremes of wide angle and ultra-long focal lengths and to be very fast. Film will probably be fast to hyper-fast, both in colour and black and white, ranging from 400ASA to 2000ASA in colour and up to 4000ASA for black and white. Excessive grain is often present in such fast film material but is used creatively to enhance the feeling of immediacy in the picture and is rarely a technical problem.

Editorial photographers are often involved in expensive location trips or are working

with privileged access to people and places and failure to bring back results would be disastrous to magazine deadlines. For this reason they tend to expose much more film on a particular subject than perhaps do commercial photographers. Whereas commercial photographers usually have precise background knowledge and detailed client briefing, the editorial photographer stalks the subject as it appears before the camera and as it reacts to it, often probing various physical or psychological aspects with the use of different lenses and different viewpoints. Routinely, editorial photographers shoot two normal exposures and one extra frame each of over- and under-exposure. The large amount of film throughput which this generates often requires motor-driven winders and the sound of these is almost the trademark of those working for the magazine industry. These expensive accessories are no luxury, but help to clear the mind of the photographer so that more may be thought about the complex problems before the camera.

Indoor lighting for editorial work will usually be compact and lightweight. Fast film requires only small volumes of light and many photographers who are in this field can consistently work with existing light which is then augmented as needed with flash or floodlight. An average size suitcase can contain most lighting needs for this type of assignment.

Editorial photographers generally carry a generous supply of special-effects filters, such as are made in systems by B+W, Cokin, Hoya or Tiffen. These should be used with moderation bordering on the abstemious, as cliché images and easy tricks are a constant hazard with such equipment.

Editorial requirement

The task of the good editorial photographer is to be quick thinking, but deep thinking also and, above all, to be original in a technical sense. Most editorial clients judge their photographers by evidence of this and particularly by their most recent submissions. Editors are ever ready to cease to use those whose work depends on a trendy image style which quickly becomes passé. The editorial photographer, unless of great renown, will generally lose artistic control over any work accepted by a magazine or publisher. This

106 *Book jackets usually have a high narrative content, often a visual précis of the contents.*

means that scale, cropping and aspect ratio will probably be decided upon by arbitrary factors, such as headline style, text presentation, advertising space nearby, and so on Those photographers who are deeply committed to designing their images in the viewfinder to a point of absolute completion and who are deeply wounded by a bad page presentation which may radically alter their image, should not work in modern editorial markets.

A decade ago, picture space in magazines was always generous, the copy support often miniscule. Readers wanted the extravagance of opulent double page pictures, the photograph was properly understood by the magazine production staff and reproduced well.

119

These sensational images played a leading part in marketing the magazine and improving circulation. Today's magazines are much more concerned with hard information than fantasy and golden dreams. Instead of being image-orientated, most are now word-orientated, and photographs are frequently very small and very straightforward, merely supporting a detailed text. Part of this change of style is because of economic pressure, part through lack of visual literacy among editorial staff, but mostly it is due to the fragmentation of the pages into an easily accepted mosaic of text and images which allows greater reader participation, but at a fairly shallow level. Big pictures in magazines demand high level skills from all who create and produce them and impose on the reader a most definite and individual point of view. It may be that such lavish image style is now a thing of the past in most magazines.

THE MERCANTILE PHOTOGRAPHER

Commercial photographers who deal mainly with mercantile assignments such as public relations, insurance records, architectural interiors, financial reports, trade brochures and catalogues, will no doubt often work in close parallel to editorial photographic styles, needing the same routines and some of the same equipment. However their clients generally require hand out prints of greater clarity or exhibition prints of large size and there is always the possibility of quality lithographic reproduction. For this reason such work demands a single lens reflex of medium format even for black and white photography. This could either be 6×6cm ($2\frac{1}{4} \times 2\frac{1}{4}$in.), 6×7cm ($2\frac{1}{4} \times 2\frac{3}{4}$in.) or 6×4.5cm ($2\frac{1}{4} \times 1\frac{3}{4}$in.). Reliable manufacturers of such equipment include Hasselblad, Rollei, Bronica and Mamiya. Mediumweight tripods are needed at times to support such cameras and a good range of lenses such as 40–50mm (wide angle), 80–100 (normal) or 150–200mm (long). Perspective control shifts on these lenses are invaluable, remote motor-driven film transport and tilting of the lens panel are also ideal attributes. The most adaptable camera of this kind on the market at the present time of writing is probably the Rollei 66E which, although it doesn't have the motorized winding facility, does have the

other features, plus excellent close-up ability and highly regarded film plane metering.

Commercial photographers often become general practitioners in the business, spreading their interests widely over the complete field. Their fee structure is usually higher than editorial photographers and they often supply a full colour and black and white printing service for clients. Usually, income is based on long-standing associations with special clients and contracts are rarely given. Assignments are awarded on a job-by-job basis. Earlier remarks about copyright and submission of work also apply to commercial assignments. Such photographers are often greatly concerned with a client's products and their respective presentation to possible consumers, with the consequent need for detailed pictorial information about the physical attributes of the object or how it should be used. This means extremely competent studio lighting control is certain to be needed with large, broad source units, wide floods and some specular light from spotlights. The emphasis will probably be on a diffused lighting style reminiscent of daylight with both top and cross lighting. Such lighting is very suitable for metallic or shiny materials, yet renders the tactile qualities of other surface textures with considerable refinement.

A commercial photographer's success depends on productivity, quick turn-around of each assignment and a high throughput of clients. This requires of the photographer considerable organization and logistics, ability in handling staff and reasonable business skills. Techniques are better if they are simplified. For example, one basic black and white developer for negatives, one for print and no more than two types of film stock (ASA100–200 and ASA400) in black and white or in colour. Filing and retrieval of clients' work should be based on long-term storage needs, as such photographers are often asked to keep original negatives and transparencies over lengthy spans of time. Studio space must be very tightly organized and always impeccably kept, as business clients frequently come from quite luxurious office surroundings and may lose confidence if the studio is unappealing or in any way doesn't measure up to their usual standards. The same is true of meetings with clients on their home ground for presentation of

107 *Typical of many assignments for the advertising photographer who makes complete trade brochures. The client often asks for a 'product' shot which details the object itself (above) and then a product-in-use shot is often required (right). This picture was set up in the studio with professional models.*

portfolios or discussion about work in hand. Neatness of appearance counts highly in business circles and conventional clothing or conservative behaviour are re-assuring to such clients, even when placing creative work: business clients demand business-like treatment from all their suppliers, including the artistic ones. The client will usually need to supply detailed backgrounds for each job, explaining technical matters about working products, marketing aspirations and the way the photographs are expected to be used. This should be listened to with great care as only the client can be considered an absolute expert on this subject. Take notes of all relevant matters and send written confirmation of agreed action by return of post to the commissioning executive. This confirmation should be particularly clear about fees, copyrights, terms of payments, expenses and delivery of finished work.

When photography commences on any commercial product, that object becomes the focal point of the whole exercise. As such it must be in perfect condition – all surfaces unmarked, labels on straight, accessories of suitable colour and style should be attached

in a technically correct manner. This could mean obtaining several examples of the same product and separate labels or accessories in mint condition from the manufacturer. Complex photographs may require a specialist from the client to assist in setting up and operating the product. Many household objects are shown in sequence pictures to demonstrate use or assembly and, even in these, the product must be so well lit and so perfectly prepared it dominates every picture.

In working to prepare or present a client's product it is wise to remember that most communities have stringent consumer and trade description laws, with very vigilant observers to see that these are upheld. The client takes final responsibility in such matters so may reject any photographs that could

be misleading or untrue representations of either goods or services and it is extremely important that the photographer does not make use of any unacceptable tricks of disguise in connection with the product.

Many times on commercial assignments, products or services need to be demonstrated with people and casting such actors needs some care. Always cast to complement the product and choose normality in their character rather than any notable eccentricity because any particularly outstanding character may upstage the product. It is best to avoid using amateur models who may be obtained for little, or no, money but who generally inhibit the shooting session and who often end up looking self-conscious or uneasy. The person who demonstrates the client's product or services for photography must completely harmonize with them and occupy a supportive role in the composition. Only professional models will have the training and skill to do this, but of course where the assignment requires large numbers of 'walk-on' people, such as in a restaurant interior shot or if the action takes place in a party atmosphere, amateur models are usually chosen. A model release must be obtained from each and of course they still must be paid, but on a lower scale than professionals. For such assignments it is wise to hire one or two professional actors or models who can mingle in a general way and who can create lively action on cue or provide a focal point for an entire scene.

THE ADVERTISING PHOTOGRAPHER

Those who aspire to be advertising photographers embark on a commercial photographic career which generates the highest fees of all, but this kind of photography also produces the greatest stress, both physical and mental and presents the greatest technical challenges. Although most advertising photographers will specialize in one style of photography, working as still life photographers, location photographers or situation photographers, within those groupings they will narrow their interests even further. They must be highly confident and competent to deliver the best work at all times and have very well developed logistical and management skills, be articulate with colleagues and clients, have access to the most sophis-

ticated techniques and equipment and have great physical endurance.

Advertising photographers always require studio space and this could be custom-designed for the speciality of the photographer or the space could be rented as needed from professional studios. The advertising industry is notoriously relaxed about the premises of photographers and, for example, location photographers need only a small business office or a tiny studio space. It should be a matter of professional pride, however, that the premises are clean, well-maintained and adequate for the technical purposes required. Those who are concerned with still life and situation photographs depend usually on artificial light and will need a much more elaborate studio, fully equipped with heavy-duty flash, large, medium and small format cameras, ranges of precision lenses, and so on. If a still life photographer specializes in food subjects, a modern kitchen is also needed, preferably equipped with two cooking tops, two ovens, two refrigerators and two freezers.

Advertising agencies

Advertising business is obtained by photographers in the same way as is commercial and editorial business – a portfolio is presented of the best and most recent work. An advertising agency is usually the photographer's direct client and most agencies prefer that the photographer should not be involved with their client who is the final commissioning client and who provides the money for the whole exercise. A portfolio should therefore be designed to impress the professionals of the advertising industry who will be excited by obviously sophisticated techniques, creative composition or clever solutions to standard problems. The portfolio is usually shown first to the art buying department of an agency and then, under their guidance, to selected art directors. Several visits will have to be made over a number of months before any work will be given.

The portfolio should be loose-leaf so that it can be constantly re-arranged to change emphasis in presentation, should be part print material and part transparency and be accurately prepared with black mounts for transparencies and plastic laminations over all print material. Each sheet of the portfolio should be clearly marked with the photog-

rapher's name and address and the whole should be contained in a suitable case, also marked with clear identification. The portfolio is almost the only way that an advertising photographer obtains work, and the cost of preparing one can be greater than buying a sophisticated camera. For those reasons and because it can be commercially very damaging if the portfolio is not available at all times, it is unwise to leave the portfolio with clients longer than a few hours and delivery and collection should be entrusted to reliable people. The portfolio must be insured on an 'All Risks' policy which permits complete replacement of lost work.

The content of a portfolio should be a mixture of 'tear sheets' from work that already has appeared as advertising, and 'test shots' for campaigns which were planned, and perhaps may not run and the photographer's own choice of his best work, some of which may show new creative ideas. The agency will be looking for reliable photographers as well as clever ones and will be impressed by those who include successful work in the industry as part of the portfolio. For each presentation the portfolio is shown in a planned sequence. First to hold attention, then to re-assure the client on matters of technique during the main segment of presentation and finally, in a short closing phase, evidence is shown of creativity and original thinking. Ten minutes may be the maximum time available for such meetings so the event must be minutely planned.

If work is awarded to a photographer, a 'briefing' session will follow at which the whole project is discussed, financial matters agreed upon and a schedule set out for the assignment. Do not proceed past this point without agreeing fees and expenses and obtaining an official order confirming such arrangements. Never begin advertising photography without all the paperwork being fully completed.

At such a briefing, a 'layout' will be shown by the agency and this will usually be the same size as the actual magazine page or may be scaled down if a poster or billboard is the object of the exercise. Layouts show type positions, pack inserts, body copy, colours, and usually typecast people who may appear in the picture. The object of advertising photography is usually to realize the drawn layout in terms of finished photography,

even going so far as to copy camera angle, spatial design and so on, as closely as possible. The photographer becomes part of an expert committee who is entrusted by a commercial management to bring to the magazine page all the complexity of the agreed message to the consumer and the idiosyncrasies of individuals are, of necessity, submerged in the group discipline needed for this exercise.

Such creative teams are usually led by an art director from the advertising agency and, as well as the photographer, may contain a copy writer who has probably written the

108 *An advertising photograph created after considerable discussion with client and agency.*

concept; an advertising liaison executive from the agency who is responsible for day-to-day client contact and budget management; a stylist who specializes in setting the mood and style of the art; and, in some cases, a hair, make-up or beauty expert or other specialist where the product needs to be flawlessly prepared in a particular way. The final commissioning client may also nominate a company executive, usually with marketing experience, to make sure company policies or points of view are not neglected.

The photographic session

Unless the photographer is very experienced in the advertising business an art director will always be present during the preparation or actual photography sessions and usually the practical team is much larger than the

109 *An entire campaign may be built around a photographic theme. Here the quality of light is very much the major ingredient in each picture, and the same model and image style was used for six advertisements in the campaign.*
(Photographed on 35mm colour reversal film.)

planning team. Wherever models are to be included, a casting session is needed beforehand, frequently for the benefit of the photographer and art director only. At this meeting all models and actors are interviewed, sometimes they are photographed on Polaroid, and a shortlist is made of those who are required for a 'call back', second interview or for a final presentation to client. Professional models will always have agents, and financial agreements are settled with them, usually against a published rate card, with extra fees being awarded to the model for exclusivity, poster use, nude modelling, and so on, all calculated at the time of booking. A model release must, for every person appearing in advertisements, be signed and witnessed before the model leaves the final photographic session in the studio. This release must grant permission to the client to use the photographs, must indicate the name of the model, photographer, products and advertising agency and must clearly state how much has been paid in model fees. Such a release is a legal document and should be prepared by professional advisers in law or accountancy.

Wherever the product is included in a picture, whether as a close-up or far away in the hands of a distant actor or model, it must be perfectly prepared. The advertising value of a photograph will be totally destroyed if the product is not presented to perfection. Should the photographer not do this well, expensive re-touching or even re-shooting may be needed, probably at the photographer's own expense. All outer packs to be photographed must be obtained direct from the package printer in flat or unassembled condition. These are then put together in the studio and kept in mint condition. Inner packs, bottles, small products, and so on, receive the same careful treatment and should be meticulously inspected for any defect or damage well in advance of the photographic session. New labels should be obtained separately for all products, again direct from the printer, and these should replace existing labels on products and be accurately aligned (to a tolerance of millimetres) on all packs to be photographed. The closer the camera to the product, the more care must be exercised in preparation as the camera will exaggerate fingerprints, scratches or surface damage to an extraordinary degree.

Lighting for advertising becomes especially intricate sometimes for the product must be seen clearly, yet the advertising concept must not in any way be lost. This often means that the product and environment are lit separately, but the whole composition must be blended with a hierarchical plan of lighting, clearly structured to allow every element to play its allotted part with the precise emphasis required. Advertising photographers use very large lights, sometimes 2 × 3m (6 × 10ft); they also use very tiny lights, sharp projection spots, long narrow lights, ring lights, and so on, to achieve the exact mood and light form needed for a desired effect. If the industry cannot supply a special light, the photographer generally makes one.

The advertising photographer always works for reproduction - sometimes in magazines, sometimes in newspapers - which have little finesse in rendering tone, brilliance or contrast and during the actual photography session compensation must be made for this fact. Lighting will be blander, shadows more open, highlights more softly rendered. Lighting ratios are kept in the realms of 3:1 ranging to 5:1, for clearly informa-

tional advertisements, but could rise to 16:1 for very moody or theatrical compositions. With a 16:1 ratio, only the highlight (1) would reproduce effectively while the shadow (16) would drop out to black or grey which would have no detail at all. Colour photographers must particularly guard against excessive contrast in any prints or transparencies supplied for reproduction but, on the other hand, black and white prints supplied for reproduction must have improved contrast, as there is considerable loss of contrast in many mechanical photo-reproduction processes.

Colour accuracy for advertising is sometimes taken to extreme degrees with test transparencies of filter and lighting trials being made beforehand. Still life subjects often remain in the studio for several days while these trials are completed and this must be reflected in the fee charged for the

110 *An advertising poster for medical supplies was made from this photograph. The lightfall had to suggest the high-intensity top light common to operating theatres.*

work. Many products containing dye materials react to photographic light and emulsions very differently from the way the eye perceives them and it may be necessary to change film manufacturers to solve this problem, as well as to filter lights and camera against colour bias.

Although the photographer may appear to be tightly confined within the intense discipline of an advertising brief, there is much that can be done during the actual photography session to improve a client's layout presentation without destroying copy concepts. Advertising photographs are not scientific investigations of reality but a mosaic of form and content, a quantity of informational and psychological data within one frame of reference.

The environment for the product, for example, can be created and styled with infinite detail to suggest the logic and narrative of the copy concept. This means effective research and considerable experience must be combined to produce exactly the right colour, the right age, the right shape for everything appearing in the picture. This environment must be perfectly lit to suggest the time of day, the ambience and the historical moment in which the product is to be found.

The product can be seen in action and this will always draw attention to it. Blurred movement is about the context of action, suggesting a continuity of uncompleted events, while frozen movement looks at the action itself and analyzes it, indicates its beginning and its future. Ideas in action may be presented sequentially with a stroboscopic effect, showing a completed progression of analytical moments contained within a master design of action which is open-ended and flowing. These modern images are rarely contributed to advertising campaigns by anyone other than the photographer and they are often the images which create the strongest impression on the viewer.

A photographic advertisement can state the drama of product usage and be noted for this; it can reflect the size of the company or

11 *The use of a sympathetically styled environment creates an ambience around this food picture and produces a photograph of great credibility for advertising a food product.*

that it has expensive taste in photography; it can emphasize reliability and friendship with the consumer; it can suggest adventure and modern thinking but, as a general rule, the photograph itself should not be noticed in an advertising context for either good or bad reasons. Such photographs should have a quiet approachable style, be a collective statement about the manufacturer, its product and the customer, and be a statement which lasts. Advertising photography must be supportive to copy concept and be a conduit for the commercial message. It has no other function.

Image management
Compositional concepts Compositional concepts reach very sophisticated levels in order that the photograph should fulfil its role, and image management becomes the most important factor in the whole exercise. For the purpose of understanding management of images and compositional control of them, it is possible to classify broadly four styles: (1) **Classic**, which are sharp edged, conventional and logic-related. Classic images suggest the real world of three-dimensional form, textures and contours and are about *reassurance* and *confidence*. They can be optically and emotionally cool. (2) **Impressionistic**: these images are about *colour* and *mood*, suppressing details and visual clues. They are emotional and subjective, needing intuitive responses from viewers. They are based scientifically on the acts of perception and vision where the eye gathers information by sharp, stabbing, half-glances and the brain organizes it. (3) **Surrealistic**: reality is far away in the unconscious of both photographer and viewer. Dreams, fantasy and symbolism are ever present. Such pictures use *juxtaposition* and *shock* to seize attention. (4) **Expressionistic**: images which are full of sentiment, action or feelings, conveying emotion directly to the viewer. They are about *theatrical events* and *entertainment* and use simplified or suppressed form to create effect. Classic images are objective, the other three largely subjective and all need technical and compositional tools to produce the desired response from the viewer.

Technically to produce the classic image, it is better to use large or medium formats, medium to fine grain film, long lenses (two to four times normal focal length) and

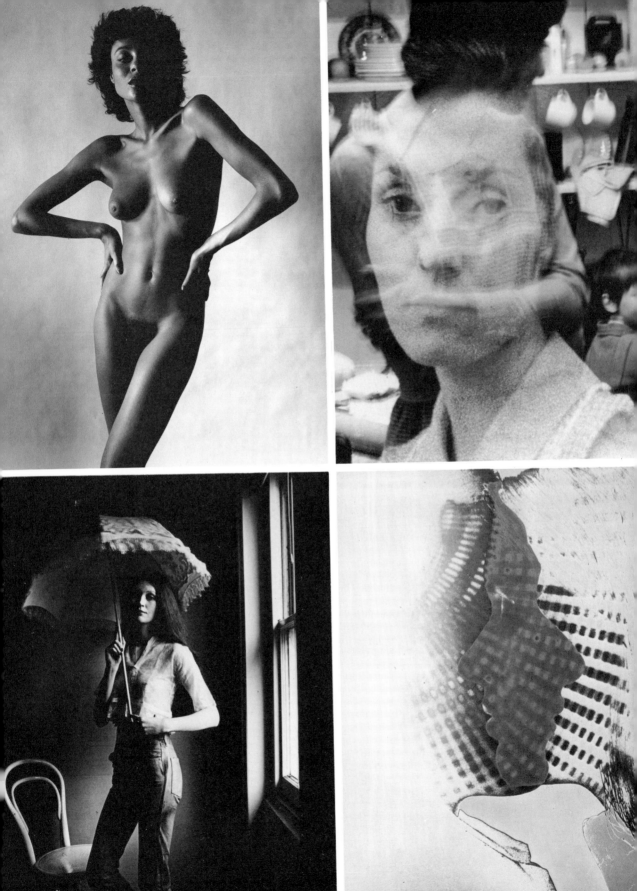

strong, but diffused, cross-lighting of daylight quality. Colours are built on analogous harmonies or multi-point natural harmonies, with an equitable distribution of the most saturated colours around the format. Camera angles tend to be 50 per cent above horizontal or higher, and deep focus, clear optical structure, is employed.

Impressionistic images are made on small cameras, 35mm or smaller, with either very fast or very slow film and slow to very slow shutter speeds. Grain may be exaggerated by high energy developers, optical purity could be suppressed by diffusion filters on the lens or vapour introduced into the atmosphere. Lighting is arranged for mood with soft highlights and obscure shadows. Colours are smoky, gently harmonized on triadic forms and tend to have a lot of neutrals as background screening. High peaks of excitement are suggested by definitive colours which are found adjacent to primaries on the colour wheel, such as orange (next to red and between yellow), turquoise (next to blue and between green), purple (next to red and between blue). Camera angles are often near to eye level.

Surrealistic images are frequently the product of liaisons between photographers and re-touchers and, for this reason, are mostly photographed on medium format cameras or sometimes on large format view cameras. Lighting can be strongly directional, emphasizing textures and tactile values and can either be diffused or sharply specular. Usually the image must be manipulated in some way, either by the use of a matte-box for in-camera montage, double exposure techniques in camera or darkroom, collage by re-touching or construction or by skilful compositional placing of radically disassociated objects. The photographic exercise is devoted to fragmentation of form and concept, rather than the integral harmonies which accompany both classic and impressionistic images. There can be several camera viewpoints within the same frame and lenses are frequently wide angle, but also could be of differing focal lengths in the final assembled image. The objective for the surrealistic

112 *Images can be broadly classified into* (a) *classic*, top left; (b) *impressionistic*, top right; (c) *surrealistic*, bottom left; (d) *expressionistic*, bottom right.

photographer is to shock and symbolize, which means colours are drawn from complementaries on opposite sides of the colour wheel or deeply saturated triadic primaries are used. Some dream-like images may need analogous harmonies with single, striking colour elements which enhance symbolism or surprise.

To make expressionist images, the photographer may require quite complex technical equipment or almost every camera format made. In this work there is a need for bold textures and strong form, which can only come from using the analytical qualities found in medium or large formats. Yet suppression of much of the image detail is also often an essential part of expressionistic compositional control, and this is achieved by the use of dense shadows, coarse lighting ratios or ring flash to flatten forward-facing contours. Two-dimensional form and edge emphasis can be explored by darkroom graphics, and time can be re-structured by the use of stroboscopic cameras, stroboscopic flash, shutter blur or combinations of all of these. All types of film are needed, various precision developers also and specific papers for printing. A much larger darkroom than may perhaps be normal for most advertising work may be required.

Small-format cameras would be useful for those images where colour was to be the primary compositional tool. Colour harmonies in expressionistic photography tend to be very bold, except where the expressive qualities of the image dictate a much softer and more intellectual approach. Camera viewpoints tend to be below 40° off horizontal and image space is always very tightly edited. Expressionist images need strong structure and the stimulus of concealed power in the image plus a definite visual opinion from the photographer.

Reality for the expressionist photographer lies within the soul and is recreated externally by the skill of the artist. Expressionism seeks to distil and then make visible the essence of a subject and is concerned with empathy, synthesis, transience and latency. Such images are very compelling and could be useful, for example, in the illustrations for banks and financial institutions, charities, community services, and so on.

Compositional controls Such deep involvement in advertising images makes it

necessary for the photographer to acquire superior compositional controls. The most basic of all of these will be the camera viewpoint. A high-angle view, for instance, attracts the intellect, appeals to the innate sense of design in a viewer and is analytical and informational. A low angle for the camera, on the other hand, appeals to the emotions, is concerned with hidden values in the subject, is anecdotal and not very explanatory or critical. High-angle viewpoints in advertising photography are concerned with *symbolism:* making visual telegrams for busy people; *information:* 'here it is, you do the rest' (participation); *documentation:* 'trust me, I was there'; *education:* 'we all have to know, let's get it right'. High angles are objective and often require classic-style imagery associated with conventional lighting and flawless optical technique.

On the other hand, low-angle viewpoints

are concerned with *narrative:* 'the old ways are full of wisdom'; they are *symbolic:* in the sense that they, too, use visual shorthand, but in a much more flamboyant way; they are *documentary*: presenting not the unassailable facts of the bird's-eye view, but reality as it really happens, what it feels like to be in the midst of reality; they are also *informational*, but disclose only partial contours, partial truths (participation, but in the sense of an adventurer, looking for a treasure-trove); they *entertain:* with a strong storyline or extravagant glamour: 'have fun, the circus is in town'. Low-angle viewpoints use unconventional and unexpected techniques to draw the viewer deeper into the composition and are more subjective and introverted.

For the deeper involvement in compositional matters and image management, which is necessary when designed images are contemplated for advertising communication, it is as well to consider some basic terminology. Definitions may be grouped into measurable or unmeasurable design elements, classified here as 'Tangible differences' or 'Intangible differences'.

113 *A high-angle viewpoint is intellectually interesting.*

Tangible differences

FRAME OF REFERENCE: an enclosure or perimeter in which the image lies

ASPECT RATIO: the proportional equation demonstrating a relationship between one side of the frame and the other

FIELD: the space enclosed by the frame of reference

FIGURE, OR FORM: object or form within or against the field

REAL SPACE: two-dimensional measurable space between the figure edge and the frame of reference; sometimes called flat space

PSEUDO-SPACE: three-dimensional illusory space between figure and ground or between contours; sometimes called deep space

EDGE: outline of the figure

AREA: two-dimensional space contained within the edge

SHAPE: combination of area and edge

CONTOUR: volumetric projection in multidirections, of area and edge

SCALE: relationship of the figure to the area of the field

LINE: boundary between the area of the figure and the area of the field

IMAGE COLOUR: harmonic structure of colours within the frame of reference.

GEOMETRIC PERSPECTIVE: an illusion of reality produced by a monocular optical device to symbolize the tactile properties of the subject

AERIAL PERSPECTIVE: an illusion of three-dimensional pseudo-space between figure and field or contours; symbolizes non-tactile properties in the image

OVERLAPPING FORMS: a depth clue created by overlapping tonal areas, edges or contours; creates pseudo-space

SEPARATION: a difference in tone or colour between figure and field, essential for perception

TEXTURE: illusory tactile values in the surface of three-dimensional form

PATTERN: similar tones or shapes which are repeated or grouped

MASS VOLUME: visual illusion of surface and weight

SPACE VOLUME: visual illusion of enclosed, internal space

IMAGE HIERARCHY: identified elements in an image arrangement which have one, clearly sovereign form, with other supportive forms arranged in descending importance

BACKGROUND: field at infinite distance

SIZE: image size measured against reality in life

RHYTHM: significant elements of an image organized to form harmonious patterns which suggest continuity

NUMBER: numerical count of similar elements within an image

IMAGE SURFACE: flat chemical surface of the photograph

POSITION: location of an element within the frame of reference

Intangible differences

IMAGE STRUCTURE: directional boundaries between figure and field, tone and space, which interact and form the totality of the subject

TIME: symbolic rendering of real time

SPACE-TIME: symbolic rendering of time plus distance

PERCEPTION: understanding what is visible

114 *A low-angle viewpoint is interesting from an emotional and a more theatrical point of view.*

VISION: stimuli reaching the nervous system through the eyes

MOOD: non-reality expressed in terms of lighter and darker tonal areas which convey the psychic values of the subject

CENTRE OF INTEREST: dominant positioning and arrangement of compositional elements of an image only sometimes near the centre of the frame

ISOLATION: giving to one form, total physical dominance of the image field

EMPHASIS: creating in one form increased psychological importance in the image hierarchy

SYMMETRICAL BALANCE: elements arranged in

131

equal tonal, spatial values on either side of the structural line to form a harmonious group

ASYMMETRICAL BALANCE: elements arranged in unequal tonal or spatial values on either side of a structural line to form a harmonious group

UNITY: the homogeneous grouping of elements to support a single concept

AMBIGUITY: image elements arranged to create contrary viewer responses and confusion

TENSION: dynamic structural differences in the image to create either harmony or instability

ILLUMINATION: the quality of the lightfall and its behaviour within the framework of reference

JUXTAPOSITION: unlikely associations of elements to create startling perceptual responses

MOVEMENT: elements of the image which are fragmented by soft- or hard-edged tone to suggest either the context or the fact of movement

LATENCY: hidden meaning and power behind the image structure to suggest potential energy

OPTICAL CENTRE: an off-centre point within the frame of reference which intuitively attracts attention

SYMBOLISM: an element in an image which represents something else unseen

ICON: the entire image area whether it becomes a representation or the condensation of concept

Image acceptance

These 'differences' are drawn from a consensus of opinion from many sources – such as educators, artists, designers, psychologists, physicists and physicians – about what makes an image more attractive, harmonious, repellent, shocking, outstanding, or in any way more noticeable than the billions of images that flood through our lives without creating a ripple of attention. 'Tangible differences' may be measured or observed; 'intangible differences' may only be deduced or comprehended by intuition. None of them work by themselves and they all interact,

modifying the behaviour of each other. The differences also interact with a viewer's own inner experiences by the use of symbolic modifiers and interact with the viewer's submerged level of unconscious vision after it has been gathered and stored. These illegible impressions from surface reality which are retained in the unconscious of both viewer and creator provide the catalyst which permits the modifiers and differences to perform their role in image construction and image perception.

The whole of this perception or understanding of an image is then filtered by other modifiers which are the product of the viewer's personal culture and that acquired from family, community or national sources. These changing and unchanging modifiers are constantly working, especially while perception is taking place. The more stable cultural modifiers could be classified as: *memories*, *moods*, *philosophy*, *experience*, *personality*, *taboos*, *intuition* and *logic*. The unstable cultural modifiers which are in a state of flux at all times could be considered as being concerned with: *sensation*, *thinking*, *intuition* and *feelings*. Acceptance of an image is influenced by all of these factors and what they mean to each viewer but it is further complicated by the fact that those who design the image, feed their own cultural modifiers into the image, particularly with regard to the intangible and symbolic modifiers. It can be said with certainty that most images mean something different for most of us, but all are translations of reality, never reality itself and so can be managed and constructed to perform a designed role in communication or art.

An image passes through five major stages when it confronts a viewer: awareness, perception, understanding, participation and, finally, acceptance. Advertising image design is concerned with acceptance but needs to be particularly successful at the third stage – understanding. Here is where the concept of the message is finally understood by the prospective buyer. The photographer or art director uses certain of the tangible or intangible visible differences in order to create attention-getting devices in the image which establishes the first step in communication – namely, *awareness* of the image. This is the earliest and primary connection a viewer has with new visual material. More differences

are then designed to follow on and to produce the necessary conditions for total *perception*. Perception is closely woven into the early stages of *understanding*, but it is to this nebulous third stage that the real skill of the image-makers must apply. Of course, understanding can lead to either acceptance or rejection and here the research and knowledge about a viewer's likely reaction to visual clues within the image is vitally important. If taboos are not activated, if memories are pleasantly aroused, if logic is not neglected, if mood is clearly stated, if philosophy and intuition are not challenged too much, it is certain that those who observe the image will begin to participate in it with its creator. And *participation* is just the beginning of *acceptance*.

Remember also, it has been said that there is more wit and wisdom and probably more art involved in a good advertising image than may be found in many a gallery painting. All photographers should welcome the challenges, opportunities and disciplines insisted upon by the more demanding of their commercial clients and never disparage the esoteric lessons of the marketplace. Learn how to see as well as how to look.

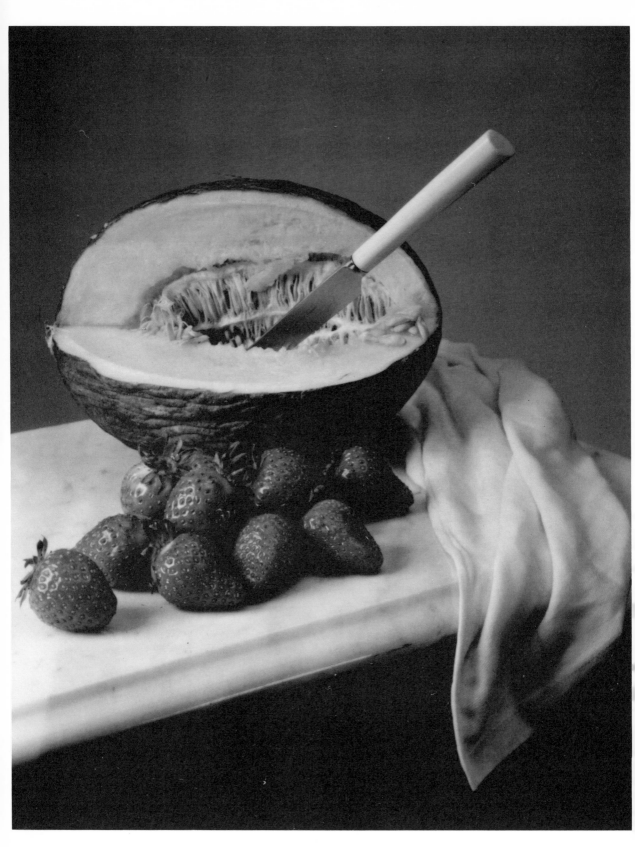

9 Life and Still Life

The French describe such subjects as *nature morte* and, literally translated, this could be taken to mean 'life which is dead'. No paradox there, just a philosophic echo about artists painting from life something which has recently stopped living. But, if we take the widely accepted meaning 'life which is still', we begin to enter a different world, one which is not dead, but momentarily at rest. Then, if we acknowledge Paul Klee's comment on the subject, 'a still life is never still', the paradox becomes evident. How can something still, which is frozen in place, have life? How can something living, ever be so still?

Still life, as a decorative painting style, was discovered amongst the wall paintings of ruined Pompeii and probably existed even earlier. During the evolution of European art still life subjects were to be found within the boundaries of large paintings, but rarely, if ever, as the total subject of the artist's canvas. Not until the seventeenth and particularly the eighteenth century did the still life become elevated to an important role in the mainstream of painting. Vermeer van Delft (1623–75), a master painter of incredible virtuosity, did produce outstandingly beautiful still lifes of simple household objects, but they were always part of a greater scene, surrounded by homely Dutch people and cosy interiors. Willem Kalf (1622–93) was one of the first of the Dutch painters to begin exploring the genre as an end in itself, experimenting with texture, colour harmonies and richly falling light. Still life began soon to interest other artists in terms of experiment, as a challenge to technique or as a working laboratory to test compositional theories. Although painted meticulously,

these early north European attempts at still life seem to be just that: exceedingly still and emotionally sterile and lifeless. In the depths of an arid pursuit for image realism, in the obsessional quest for a hand-crafted mirror of nature, which is so much the hallmark of these particular painters, the essence of life was lost.

It remained for a Frenchman, Jean-Baptiste Siméon Chardin (1699–1779), to bring such pictures to startling life. Flawless technique, humble subjects and an all-pervasive atmosphere of humanity and humility were bound together in exemplary paintings that reflect not only the simple style of the bourgeoisie life of that time, but the spirit and power of the artist as well. These pictures remain as masterpieces, studied through generations by painters for what they disclose of both art and life. Every photographer who wishes to become involved with still life subjects should become familiar with Chardin's paintings.

Gradually, the still life became more than a style of painting for a few specialist artists and a limited patronage, until, in the early twentieth century, the avant-garde, the experimentalists and the art anarchists adopted it as a major means of expressing their forceful views and explosive new techniques. Still life remains possibly the most wilful form of art, bearing witness to the moods and skills of the originator, for nothing appears in the frame of reference that has not been selected and edited to perform exactly as the artist wishes. This is both its strength and its weakness and mature artists approach this genre with some wariness. The still life element in the work of the following modern painters should be of interest to photo-

116 Opposite *Still life in a classic antique style.*

graphers: Cézanne, Matisse, Braque, Picasso, Gris, Magritte and Klee.

After a little thoughtful research, the methods of making outstanding still life for either photographers or easel painters soon become clear. Deep background will be needed about the subject, strong visual concepts are essential and well-presented narrative is of great importance. Meticulously prepared objects must be placed with infinite care, precisely where the composition will gain most benefit. The picture must have superficial repose but hidden within it there should be turbulence rather than tranquillity, vitality rather than rigidity or inertia. The composition must contain the dynamic harmonies arising when instability or tension are balanced by nobility and convention.

The image of a still life responds perhaps more to its frame of reference and aspect ratio than most other forms of art. Psychic structure, fragmentary meaning and tremulous immobility of thought evident within the composition must invite the viewer ever deeper into this mysterious window to humanity, which yet must never carry any direct representation of humanity itself. Truly, as Paul Klee says, 'the still life must never be still'.

In camera club jargon, the still life was always referred to as 'table-top photography' and regrettably this phrase is still to be found in some well-meaning books about photography. 'Table-top photography' suggests an amateur's occasional activities in kitchen or dining room on a wet winter's day after the meal has been cleared, using a standard 35mm camera, little concentration and no preparation. It in no way indicates the discipline, veracity and the controlled emotion which must be a primary part of successful still life photography.

EQUIPMENT AND TECHNIQUES
Cameras

Fixed-bodied cameras, whether 35mm or 120 format are not really suitable for many of the sophisticated optical situations which arise in still life. Whenever the camera is in a look-down position (and 90 per cent of still life compositions will require this) verticals will begin to flare out and there is no way of correcting the problem with small format cameras. Still life is also largely about texture and *trompe l'oeil* and small cameras cannot deliver the necessary quality in this respect. Of course, with close macro focusing and perspective control shifts now available on some 35mm lenses it is possible to overcome part of the problem and produce elementary still life pictures of some quality, but the breath-taking clarity and exciting, tactile values which are so important for the vitality of the image and which so much add life to the still life – will not be present.

The ideal camera is, therefore, the view camera, the most preferred probably being the 9 × 12cm (4 × 5in.), 13 × 18cm (5 × 7in.) or 18 × 24cm (8 × 10in.). These cameras use sheet film, have considerable movement potential of the lens plane and the film plane and, properly used, can deliver infinite control over focus, depth of field, image geometry and perspective, especially when used at distances under 2m (78in.). All such cameras are systems cameras, with elaborate

117 *Still life in the modern photographic style.*

118 *Still life with action.*

support systems of specialist lenses, reducing or step-up backs to change format, various bellows combinations and complex lens hood compendiums, which carry large filters. Such cameras require that a heavy tripod is used and that the camera be connected to it by a universal tilting head which will allow the camera to be swung and tilted in every direction and then absolutely locked in a final position. For the tripod and universal head, be prepared to pay nearly as much for the camera body itself.

Still life is a somewhat contemplative activity with considerable introspective study of the elements as they are put before the camera. There is no need for many quick changes of camera angle or position and there is equally no necessity for rapid film loading or film transport, so the extra time involved in handling the view camera is not in any way disadvantageous.

An important accessory to the view camera is the Polaroid back (see Chapter 7). The use of instant film for a precision preview of the subject in real photographic terms is always of tremendous help. Making initial tests on Polaroid also permits checking of the mechanics of the camera and lighting systems and, in some cases, the photographer

will also use large format instant films for the final result, producing a unique 'one off' print in black and white or colour.

The cost of view cameras is comparatively reasonable, especially as it is not necessary to have elaborate automation and electronics fitted to them except for constant professional use. Lenses, however, can be expensive as they are usually large and always prime examples of the lens maker's art, being highly corrected against aberrations and distortions. Very suitable cameras of the nineteenth and early twentieth centuries may still be bought at auctions, or from second-hand or antique dealers, and modern lenses may be fitted to these. The basic design of the body system has changed very little in 100 years, except to evolve the monorail system, so such cameras may be reasonably priced and aesthetically of interest. They are usually built of polished wood and brass and, although sometimes limited in swings and tilts, are most adequate for nearly all still life subjects.

Modern manufacturers of systems view cameras include Arca-Swiss, Calumet Deardorf, Linhof, Plaubel, Sinar and Toyo, most of these being built of metal on the optical bench monorail principle. Lenses for such

137

cameras are obtained from makers such as Nikkor, Rodenstock, Schneider or Zeiss, and some second-hand lenses which are no longer manufactured are also most acceptable. Of these, the Kodak Commercial Ektar and the Voigtlander Apo-lanthar are exceptional.

Lenses

Ideal lenses for still life photography will be somewhat longer than normal as this tends to minimize distortion of perspective, especially in close-up situations. For a 9 × 12cm (4 × 5in.) the lens preferred is at least 210mm with an acceptance angle of 30–32°; for 13 × 18cm (5 × 5in.) it is a 320mm, and for 18 × 24cm (8 × 10in.) it is something longer than 400mm.

Shorter lenses can be used, even ultra-wide angle lenses, which bring in optical distortions and tend to distance the viewer from the composition by suggesting that objects are further away. Spatial distances between perceptual planes of the subject will be considerably distorted and lengthened by wide angle lenses, giving rise to surrealistic elements in the picture. Longer lenses will have just the opposite effect, eliminating distortion, compacting the image to make background objects appear closer to other objects and bringing the viewer into more immediate contact with the image. Longer lenses require more skill in controlling depth of focus, but produce heightened realism and normal perspective at normal viewing distances.

Lighting and exposure

Lighting for comprehensive still life photography indoors will usually require a suite of lights which includes a large broad source, at least 1m (40in.) square, for a softly diffused light; a small diffused source of about 40cm (16in.) square, some sharply specular lights in bright reflectors and at least one focusing spotlight with a well-defined beam. These lights are best mounted on boom stands or on an overhead gantry. In most still life situations, the top light and the top back light will be found essential to a good lighting plan for the key light or for principal accent lights, as these will increase the visual separation of receding planes in the composition, making objects more apparently three-dimensional.

Exposure measurement is critical in this type of photography as form and textures will not retain their tactile qualities if over- or under-exposed. Separate hand-held meters are normally used to make final judgements and these can be of two types. The incident meter is held in the focused area of the picture and aimed towards the lens, measuring light falling on the subject, while the reflectance meter is near the lens, aimed along the lens axis towards the subject, and measures light reflected from the subject. A variation of the reflectance meter is the spot meter which has a very narrow angle of acceptance, sometimes as little as 1°. This accuracy offers great selectivity in measuring small areas of tone and, therefore, adjusting exposure precisely to accommodate highlight and shadow values. The normal incident meter is also available as a flash meter for estimating flash exposures with complete accuracy. Most professionals will probably consider Polaroid as part of the exposure

119 *Still life as an analytical study of textures.*

measuring process but, as a rule, they will use black and white material for this purpose rather than colour, because highlight and shadow values are more correctly judged in terms of grey tone rather than colour tone, even when colour materials are being used for the final image.

It is fairly common practice to use slow-speed emulsion for most still life photography, for colour in the 50–100ASA range and for black and white in the 25–200ASA range. There is usually no need to be concerned about movement during long exposures, therefore slow films are not in any way inconvenient and the enhancement in terms of acutance and tonal scale is considerable.

Processing and colour correction

For all still life subjects, contrast control is necessary and it will be normal for black and white workers to process in soft working, fine grain developers such as May and Baker Promicrol, diluted 1:1 or 1:2; Kodak D76,

diluted 1:1; Paterson Acutol or Ethol U.F.G., diluted 1:5. Colour materials will need to be under-exposed by about one-third of an 'f' stop, with good detail being introduced into the shadows by the use of reflectors or by diffused lighting units. When working with tungsten light, black and white materials are 15–20 per cent slower in real film speed terms than the manufacturer's recommended daylight settings, so this difference will require compensation in exposure or processing. It is as well to remember again that black and white film *density* is controlled by exposure while *contrast* is controlled by development.

Those photographers who use black and white materials for still life subjects rather than colour set themselves additional technical tasks. Due to the considerable abstraction already inherent in the composition, once colour is removed success will depend,

120 *A pictorial still life with modern style created by the use of a wide angle lens.*

121 *A complex still life subject.*

the test, either process the remaining film as required or discard and re-shoot. For critical work, especially for professionals who must be extremely precise in rendering colours in the way the client has requested them, it is essential to make several full camera tests, right through to final processing. Most professional still life is usually made with transparency colour materials as tests and final images can be more accurately and swiftly assessed. Colour-correction filters are usually needed and first test shots should include a spectrum target plus all the important materials and objects which will be in the final composition. Due to unknown factors in the dye bases of modern fabrics and materials, many of them react to photographic lighting and to colour film in quite unexpected ways. Only a normally exposed and processed transparency can be a reliable guide to a successful result in an actual shoot.

A word of caution is perhaps needed about viewing test transparencies. Assessing colour is a very subjective matter and each person will see it in a special way, unique to themselves. In general, most people prefer a sunny look to the colour transparency, which means that a warming filter is added to the camera lens. This could be from the 81 series of Kodak/Wratten CC filters (which are the industry's standard for colour filtration), and these are supplied in the form of ultra-thin gelatin film squares, dyed to the indicated colour and density. These filters are applied to the lens in a special filter holder. The 81 series warms the result by lowering colour temperature and these filters are yellow/amber in colour, deepening to brown in the higher densities. If it is felt that test transparencies are too warm, a bluish filter will be needed, possibly from the 82 series of Kodak/Wratten filters, to raise colour temperature. Other colour casts can be minimized by using other CC filters in the series which consists of magenta, cyan, yellow, red, blue and green. These all come in a range of densities from 0.05 to 0.50 and are obtainable from Kodak or from professional photography stores (see p. 41 for the table on colour compensation).

When the first test transparency is processed, place it on a light-box which has a colour temperature of 5000-5500K, with all but a 1cm ($\frac{3}{8}$in.) border outside the transpar-

almost totally, on superlative print quality in the final presentation. The choice of film, developer and enlarging paper are critical, and flawless handling and processing at all stages is absolutely necessary. My personal choice for the final exhibition print would be Ilford Limited's Gallerie paper which has a very superior gradation of tone, lustrous blacks and brilliant highlights and is certainly worth the extra cost.

When working in colour, still life photographers will again need a very confident technique. Once lighting is planned to establish the mood of the picture, exposure must be extremely accurate or that mood may dissipate. Bracketing of colour exposures is often a good idea: two sheets of film are under-exposed by half a stop, two sheets are exposed normally and two sheets are over-exposed by half a stop. Process only one sheet of this bracket at normal exposure and review this on a corrected light box if it is transparency material, or make a test print if it is on negative film. When satisfied with

ency masked off. Lay various CC filters or mixtures of filters on the transparency until the colours are close to visual accuracy. This filter pack is then applied to the camera and further tests made. Not more than two primary colours should be included in the pack, as they begin to cancel out colour and introduce a neutral-density factor. It is unwise to use more than three filter thicknesses in any one filter pack as this could interfere with lens definition.

Colour still life subjects containing food will often need to be considerably warmer in tone than many other subjects. Jewellery, for example, must always be neutral or cool in colour mood. Old wood or scenes lit by candlelight need warmth and mellow lighting, while simulated daylight, for example, even when the subject is old wood, needs a distinctly bluish highlight. This can be obtained by the use of a mild CC filter on the camera lens or acetate gels, such as Rosco filters, on the light source itself. Colour temperature can be very precisely controlled in this manner.

Any still life which is based on large areas of white, light grey, beige or cream, needs particular care in exposure and processing. Black and white materials are easily mishandled by over-exposure, causing blocked highlights, low contrast and unprintable densities. Over-development can contribute to these problems. Colour poses special problems of its own, chiefly because colour shifts are very noticeable in such delicate tones. Under-exposure can add blue or green to an unpleasant degree. Old film stock can create magenta shifts in some emulsions and over-exposure or push-processing can add substantial amounts of yellow. For light, high-key subjects, it is advisable to test several manufacturers' sheet film products as each will react differently to whites, grey and neutrals. Use only correctly stored, fresh film stock, brought slowly to room temperature before opening. Test all lighting for colour bias and make all exposures and processing as near to normal conditions as recommended by the film manufacturer. If white or high-key subjects are processed in the same bath as very dark subjects containing many blacks or deep blues, discoloration of highlights or a bluish colour cast may be very noticeable. Process all high-key colour subjects, therefore, separately, if possible.

Sheet film is only manufactured to professional standards and especially in colour materials it will be noticed that in matters of film speed and colour balance, manufacturers work to extremely fine tolerances. This means greater precision, of course, for the professional, but also means no latitude whatsoever in terms of exposure, reciprocity, shifts in colour or in storage or handling conditions. Keep all such unexposed films in their original sealed packages stored in a refrigerator or, for long term, in a deep freeze; allow sufficient time for warm up (see Chapter 3). Process not more than 24 hours after exposure (preferably immediately), calculate exposure to one-quarter stop accuracy, allowing for over-long or ultra-short exposures and follow the manufacturer's instructions precisely.

VISUAL CONCEPT

Once a degree of confidence and competence has been reached in technical matters, the still life photographer can begin considering

122 *A still life of a food subject – note the careful rendering of appetizing textures and the structuring of the picture.*

visual concepts and design elements in the composition. If it is a professional assignment the client will dictate many of the essential items in the final picture and, for professionals, a layout will be provided, showing type position, format size and shape, position on the page, colours and even camera positions. Such photographs are a working tool in the general use of commercial media and the photographer's expertise is very much part of a team when photography takes place.

Where the professional photographer has freedom to supply an image of his own design or there is no professional element involved, concepts, styling, compositional control and, in fact, everything in the image, is placed there by the photographer. If it is a successful picture, it is the photographer who made it so, as there are no accidental arrangements in still life. Equally, if the photograph is unsuccessful, it can only be because the photographer failed to reach acceptable standards of technique or concept. Still life photography, then, has obvious parallels with easel painting, in that it deeply

123 *A complex still life with intensively controlled lighting and composition.*

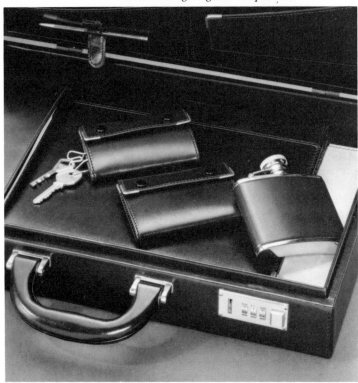

challenges technique and is a complex compound of all that the artist can bring to the project in terms of experience and concept.

Good visual concepts are obtained by a disciplined and methodical approach to the making of the image. List basic known facts about the image, such as: the purpose of making it, the format shape, format size, primary element, secondary and supportive elements, visual accents, the colour plan within the picture, the mood to be projected, the style to be contrived, and so on.

At this point it may be wise to begin to collect any items known to be essential to the narrative of the picture, or the process of visualizing various possibilities can help. In this case the still life is produced in 'the mind's eye', imaginary objects being projected and discarded in various computations of lighting, lens lengths and camera position. When any useful combination is reached in the imagination, this is quickly sketched on layout paper with stamp-size drawings. When the introspection and visualizing is over, quite a number of sketches should remain, prompting further detailed study and refinement.

Another, but time-consuming, method of preparing a still life is to obtain everything which could have a possible part in the story and bring it into the studio. Any perishable items must be bought in quantity and kept at the peak of perfection until needed. For setting up, stand-in objects are used, being replaced at the last moment, just before exposure, by the real item. During the setting-up time, the photographer works slowly and intuitively, referring constantly to the camera back for a continuous review of the composition as it grows, applying light in quantity or quality in instinctive ways, discarding objects thought to be confusing or irrelevant, changing camera positions, and so on. Such still life sessions become challenging marathons, sometimes going on for several days while the whole concept is built and visually supported by every part of the photograph. The risk in this method, of course, is that results may appear to be laboured, over-refined and too obviously taking place in a sophisticated photographic studio, losing therefore some or all of the natural vitality of real life.

Best results come from a little of both methods. Pre-visualization, research, under-

tanding the subject, pursuing a logical narrative in the visual theme, layout sketches and logistical lists for obtaining all props for the picture, are essential first steps. Then, in a controlled environment, the intuitive build-up of objects takes place in front of the camera, but it is guided closely by the preliminary planning. The photographic session becomes highly structured in many ways, but the introspection and meditation are still there, letting the individual's creativity and imagination reach its full potential.

It should be noted in passing that the camera tends to exaggerate details or faults especially in many of the close-up situations found in still life photography. Any object which must be seen as new or fresh, must be perfect, with no blemishes, damage or dirty surfaces. This may mean buying many extras of the same object and eliminating any not up to standard. Old objects may look older, their patina may seem lifeless and uncared for. This could be helpful for the whole composition or it may be necessary to restore the surface condition somewhat. For any major cleaning of valuable antiques, use reputable craftsmen or organizations and, if the object is hired or borrowed, obtain written permission from the owners for the work to be done.

Viewpoint

The control of the image itself will begin with the placing of the camera and the selection of the lens. Mature still life photographers know that there is only one correct viewpoint if the resulting picture is to be seen at its best. Finding this viewpoint may take some time and is closely inter-related to the type of lens chosen.

As a generalization, a high angle for the camera obtains a greater intellectual response than an emotional one and is uniquely photographic. The top view, or 'bird's eye' view, did not appear in art until photography was well established. This viewpoint discloses volumes of information about the object and its environment, together with its surface structures and colours, while at the same time it tends to diminish form to a considerable degree. Such a high viewpoint says little about the psychic values associated with an object, the mood of the image or the structural essence of objects within the picture.

124 *Pre-visualizing a possible still life is a great help in planning a successful picture. Here are the actual small sketches which have been quickly drawn while imagining various projected photographs in the mind, during the planning stages of a food assignment.*

A low camera angle presents a theatrical view of the subject, more expressive, extrovert and mysterious. Information is greatly restricted in the total environment of the picture, tactile surfaces are shown exquisitely, but only in highly selected areas of the composition. Mood is paramount in such a case and these photographs appeal instantly and intuitively to the emotions of the viewer rather than being carefully analyzed by the intellect.

The search for the ideal combination of viewpoint and lens length should be thorough and perhaps contemplative. This part of the assignment should not be hurried. Only when many possibilities have been carefully assessed and a final viewpoint chosen is the camera locked solidly into position and the lighting of the set is considered.

125 *An organic
still life made from a
sunflower, using
strong spotlights.*

Lighting

First decide the key light position. The key
light sets the mood of the picture as much
from its nature as from its direction: soft
light indicates a romantic ambience, a deli-
cacy about the object and hints of refinement
and luxury in the environment; harsh, spe-
cular light suggests a frankness of mood and
tells of robust activities nearby; broken ligh[t]
patterns lead to mystery and a hint of th[e]
exotic; clear, bright light, falling in a closel[y]
controlled area of an otherwise softly lit com[-]
position, can bring to mind half-remembere[d]
or nostalgic times.

The direction of light also indicates muc[h]
about the time of day and the condition[s]

prevailing outside the frame of reference: a long, low, soft light could come from a partially opened but gauzily curtained window, a strong, slicing light from the top side position, could be evidence of an open door through which sunlight is reaching the composition; bright top light can indicate light falling from a ceiling fitting, so the time is obviously evening, when the house lights are turned on. The colour, direction and quality of the key light underlines the theme of the still life but still must reveal all the principal textures, delineate the spatial volumes between objects and give character to each.

Once the key light is set, fill light is introduced to supplement and augment the shadows. Bright reflectors or diffused lamps create depth and translucency in important areas, helping to suggest volume and depth in the image. Where considerable theatricality is called for, fill light would be minimized or perhaps black minus 'reflectors' could be placed to soak up light spilling from the key light. Access lights in still life perform a very important function. They restore texture and surface condition in planes of the composition which have not been struck by the key light; they bring sparkle and sheen to glossy articles and restore translucency and brilliance to transparent objects such as bottles and glasses. Many of these accent lights may be introduced by small, cosmetic mirrors using either the plain or concave sides.

STILL LIFE SUBJECTS

In setting out to specialize in still life, the photographer could identify two prevailing points of view; one concerned with organic objects and situations, the other with human activities and artificially constructed events.

The organic still life

Many famous photographers have worked indoors with fragments of nature, producing semi-abstractions of organic textures. Driftwood, seashells, rocks, eggs, flowers – all these have all been revealed, by superlative technique, to have an instrinsic beauty far beyond their surface presence. The photographer faced with this subject looks for line, asymmetry, rhythm, echoing forms, symmetry and balance, and the suppression of detail or ambiguity. Such compositions become a search for nature's arcane essence and for the cosmic infinities of the universal

which may be found in that particular and unique object. Photographers whose work provides radiant examples of this kind of modern still life include Paul Caponigro, Imogen Cunningham, Hans Hammarskold, Paul Outerbridge, Albert Renger-Patzsch, Edward Steichen, Otto Steinart, Paul Strand and Edward Weston; those who pursued the same concepts but who used man-made objects indoors, include Cunningham, Hans Finsler, Hiro, Outerbridge, Raymond Moore, Irving Penn, Walter Peterhans, Renger-Patzsch, Brett Weston and Minor White. Most of these photographers, perhaps with the exception of Peterhans, did not major in still life as a subject but used it as a disciplinary exercise to underscore other main stream photography. This is still a most valid point today for all those photographers who seek to acquire a swift and intuitive eye for photographic design, and it is certain that constant still life self-assignments with a large view camera have no equal as a training ground for those who prefer to use small-format cameras, especially where such photographers are involved with fast-breaking documentary action. The slow, contemplative exploration of all facets of photographic composition; the inescapable elements of sole authorship and the acceptance of its contribution to the acquisition of an individual style; awareness and control of light, conservation of film material, and so on - all are some of the vital endowments for a successful documentalist and these may be instilled by progressive still life exercises.

The narrative still life

For those who do not wish particularly to explore organic subjects, the narrative still life, particularly where it suggests human events, is a deeply fascinating activity, having its roots in the long history of still life painting. To prepare for this kind of photography, the student should consider the easel painters who have succeeded in turning this kind of picture into high art and who are mentioned earlier in this chapter. Photographers have not explored this area very fully, perhaps discarding it as too simple or possibly too romantic or baroque. Apart from the ease with which natural perspective and optical purity may be presented, photography brings to such pictures an underlying mood not possible in any other art form and

126 *A large interior still life with scale and story-line for use in an editorial article.*

a delicacy of statement in terms of lightfall which is probably unsurpassed. As an exercise and challenge to photographers the narrative still life is probably unequalled.

For such an assignment, the story must be clearly conceived. It begins with logic and commonsense. The objects appearing together should reasonably expect to relate to each other and to the story-line. They should be complementary to the period and place in which the story lies and have a valid style which belongs to the unseen human presence nearby. Narrative still life always is about humanity and such pictures should suggest the isolation of a moment in real life which, instead of slipping inexorably into history, is held open for our inspection and given eternal life.

The most desirable attribute of the narrative still life is this suggestion of human activity, just completed or about to begin. Although this appears to take place immediately outside the frame of reference and remains unseen, indisputable evidence of an active event is featured in the picture: a drink is spilled; liquid is steaming; a flower has fallen; neat arrangements of fruit are disturbed; a cloth is carelessly flung down, and so on. These activities are used as design elements, but also bring a breath of real life and immediacy to the story.

All props which appear in the frame of reference must become actors in the drama which the photographer seeks to unfold and, as such, they must be brought to life by the quality of the photographer's technique. Every object must be given both its real and subjective dimensions: glossy surfaces must dazzle the eye; soft, deep textures must invite the hand; liquids must move and flow; vapours must rise translucently through established planes of perspective. Objects which are wet should present gleaming highlights and oily shadows; those that are dry should appear crisp and brittle in their aridity; wood must appear heavy; gauzy fabrics must float on unseen winds; metals must appear cold and perhaps a little menacing; food must delight the appetite and invade the senses – everything within the frame of reference must be given the true characteristics of life itself.

Most of these attributes can be produced by thoughtful lighting and careful optical control of the camera, together with an

understanding of moments of action in such pictures. Arrested time in real life is seen by the swift half glance 'out of the corner of the eye': equilibrium is momentarily disturbed; form may be a little obscure; information is less obvious, while essential and structural character is quickly perceived.

There is an interaction of space between the edges of objects and the frame of reference and there is an interaction also of spatial depth between three-dimensional objects and then the further, very complex, relationship between two-dimensional space and three-dimensional space within the picture. These are all controllable by skilled still life photographers who, by this means, move the viewer into and around the composition at will. Separation of forms attracts attention to them; textural lighting advances any forward projecting contours; evenly lit areas of tone take the eye back into spatial depths and away from clearly structured surfaces. These are some of the basic tools of the advanced still life photographer.

Colour, of course, is also a major design factor in such compositions and it brings the flush of life to every object. Harmonies in still life pictures can vividly support the narrative, enhance mood and establish time of day. Analogous harmonies from adjacents on the colour wheel will suggest quiet good taste, decorum, luxury and possibly wisdom. Closely modulated harmonies with narrow intervals between colours can lead the viewer in a disciplined search of the composition, the eye restlessly probing while the mind is intuitively absorbing the story laid out by the photographer. Complementary harmonies vibrate with life and action, attracting and repelling the eye with emotional ambiguity, while a spread of controlled colour throughout the picture area can satisfy the mind, restore dynamic balance and produce symphonic responses from the average observer.

The colour photographer must choose ob-

jects partly for their colour characteristics and then design a lighting plan which fits the technical needs of a chosen colour film type, but still one which establishes the intangibles of the picture. Such lighting may involve mixing daylight and tungsten, or multi-coloured filtration of all lighting units. Every technical attribute of the picture must be directed at supporting the story-line and nothing should appear either in terms of technique or in props which is not absolutely essential. The good narrative still life will appear to pulse with real life rhythms, but will, in fact, have been closely and continually edited until only the concepts shine through. The objects must appear effortlessly and accidentally fixed in time and space.

The photographer's still life

There is possibly a third classification of still life and perhaps it should be deemed 'the photographer's still life'. These pictures are bravura attempts at displaying technique and usually have no story-line, no organic realities and very little true design concept, resting heavily on half-understood elements of surrealism. Such pictures remain fairly elementary as still lifes but are often seen in professional photographers' portfolios or on the exhibition walls of advanced photography competitions. Mature still life photographers quickly move on from this point.

The still life photographer may commence working in this field purely as an exercise or as a learning process or, perhaps, as a relief from the normal turmoil of conventional photography, but once it is evident that the personality of the photographer is identifiable in the image, once the individual's psychic fingerprint is to be found along with all the objects portrayed, it is certain that making such photographs may become a main stream creative activity, full of challenge, surprises and deep satisfaction.

10 Reproduction and Record

However specialized a professional photographer elects to be, it is certain there will be a time when either a copy must be made of flat subjects or one must be made of three-dimensional objects for the purposes of information. These very basic photographs do not need intricacy of lighting or complicated creative concepts, but do require a high level of concentration and strict attention to practical techniques.

RECORD PHOTOGRAPHY
Equipment and techniques

Informational photography of objects is usually to supplement such things as insurance records or to catalogue art collections or to provide technical illustrations for editorial use. The entire purpose of the exercise is that the photograph clearly shows all properties of the object, sometimes including scale and it is normal to work on large format view cameras for this reason. 35mm SLR cameras are sometimes used, particularly for colour records, and the Polaroid SX70 is also convenient when strictly accurate colour may not be vitally important. For either of these types of camera, a tripod will be needed and a cable release, while the viewpoint should be eye level or near to it, so that perspective remains as near to normal as possible.

Lighting for record photography of art objects is better if it is diffused from either a broad source lamp and reflector or from a large window diffused with tissue, sheer curtain material or special photographic diffusing frost. Such key lighting should be allowed to fall across the object from a side left or side right position and a bright, but diffused, fill light should enhance the shadows. Accent lights may be important to show patina, details of surface, structure or special features. Lenses tend to be medium to long and it is important that a clean, uncomplicated background stands under and behind the object. This background is often a scoop of thin card of a suitable colour which provides maximum separation between the object and surroundings. Shadow to highlight ratios should be in the region of 3:1 for colour and not more than 5:1 for black and white. Contrast control technique should be employed for black and white processing and a moderately active developer, such as Kodak DK50, Ilford ID11 or Suprol, from May and Baker, diluted 1:20, should be coupled with panchromatic films of ASA100–200. Colour film speed should be in the ASA50–125 range.

When working with black and white, filters may be needed to enhance the character of certain material. For example, a light orange filter will improve the wood grain of reddish wooden objects and a blue filter could clean up the rendering of tarnished metal. Whenever filters are needed for corrective work, panchromatic film should be loaded. This could be Ilford FP4, Agfa 100, Kodak Ektapan 4162 or Kodak Plus-X Pan. The secret of filtration is, to lighten a colour or texture and thus make it more easily seen in the final monochrome print, choose a filter near to the same colour as the area to be lightened. To darken a colour, choose a filter of opposite or complementary colour. To give reasonable balance to all tones, use a very light green or medium yellow filter. When only very selected areas of an object need compensatory treatment, filters can be applied direct to lamp-heads, but be sure they are of non-combustible material, such

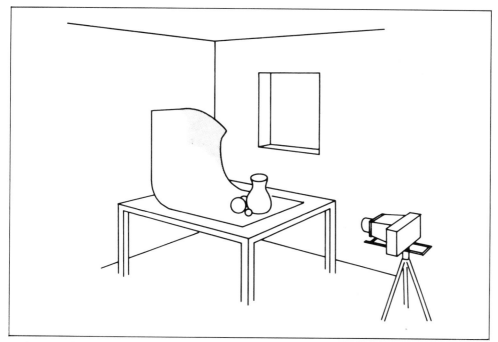

as those marketed by Rosco (see List of Suppliers).

Colour should be as accurate as possible for informational purposes and it is certain that CC filters, such as the Kodak Wratten series, will play a large part in controlling colour bias (see Chapter 3). It is normal to use tungsten film balanced for 3200K and small floodlights for this kind of work, as flash often proves uncontrollable in some of the close-up conditions which prevail. A set of Par 38 100-150 watt, sealed beam, self-reflecting, garden spotlights, is often ideal for simple assignments.

Occasional records may be made to fairly high standards by working on a small table placed near a large window. The table is turned so that a cross light emphasizes the contours of the object and a white reflector is aimed into the shadow side of the subject to improve detail there. Backgrounds are very important and need careful placement to catch the light. Of course, if colour is being used, it should be a daylight film and a tripod and cable release must be employed to avoid camera shake.

If a view camera is not being used, lenses for close-up records of small objects will need accessories to assist close focusing and permit the image to fill the format. These can be extra lenses applied to the front of the standard lens, extension tubes or rings

127 *Typical lighting arrangements for small objects, using a cross light from a small side window to produce texture. Dark tone in the background can be produced by folding one corner of the paper scoop in order to create shadow behind the object.*

applied to the back of the lens before it meets the camera body, or small bellows which are interposed between lens and camera and which permit very flexible focusing arrangements. Bellows or extension tubes are to be preferred over supplementary lenses as the image quality will suffer less. If much work is to be done on 35mm in this field, a macro

128

FILTERS ABSORB THEIR COMPLEMENTARY COLOURS	
Filter colour as seen	**Colour of light absorbed**
Red	Blue and green
Yellow (green and red)	Blue
Blue	Red and green
Magenta (blue and red)	Green
Cyan (blue and green)	Red
Black	All colours except UV or infra red
Clear	None
Grey	Equal amounts of all colours

lens, particularly one that permits half life-size (1:2) or life-size (1:1) images, is a good investment. These may be focused, without extra attachments, right down to a few inches from the object, and often compensate for the exposure differences which are due to the long extension of the lens.

When extending a lens beyond its normal focus provision, a loss of light occurs because the aperture ceases to perform at its designated value. Exposure must be increased by what is known as Bellows Extension Factor. This is calculated by the formula:

$$\frac{\text{total extension of the lens} \times \text{actual 'f' stop}}{\text{focal length of the lens}}$$

If a standard SLR lens is 50mm in focal length and it is extended to 100mm and the chosen aperture has been selected as f8, the mathematics look like this:

$$\frac{100 \times 8}{50} = \frac{800}{50} = f16$$

This is the real 'f' stop value and not the one showing on the aperture ring. Thus for this image, which would be life size (1:1), a two-stop increase of exposure is needed to obtain normally exposed colour or black and white materials. The B.E.F. compensation is, of course, needed on all cameras including view cameras.

View cameras on sturdy tripods are by far the best means of making informational records as they not only have the flexibility of

129 *A bellows extension is needed when photographing small objects close to camera. Such extension is also necessary for 35mm macro modes, and usually requires that more* *exposure must be given: (a) no extension for distant or middle-distance objects; (b) considerable extension for close objects.*

focus, but also the valuable attribute of perspective control through tilting lens and film panels (see Chapter 1). This means that instead of dropping the camera near to eye level to photograph an object, as is advisable when using fixed-body cameras, a more three-dimensional result can be obtained in a look-down position with correct perspective and precision control over depth of field. Filters are easily applied to such cameras and longer lenses give less technical problems. Polaroid backs for view cameras are standard accessories and these can be used for checking exposure, focus or lighting, or frequently even to make the final record picture itself. Many photographers will use a view camera with 9 × 12cm (4 × 5in.) format and Polaroid 55 film, which generates both a positive print and an excellent fine grain panchromatic negative.

Recording in the studio

The professional who must make clear records of small objects in the studio will normally 'float' the object on a sheet of clear glass and run a seamless paper scoop behind to give a tonally interesting but perfectly plain background. Those who do much of this work will probably have an opalized acrylic scoop made thick enough to stand the weight of most normal objects, which are then placed on the floor of the suspended scoop. This is then transilluminated to give shadowless footing to the object and carefully lit by a diffused cross light to show surface contours. Such an arrangement is perfect for precious glass objects or anything with translucency. A variation of this is to obtain a large piece of opalized acrylic sheet, sized 120 × 180cm (48 × 72in.) and not more than 3 or 4mm ($\frac{1}{8}-\frac{1}{4}$in.) in thickness. This is then secured to a table with four C–clamps and the loose end is swept up to form a soft curve and a vertical background. This is seamless but does not allow underlighting of the object unless small holes are cut in the table top to allow the light through. The background, however, can be back-lit to great effect.

Photographers may be asked to make records of architectural or other kinds of scale models. The architectural model should be

131 *'Floating' an object on a clear acrylic scoop 4-6mm ($\frac{1}{8}-\frac{1}{4}$in.) in thickness.*

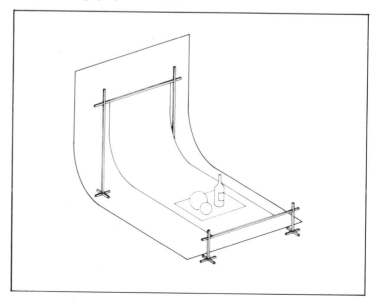

130 *A macro photograph of an object 1cm ($\frac{3}{8}$in.) in diameter.*

132 *An architectural model photographed to give an impression of some light.*

set up against a grey paper scoop or a brilliant white background, depending on the effect desired and a spotlight is thrown as the key light to affect the model in the same way as would the sun on the actual building. This key light is then augmented by very diffused fill light to open up the shadows. Fixed-body cameras are quite suited to do this work, but view cameras are still to be preferred. Long lenses, at least three times normal focal length, will assist in producing natural perspective. The same lighting treatment may be used on models of ships, aeroplanes, or hobby models, with one sharp, specular key light and diffused fill light to give the impression of real life.

When very complicated objects must be shown for catalogue or training purposes, they are often carefully taken apart and shown as an 'exploded view'. All the working parts are placed on opalized glass or acrylic, in position and sequence as they would be in a fully assembled object but separated by a tiny space, usually not more than 5mm (3/16in.). Lights are arranged both under and over the opal acrylic. The top lights are placed to render texture, contour and surface condition of all parts, regardless of where the shadows fall. An exposure is given for this

arrangement and the top lights are turned off. Without moving the camera or film, a second exposure is made on the same piece of film with only the under-lighting turned on. This will wash out the shadows and leave the object and its parts floating in clean white space. It is not always necessary to make double exposures of such a set-up, provided that the strength of the under-lighting is at least four times that of the top-lighting. Tungsten lighting is more flexible for this work than is flash lighting.

Recording *in situ*
Where objects are too large or too valuable to bring to a studio, they must be photographed *in situ*, often at unsociable times when the public has no access to the space. If it is an art object, it will be lit for exhibition and it is usually possible to use these existing lights, augmented by some photographic lights, to make the exposure. If the photograph is in colour, it is necessary to make some investigation of the age and type of lamp in the exhibition fixtures, as many of these fade rapidly and experience a substantial drop in colour temperature. This lower Kelvin rating would result in much warmer colour in the final image. Fluorescents should not be used if at all possible for this kind of colour record and, again, a view camera on a substantial tripod is the

ideal choice of equipment. Lenses should be as long as possible in the space available, as wide angle lenses create many problems with regard to perspective.

Where the background is particularly obtrusive, it can be cleaned up the following way. Load the view camera double cassette on one side with normal, medium-speed panchromatic sheet film and the other with the fastest high-contrast film obtainable. Expose the panchromatic film first with the main object properly lit, then, without moving camera or tripod, make a second very full exposure of the background only, on the high-contrast film, but with no light falling on the main object at all. This should give the main object a silhouette treatment, totally in shadow, but with background brightly lit. It is important that the high-contrast film is given a heavy exposure and, as it is considerably slower than the pan film, time exposures may reach unusual lengths. In the darkroom, process the high-contrast film in a lith developer such as Kodak Kodalith and the pan film in a crisp developer such as Kodak DK50 or HC110, Ilford ID11 or May and Baker Suprol diluted 1:20. The lith film when processed should be clear in the area where the main object was standing and be densely exposed in the background.

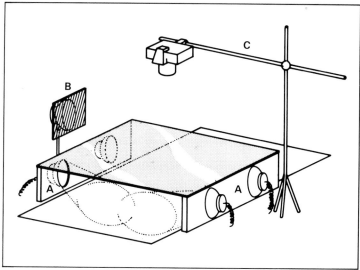

133 *Typical set-up for photographing an exploded view: strong underlighting at A needs an opalized screen; diffused but strong cross lighting at B; high-angle of view for camera position at C.*

134 *A lighting set-up for double exposure: lights are placed for a second exposure on contrast film at A, aimed away from main object; main object is photographed at B separately on fast pan film with lights at A extinguished.*

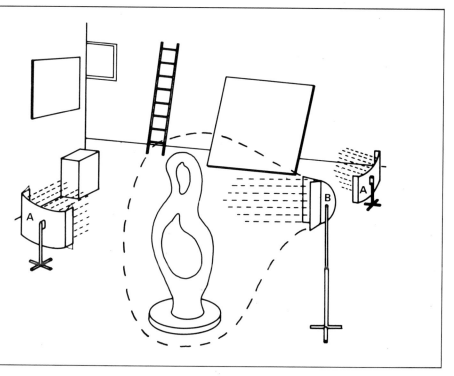

When dry, the two negatives are bound together in perfect register and printed to give the correct rendering of the object which has good tonal values but which is now seen against a clean white background.

Record photography frequently includes making good copies of electronic screen signals such as cathode ray tubes or a television screen or VDUs which are attached to machinery such as scanners, or non-invasive diagnostic equipment. Because of the scanning lines which make up a TV image, the moving electron beam must scan the picture in two

135 *Photography of any VDU screen should be carried out in the same way that ordinary TV screens are photographed.*

passes: one to trace even numbered lines and one to deal with odd numbered lines. Each pass lasts 1/60th second, needing 1/30th second, therefore, for a complete image. Leaf shutters may be set at 1/30th second or slower for a full image, but focal plane shutters must operate at 1/8th second or slower if an even exposure is to be obtained across the whole screen.

Place the camera on a tripod and line it up on the centre of the screen, carefully watching the horizontal and vertical geometry so that the screen becomes a perfect rectangle in the viewfinder. Focus on the tube lines, not on the moving image. Use a close-up accessory, if needed, in order to fill the frame. Turn off all room lights and black out any light reaching the screen from windows. Wrap any metal part of the tripod in black cloth and use a long cable release to keep the operator's hands and face out of the picture. Exposure of a 400ASA film will be approximately 1/30th second at f5.6 or, in the case of SLRs with focal plane shutter, 1/8th second at f11. Make the exposures when there is minimal movement on the screen image. When colour is being used, adjust the controls of the TV set to a lower contrast than normal and load with daylight 400ASA film. Use a Kodak Wratten 81B CC filter or, on certain sets, it may be necessary to add an extra CC30 or 40 red filter to improve the reds of the TV picture and to counteract the excessive blue/green. Exposure compensation with this filter pack may require a one-half to two-third stop extra.

The complexities of oscilloscope and radar recording are a special subject in themselves, but shutter speeds of 1/100th second or less are advisable and 400-1000ASA film would be suitable. As with TV screens, stray light should not reach the screens, reflections must be minimized and room lights must be at a very low level or out altogether for some minutes before photography commences. Some manufacturers make special film material for oscilloscope recording and this should be considered as a first choice.

When a photographer is faced with two-dimensional or 'flat art' subjects to be recorded, it is advisable to consider purchasing extra equipment in order to obtain reliable and acceptable results without too much trouble. Flat art copying needs to be organized around a central axis with at least two

but preferably four, copy lights of equal strength set at an angle of about 45° off this axis. The lamps should have a wide reflector pattern, each of which casts light more than halfway across the largest copy area anticipated. Means must be provided to fix the camera securely on this axis with lens and film planes exactly at right angles to it and with copy board also precisely at 90° to the central axis. Copy board, lens panel and film plane must all be precisely parallel for any acceptable copies to be made.

This arrangement can either be in horizontal mode, which takes up much more room but permits very large originals to be copied or, more usually for photographers, in a vertical mode, which should comfortably permit the making of copies of originals of 40 × 50cm (16 × 20in.). Vertical rigs minimize the floor or bench space needed. Preferred cameras would again be of the view camera type, although certain high-volume work in colour may be photographed on a 35mm SLR with motorized film transport. The copy stage, which holds the original material, should have provision for the trans-illumination of transparency material.

COPY PHOTOGRAPHY
Equipment
Lighting in copy set-ups is normally tungsten halogen, balanced for 3200K, but in the case of 35mm slide copiers, it is usual to expose by electronic flash. Provision for both in copy equipment is an ideal arrangement, if much copy work is contemplated. Lenses for copying need to be well corrected against colour aberration and should be calibrated for best performance under 2m (6 ft). They are usually designated 'apochromatic', meaning that all colours focus sharply in one plane. View camera copy lenses should not be used at very small apertures for best results because at such settings as f64 or f90 image sharpness may be impaired. Cable releases are normally essential, not only to ensure vibration-free exposures, but also to allow the operator to stand away from the copy board and so avoid troublesome reflections appearing in dark copies. Copy equipment should be sited on solid floors and away from machinery or passing heavy traffic. If vibration becomes a problem, electronic flash exposures must be used at all times.

Copying even simple originals needs some corrective filtration and thin gelatin colour-compensating filters such as the Kodak Wratten CC series and a suitable filter holder are sure to be required. These filters are made in the photographic primaries of cyan, magenta and yellow as well as red, green, blue and non-colour, neutral-density filters. Densities in the filter range begin at 0.05 and run to 0.50. For black and white copying, a stronger filter set will be required and this could also be chosen from the Kodak Wratten range. Possible numbers needed are 3, 4, 8, or 12 (yellows), 15, 21 (yellow/orange), 23a, 25 (red), 11a (yellow/green), 58 (green), 43, 47 (blue).

Film stock for copying will have to consist of a lith emulsion (very slow film,

136 *To photograph crystals in terms of macro photographs, a simple copy set-up is constructed: at A the lens is covered by a rotating polarizer; at B the crystals are secured in focus in a glass sandwich, and at C*

a polarizing filter is placed over the light source, in this case an extension flash. Beautiful colour abstracts may be made in this way.

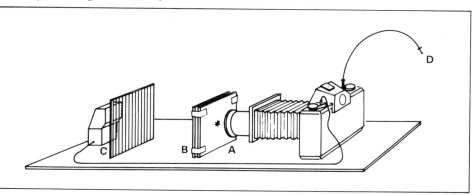

sensitive to blue only) and orthochromatic continuous-tone emulsion (slow-speed, insensitive to red) and a medium-speed, fine-grain panchromatic emulsion of about 125ASA which is sensitive to all colours. Developers to use with these films include a lith developer (in two parts, A + B) for processing clean fine line made on high-contrast lith film; active high-energy developers such as May and Baker Suprol diluted 1:15, Kodak D19, DK50 or HC110; and longer-scale developers for processing continuous tone material, such as Ilford ID11, Kodak D76 and occasionally May and Baker Promicrol (undiluted).

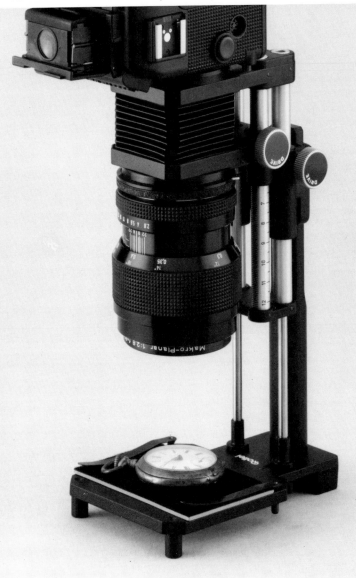

137 *A small copy set-up for occasional use.*

If copying is only very occasionally needed, temporary set-ups can be made, as in figure 140, but it is time-consuming to line up the camera and arrange lighting, and it is easy to make considerable errors in the image geometry. Even illumination of the copy is also a problem with temporary set-ups. For 1:1 slide copies of 35mm slides, it is worth buying a simple unit such as the Multiblitz or Bowen's Illumitran copier, both of which have a bellows extension accessory and a small copy stage containing electronic flash with a focusing light. This is reasonably expensive as a first cost but soon pays for itself, is fast and easy to operate and takes little bench space in the darkroom. Polaroid and other manufacturers market a small 35mm copy unit using flash and Polaroid film which is especially interesting to those who need black and white positive/negative copies from 35mm colour slides. For colour-to-colour copies, it may be that Polacolor is too contrasty for critical workers, but as a proofing technique it is excellent.

The greatest enemy of slide copying in colour is high contrast, and with the small bench copiers it is a simple matter to reduce this contrast, particularly if the camera has double exposure facility. Before each copy exposure the camera takes a brief flash exposure of a neutral-density filter instead of the slide to be copied. On the same frame (double exposed) the copy is then made as normal. With a little experiment, very fine results can be obtained. A neutral-density filter of 2.0 is exposed to the same aperture and lighting combination as is used for copying the original.

Flare and reflections

Copy work often needs the use of such close-up accessories and bellows extension factors as have been discussed earlier in this chapter, but two other problems associated with flare and reflections intrude above all else. Camera flare and surface reflections which are seen in any finished copy of dark originals will desaturate the copy image and give hazy colours in colour copying and produce weak blacks in monochromatic works. These are either caused by internal reflection within the camera due to poor lens construction or glass quality, or reflection from any light or white colours which are adjacent to the outside edge of the original which is to

be copied. To cut down internal flare in the camera, over-sized box bellows are needed if a view camera is being used, rather than bellows which taper. All internal metal must be properly coated with a matt black photographic paint. External flare is controlled by large bellows-type lens hoods and by masking edges of original material with matt black card. Other reflections which may be seen in dark copy generally come from overhead lights or the image of either the operator or the camera caught in the light spill from copy-floods or bouncing off the copy board. Heavy texture and grain on prints to be copied or shiny, buckled print surfaces can also cause unwanted reflections.

One certain way to reduce excessive flare and reflections is to use polarizers on both lights and lenses. A rotating polarizer is used on the camera and it should be of superior quality. Sheets of polarizing material are then cut to fit the lamp reflectors and, with the screen grid running horizontally, are held in place by metal clips. Normally, polar screens will show a registration mark to indicate horizontal grid lines. To achieve the maximum polarizing effect, a glass or ceramic object is put into the usual copy position and one side of the copy lighting turned on. Highlights will be very noticeable until the lens polarizer is rotated to a point where most highlight reflections are extinguished. Leave the lens polarizer and the first polarizing screen in place and turn out the first set of lights. Turn on the other set of lights and rotate the screen on these until all reflections disappear. Then turn on full lighting, leaving all three screens untouched. Now, when shiny, textured or damaged copy is photographed, most of the troublesome reflections will not record. Black and white copy prints will be richer and cleaner and colour copies will gain more saturation. This indicates an increase in contrast to some degree and black and white copies made with polarized light often need contrast control by 20 per cent over-exposure of the negative and 30 per cent less development. Light loss with polarizers is considerable and an increase of between four and eight 'f' stops may be needed.

Copy originals are almost always valuable and must be held firmly, but totally without damage. On vertical set-ups there is no problem, because a 6mm ($\frac{1}{4}$in.) glass cover plate

COPYING WITH FILTERS

Materials	Film	Filter
Faded prints	Orthochromatic	Blue
Stained yellow	Panchromatic	Yellow
Blueprints	Panchromatic	Red
Paintings	Panchromatic	Yellow-green
Old documents	Panchromatic	Deep yellow

To eliminate unwanted coloured backgrounds or coloured stains and render them invisible choose a filter of a similar colour to the colour to be dropped out and panchromatic film. In faint or highly detailed originals in low contrast with their background where they must stand out clearly, use a filter of an opposite or complementary colour and panchromatic film.

To render type material or line drawings in colour as either black or white images, use panchromatic film and the following filters:

Colour	Filter for black	Filter for white
Blue	25 (red)	47 (blue)
Turquoise (cyan)	25 (red)	58 (green)
Green	47 (blue)	58 (green)
Yellow	47 (blue)	58 (green)
Red	58 (green)	25 (red)
Pink (magenta)	58 (green)	25 (red)

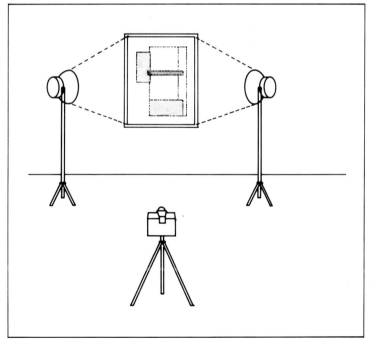

139 *A simple, temporary copy set-up.*

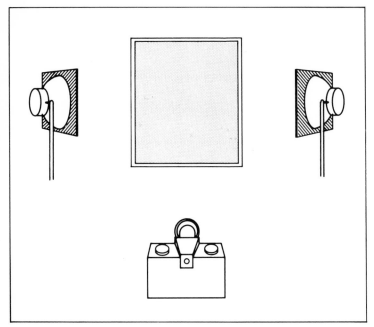

140 *A more elaborate permanent copying arrangement, using polarizing screens on the lamps and a rotating polarizer on the camera, to eliminate reflections from copy surfaces.*

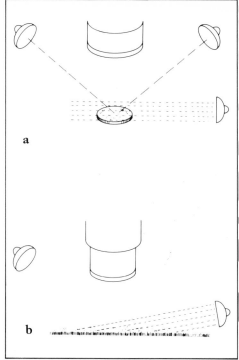

141 *Two ways to use macro copying techniques: (a) a coin is lit by two lamps of equal strength from near the lens axis, while a strong cross light is beamed in from one side; (b) for textured objects, copying is done by strongly lighting the surface from one side, with suitable balanced fill light from the opposite side and near the lens axis.*

can keep the material very flat, but on horizontal copy rigs it is necessary to have vacuum boards, magnetic boards or copy easels coated with low-tack adhesive. When working in colour, note that most glass has a greenish tinge which must be filtered away with red or magenta CC filters of densities normally between 0.10–0.20.

Exposure

Exposure of copies must be more closely calculated than for normal indoor photography. Over-exposure clogs fine lines and blocks up delicate mid tones, whereas under-exposure loses necessary details in the dark areas, and the bellows extension factor complicates exposure matters still further. Hand-held meters are best for measuring light on the copy board and most photographers prefer an incident meter fitted with a small probe to do this. Minolta make an excellent one. If using a reflectance meter, it is perhaps more accurate if an 18 per cent grade neutral test card is placed on the copy board and the reading made from that. Always increase half a stop exposure for dark originals and decrease half a stop for light or airy ones, whatever meter is used.

Reducing contrast

Contrast is inherent in most copy procedures, particularly with colour, and can be lowered in several ways. Colour film may be first exposed to an 18 per cent grey card with an added 1.0 ND filter in place over the lens and then the same piece of film re-exposed to the copy original before processing. Some experiment and tests are needed first with this technique to find the necessary ND filter as colour contrast is a very subjective value judgement, depending much upon which colours are adjacent to the borders of the main colours in the picture.

Black and white contrast control can start with the original. If any material is being created especially for copying, as often happens with montage or collage images, or when copy negatives are being made from original negatives, prints should be made on a grade of paper at least one contrast step

below that which would be chosen for standard use. Slight over-exposure in the enlarger and slight under-development in the print developer, results in a long-scale, flat print with grey highlights. Subsequently, when this is copied, contrast can be easily controlled by film and developer choice and by processing to reach any desired level.

Very long-scale film material can be used, such as Kodak Gravure Positive and this can give extremely good results, with clean highlights and rich shadow detail. 30–50 per cent over-exposure of medium-speed negative material and 20–70 per cent under-development, in a fairly active developer such as Kodak DK50 or May and Baker Suprol, diluted 1:20, can give tremendous control of contrast.

Positive/negative Polaroid film, such as Type 55, 9×12cm (4×5in.) film is an excellent choice as a copy film, particularly where originals have areas of line or text in addition to coloured, continuous tone. Very good negatives, with excellent printing contrasts, are obtained by over-exposing the Polaroid slightly to get a fairly dense negative. Although this wastes the positive print, if the negative is then printed on a paper grade one step more contrasty than usual, line is rendered crisply and full monochrome detail is to be found in the coloured areas.

When it becomes necessary to copy original negatives in order to make a new negative, a direct reversal material, such as Kodak SO 015, may be used. This gives a one-step chemical reversal, so a negative is obtained directly. The more usual technique is to make very flat prints from the original negatives, spot and re-touch these and then copy these special prints on orthochromatic continuous-tone film processed in Kodak D76, Ilford ID11 or May and Baker Suprol (diluted 1:20). It may be necessary to wash original negatives or re-touch them, and removing yellow or brown stains on old negatives is possible by photographing through a yellow filter or perhaps a Wratten 81EF CC filter.

Where contrast is already at its maximum, as happens with black lines on white backgrounds, this contrast must be maintained by using colour-blind emulsions called 'lith films', processed in caustic, high-energy developers. Such films have very little latitude and exposure must be extremely accurate.

142 *A low angle and low lighting to dramatize a very ancient solid gold object.*

Too much exposure and the fine line areas of such originals will be lost, too little and the white areas on the negative become grey instead of black and the film is covered in pinholes and defects. For best results with this copy material, use a two-bath lith developer such as Kodak Kodalith, expose a number of bracketed tests and develop at 20°C (68°F) precisely for the recommended time for full development. Do not agitate too much after the film has had one minute of development, dispense with an intermediate acid stop and, instead, replace it with a fresh water rinse. Agitate carefully in the fixer but do not over-fix. Most lith copy negatives will

still need patching or spotting with opaque medium to cover up pinholes and defects however careful the operator is.

Common problems and solutions

Each copy of original material will pose different problems and below are some considerations of the more usual ones which may be expected in black and white work and how to begin solving them:

AQUATINT: use panchromatic film and active developer, but not lith developer

BLUE PRINTS: use panchromatic film and deep red filter to get white line on black ground; make a positive of this negative, and print from the positive to obtain reverse tones, if a black line is wanted on a white ground

CREASED PRINT: cover the surface with a thin layer of glycerine, sandwich the print between thin, clear glass and then copy. The glycerine is washed off in water afterwards

DAGUERREOTYPE: avoid finger marks, surround the original entirely with black velvet, use a black shield on the camera and black gloves on the camera hand, in order to minimize reflection

FADED DOCUMENTS: use panchromatic film and a yellow filter to remove any yellowing, or a blue filter if yellowing is to appear as grey tone in the final print

HALF TONE REPRODUCTION: to minimize the dot screen use a lens stopped down to f64 or f90: at these apertures acuity of the lens is

143 *An example of textural copy lighting on the impasto surface of an oil painting.*

considerably reduced and the dot may be lost without totally losing the appearance of sharp focus in the main image

HANDWRITING: use lith film and lith developer but, if tone is wanted in the background, or texture, use panchromatic film with enhanced contrast by over-development

INK DRAWINGS: use lith film and lith developer

MAPS: use high-contrast continuous-tone panchromatic film, or lith film if line only is wanted

MEDALS: rub lightly with powdered graphite and blow clean, leaving slight darks in all the recessed areas; photograph as normal copy, but with a strong diffused side light as an additional light in order to increase modelling

OIL PAINTINGS: use polarized light if the varnish is bright or there is heavy impasto surface; copy on panchromatic film with a yellow filter

PENCIL DRAWINGS: use high-contrast, continuous-tone ortho film or slow-speed panchromatic film with under-exposure and increased development to lift contrast

PLANS: high-contrast lith film with two-part lith developer

SELECTIVE COLOURS: on white paper, coloured print which is needed as black on the final print, use a filter of the opposite colour

SEPIA TONE: use an ortho film or a panchromatic one with an orange/yellow filter

STAINED PRINTS: use panchromatic film and add a filter of the same colour as the stain

TYPED MATTER: use lith film and lith developer; back thin pages of single sided type with white paper and thin sheets of double sided type with black paper

UNIFORM FADING: use an ortho continuous tone film, with a blue filter

WASH DRAWINGS: if the wash is to be eliminated or reduced in tone, use panchromatic film and a filter of similar colour to the wash tone; if the wash is to be enhanced and show as a grey tone, filter with a colour opposite to that of the wash colour

WATER COLOURS: use panchromatic film and a light yellow filter

All soiled and damaged copy material can be improved by cleaning, but this should never be done without the owner's permission and, the more valuable the original, the more skilful must be the reconditioning. Some soiling can be removed by using alcohol, film cleaner, art gum or fresh white bread kneaded to a wad with the fingers. The bread leaves the least damage on most paper material. Be cautious about washing valuable originals.

A word of warning about copying: under most laws of copyright any operator who copies material which is copyrighted is also liable for penalty, sometimes severe. For ethical reasons as well as for commercial prudence, do not copy another photographer's work or any material which is possibly protected. Make sure any commissioning client gives a written indemnity against legal proceedings, if there is any doubt whatsoever. Never copy bank notes or coins of any legally valid currency, unless written permission is first obtained from the proper authorities.

List of Suppliers

CAMERA MANUFACTURERS

	UK distributors	US distributors
ARCA–SWISS OSCHWALD BROS 8047 Zurich Fellenbergstrasse 272 Switzerland (Large format)	KEITH JOHNSON PHOTOGRAPHIC LTD 11 Gt Marlborough Street London w1 Great Britain	CALUMET PHOTO INCORPORATED 1590 Touhy Avenue Elk Grove Village Illinois USA (Large format)
CANON JAPAN CANON INC. 11–28, Mita 3–Chome Minato-Ku Tokyo 108 Japan	CANON (UK) LTD Brent Trading Centre North Circular Road Neasden London NW10 0JF Great Britain	CANON USA 1 Canon Plaza Lake Success New York USA
VICTOR HASSELBLAD AB Box 220 S–401 23 Goteborg 1 Sweden	HASSELBLAD (GB) LTD York House Empire Way Wembley Middlesex HA9 0QQ Great Britain	VICTOR HASSELBLAD INC. 10 Madison Road Fairfield New Jersey 07006 USA
LEICA ERNST LEITZ WETZLAR GMBH D–6330 Wetzlar West Germany	E. LEITZ (INSTRUMENTS) LTD 48 Park Street Luton Bedfordshire LU1 3HP Great Britain	E. LEITZ INC. Rockleigh New Jersey 07647 USA
MINOLTA JAPAN MINOLTA CAMERA CO. LTD. 30, 2–Chome Azuchi-Machi Higashi-Ku Osaka 541 Japan	MINOLTA UK 1–3 Tanners Drive Blakelands Milton Keynes Great Britain	MINOLTA CORPORATION 101 Williams Drive Ramsey New Jersey USA
NIKON JAPAN NIPPON KOGAKU KK Fuji Building 2–3 Marunouchi 3–Chome Chiyoda-Ku Tokyo 100 Japan	NIKON UK LTD 20 Fulham Broadway London sw6 1BA Great Britain	NIKON INC. 632 Stewart Avenue Garden City New York USA

	UK distributors	**US distributors**
OLYMPUS OPTICAL CO. LTD 43–2 Hatagaya 2-Chome Shibuya-Ku Tokyo Japan	OLYMPUS OPTICAL CO. (UK) LTD 2–8 Honduras Street London EC1Y 0TX Great Britain	OLYMPUS CAMERA CORP. Crossways Park Woodbury New York 11797 USA
POLAROID CORPORATION 549 Technology Square Cambridge Massachusetts USA	POLAROID (UK) LTD Ashley Road St Albans Herts AL1 5PR Great Britain	POLAROID CORPORATION 459 Technology Square Cambridge Massachusetts 02139 USA
ROLLEI FOTOTECHNIC GMBH 33 Braunschweig Salzdahlumer Strasse 196 West Germany	A.V. DISTRIBUTORS LTD 26 Park Road Baker Street London NW1 Great Britain	BERKEY PHOTO INC. PO Box 1060 Woodside New York 11377 USA
SINAR AG Schaffhausen CH 8245 Feuerthalen Switzerland	LAPTECH PHOTOGRAPHIC DISTRIBUTORS LTD 151–153 Farringdon Road London EC1 Great Britain	SINAR-BRON AMERICA 166 Glen Cove Road Carle Place New York 11514 USA
CONTAX-YASHICA COMPANY LTD 20–3 Denenchofu-Minami Ohta-Ku Tokyo 145 Japan	PHOTAX (LONDON) LTD 59 York Road London SE1 7NJ Great Britain	CONTAX CAMERA YASHICA INC. 411 Sette Drive Paramus New Jersey 07652 USA

FILM AND CHEMICAL MANUFACTURERS

	UK distributors	**US distributors**
		ACUFINE INCORPORATED 439–447 E. Illinois Street Chicago Illinois 60644 USA (Developers and chemicals)
AGFA–GEVAERT A.G. 5090 Leverkusen 1 Bayerwerk West Germany	AGFA–GEVAERT LIMITED 27 Great West Road Brentford Middlesex Great Britain	AGFA–GEVAERT 275 North Street Teterboro New Jersey USA
	KODAK LTD Hemel Hempstead Herts Great Britain	EASTMAN KODAK COMPANY 343 State Street Rochester New York 14650 USA
		EDWAL SCIENTIFIC PRODUCTS CORPORATION 12120 S. Peoria Street Rochester New York 14650 USA (Developers)

	UK distributors	**US distributors**
		ETHOL CHEMICALS INCORPORATED 1808 North Damen Avenue Chicago Illinois 60647 USA (Developers)
FUJI PHOTO COMPANY LTD 26–30 Nishiazabu 2-Chome Minato-Ku Tokyo 106 Japan	FUJIMEX Faraday Road Dorcan Swindon Wiltshire SN3 5HW Great Britain	FUJI PHOTO FILM COMPANY LTD 350 Fifth Avenue New York NY 10001 USA
CIBA–GEIGY PHOTOCHEMIE AG CH–710 Fribourg Switzerland	ILFORD LIMITED Basildon Essex Great Britain	ILFORD INCORPORATED West 70 Century Road PO Box 288 Paramus New Jersey 07652 USA
	3M COMPANY LIMITED Bracknell Berks Great Britain	3M COMPANY 3M Center St Paul Minnesota USA
	MAY AND BAKER LIMITED Dagenham Essex RM10 7XS Great Britain	
	PATERSON PRODUCTS LIMITED 2–6 Boswell Court London WC1N 3PS Great Britain (Chemicals; film clips; darkroom equipment)	
	POLAROID (UK) LIMITED Ashley Road St Albans Herts AL1 5PR Great Britain	POLAROID CORPORATION 459 Technology Square Cambridge Massachusetts 02139 USA (Polaroid hot line: (617) 547 5176 during business hours, USA time)
		UNICOLOUR DIVISION–PHOTO SYSTEMS INCORPORATED PO Box 306 Dexter Michigan 48130 USA (Colour materials and equipment)

FILTERS AND LENSES

	UK distributors	US distributors
HOYA JAPAN 572 Miyazawa-CHO Akishima SH1 Tokyo 196 (Filters)	INTROPHOTO Priors Way Maidenhead Berks Great Britain	HOYA UNIPHOT INC. B1-10 34th Avenue Woodwise New York 11377 USA
	KEITH JOHNSON PHOTOGRAPHIC LTD 11 Gt Marlborough Street London W1 Great Britain	TIFFEN MFG CORPORATION 71 Jane Street Roslyn Heights New York 11477 USA (Filters and special effects)
CARL ZEISS Postfach 1369/1380 D-7082 Oberkochen West Germany (Lenses)	CARL ZEISS (OBERKOCHEN) LTD 31-36 Foley Street PO Box 4YZ London W1A 4YZ Great Britain	

LIGHTING EQUIPMENT

	UK distributors	US distributors
	BERKEY TECHNICAL COMPANY Westwood Park Trading Estate 22 Concord Road London W3 0TQ Great Britain (Cameras, enlargers, tripods, lighting)	BERKEY TECHNICAL COMPANY 26-45 Brooklyn-Queens Expressway West Woodside New York 11377 USA
	BOWENS SALES AND SERVICE LIMITED Royalty House 72 Dean Street London W1V 6DQ Great Britain (Professional flash equipment, cameras, enlargers, meters)	BOGEN PHOTO CORPORATION 100 S. Van Brunt Street Englewood 07631 New Jersey USA
BRONCOLOR BRON ELEKTRONIC AG CH-4123 Auschwil Switzerland (Flash equipment)	LAPTECH PHOTOGRAPHIC DISTRIBUTORS LTD 151-153 Farringdon Road London EC1 Great Britain	SINAR BRON AMERICA 166 Glen Cove Road Carle Place New York 11514 USA
	KEITH JOHNSON PHOTOGRAPHIC LTD 11 Gt Marlborough Street London W1 Great Britain	LARSON ENTERPRISES INCORPORATED PO Box 8705 18170 Euclid Valley Fountain Valley California 927808 USA (Photographic light control systems, lighting equipment, location equipment)

	UK distributors	**US distributors**
MULTIBLITZ	KEITH JOHNSON PHOTOGRAPHIC LTD	MACDONALD'S PHOTO PRODUCTS
DR. ING DA MANNESMANN GMBH	11 Gt Marlborough Street	11211 Gemini House
D 5000 Koln 90	London w1	Dallas
Westhoven-BRD	Great Britain	Texas 75229
West Germany		USA
(Flash equipment)		
	KEITH JOHNSON PHOTOGRAPHIC LTD	NORMAN ENTERPRISES INC.
	11 Gt Marlborough Street	2601 Empire Avenue
	London w1	Burbank
	Great Britain	California 91504
		USA
		(Studio and location flash equipment)

Index